SHOOTING
LINCOLN

SHOOTING
LINCOLN

MATHEW BRADY, ALEXANDER GARDNER,
and the **RACE TO PHOTOGRAPH
THE STORY OF THE CENTURY**

NICHOLAS J. C. PISTOR

Da Capo

Da Capo Press
Hachette Book Group
1290 Avenue of the Americas, New York, NY 10104
www.dacapopress.com
@DaCapoPress; @DaCapoPR

Printed in the United States of America

First Edition: September 2017

Published by Da Capo Press, an imprint of Perseus Books, LLC, a subsidiary of Hachette Book Group, Inc.

The publisher is not responsible for websites (or their content) that are not owned by the publisher.

Print book interior design by Amy Quinn.

Library of Congress Cataloging-in-Publication Data

Names: Pistor, Nicholas J. C., author.
Title: Shooting Lincoln : Mathew Brady, Alexander Gardner, and the race to photograph the story of the century / Nicholas J. C. Pistor.
Description: First Da Capo Press edition. | Boston, MA : Da Capo Press, 2017.
| Includes bibliographical references and index.
Identifiers: LCCN 2017031093| ISBN 9780306824692 (hardcover : alk. paper) |
ISBN 9780306824708 (e-book)
Subjects: LCSH: Lincoln, Abraham, 1809–1865—Assassination. | Lincoln,
Abraham, 1809–1865—Assassination—Press coverage. | Brady, Mathew B.,
approximately 1823–1896. | Gardner, Alexander, 1821–1882. |
Photojournalists—United States—History—19th century.
Classification: LCC E457.5 .P57 2017 | DDC 973.7092—dc23
LC record available at https://lccn.loc.gov/2017031093

ISBNs: 978-0-306-82469-2 (hardcover), 978-0-306-82470-8 (ebook)

LSC-C

10 9 8 7 6 5 4 3 2 1

For reporters and photographers everywhere

CONTENTS

Shooting Lincoln

— Sunday, February 5, 1865 —

THE PRESIDENT LOOKED like he was already dead.

The bags under his eyes resembled the piles of bodies stacked on Civil War battlefields across the North and South. His face was sunken. His lanky frame looked downright skeletal. His wiry salt-and-pepper hair jutted from his head in a tangled mess—untouched by a comb from yet another restless night. His wrinkles crisscrossed deep in every direction, offering a reminder that Abraham Lincoln wore the scars of war on his rugged rail-splitter flesh.

This was not a good day for Lincoln to get shot. The Confederates were on the run. The air was filled with the whiff of surrender. The busy president, not yet into his second term, had unfinished business. But there he was, seated on a Queen Anne–style chair under a skylight in the direct aim of Alexander Gardner. Lincoln's mischievous eleven-year-old son, Tad, rustled about nearby.

Washington was in a cold snap. A snowstorm was on the way.[1] Lincoln sat corpse-like, as frozen as the weather outside. On the streets, business was deadlocked. Nobody wanted to operate until the country's future became more clear, the *Washington Evening Star* noted.[2] Time stood still. The quiet was broken only by the clang of church bells—two dings noting it was two o'clock in the afternoon.

Gardner, a burly Scottish immigrant with a wild beard, didn't have a gun trained on Lincoln's cavernous face. He had a wooden box with a glass lens, which required Lincoln to be still. He was conducting a photo shoot of the wartime president at his upstairs studio at Seventh

and D Streets in Washington, a few blocks from the White House. Outside, men around the country dreamed about making it Lincoln's last—and at least one was preparing to make sure of it.

Assassination attempts weren't new to Lincoln. He had lived with the threats ever since he was elected. In Baltimore he narrowly avoided an attack years earlier while taking a train to his inauguration. At the moment, though, Lincoln was more concerned with ending the war he had overseen since 1861. The president was traveling throughout Washington with little security. A few months before, Ward Hill Lamon, the marshal of the District of Columbia, scolded Lincoln for slipping out to a local theater without protection. "I regret that you do not appreciate what I have repeatedly said to you in regard to proper police arrangements connected with your household and your own personal safety," Lamon wrote. "You are in danger. . . . And you know, or ought to know, that your life is sought after, and will be taken unless you and your friends are cautious; for you have many enemies within our lines."[3]

The days and months ahead would be shrouded in myth, talked about and investigated by researchers for the next century and more. But one thing was obvious right then and there. The president was careless about his personal safety. And the man who pioneered the use of photographs to develop his political persona cared even less about how he looked.

———◆———

As GARDNER DIRECTED Lincoln in different poses, John Wilkes Booth, a famous actor, was working on his conspiracy. For the moment, he had settled on capturing Lincoln—not shooting him. Possibly at the nearby Ford's Theatre.

Booth knew the theater well. He had stood on its stage sixteen days earlier in a performance of William Shakespeare's *Romeo and Juliet*. The handsome, baby-faced Booth played Romeo. A few days before, he was at the theater, eyeing its exits and pathways for a potential abduction of Lincoln, a fan of comedies and a known guest of the place. John Sleeper Clarke, Booth's brother-in-law and famed American comedian, was performing the play *The Rivals* at the theater the following day.[4] Perhaps Lincoln would show.

The twenty-six-year-old Booth wasn't the type one expected to plan a political coup. He was from a famous theatrical family. His

brother Edwin, also a famous Shakespearean actor, once saved Lincoln's son from getting hit by a train. When Edwin scooped him off the train platform, the son, Robert Todd, recognized Edwin's face from pictures he had seen.

But John Wilkes Booth was not like his brother. While he was an accomplished actor, he was also a drunken Confederate sympathizer who despised Lincoln. At the moment, the public saw otherwise. "As earned by his Romeo, we hasten to add our laurel to the wreath which the young actor deservedly wears; to offer him our congratulations, and to say to him that he is of the blood royal—a very prince of the blood—a lineal descendant of the true monarch, his sire, who ranks with the Napoleons of the stage," a critic for the *Washington Daily National Intelligencer* wrote. "We have never seen a Romeo bearing any near comparison with the acting of Booth on Friday night."[5]

Booth's own life was headed for tragedy, just like the Shakespeare plays he headlined. Despite outward appearances, he was broke and angered by Lincoln's continued prosecution of the war. The Confederacy was in its darkest days. The end was near. General William Tecumseh Sherman had wasted Georgia and was lurching north through South Carolina, the jewel of the rebellion. Lincoln and his cabinet were starting to focus on how to put the fractured country back together again. Since the South couldn't handle Lincoln in battle, Booth figured he had to do it himself.

Booth lived on and off at the National Hotel, a place popular with Southerners in a city built at the crossroads of North and South. The hotel, a series of six connected townhouses, was a Washington landmark that housed all the greats, from Lincoln to Dickens.[6] By now, however, it had developed a sordid past. In 1857 the hotel hosted a preinaugural ball and lodged President-Elect James Buchanan. During his stay, Buchanan grew ill with an upset stomach. A few weeks after the inauguration, Washington was gossiping about a strange disease overtaking the hotel's guests.[7] People quickly panicked.

The newspapers didn't help. The scandal-loving reporters offered detailed accounts of hotel guests who grew sick during their stays. Several posited that the illness was attributable to poisoned rats that died in a water reservoir. Just about any rumor or theory made it into print. The *Columbus (GA) Enquirer* later reported that President Buchanan was near death. "The disease contracted by [the president] at the National Hotel appears to be hastening the president's fate," the

newspaper reported, based on an account from an unnamed "very distinguished democrat."[8] The *New York Times* downright speculated that the disease was the result of a botched assassination attempt on the president by radical abolitionists. None of that was true. But it goes to say: the National Hotel was a great place to hatch a conspiracy.

———•———

BOOTH HAD BEGUN tracking Lincoln's movements throughout the capital city, but there was no indication he knew Lincoln was at Gardner's studio. Gardner had photographed Booth there before, as he had so many other celebrities and politicians and generals. He and his old boss, famed photographer Mathew Brady, had perfected the wet-plate process, which allowed them to duplicate photos and sell them to the general public. Many of their famous subjects wound up on small card stock. Americans traded them like baseball cards.

Gardner was a realist. He was not in awe of celebrities like Brady. Still, his studio was packed with famous faces. Grant. Sherman. Lincoln. But in recent years, Gardner's gallery had become dominated by the Civil War itself. The three-story building's brick exterior wore a large sign with big block letters reading: VIEWS OF THE WAR.

Gardner, who appreciated the news value of his work, had seen bloody battles and captured their aftermath countless times. His gallery displayed large images of the war, everything from Antietam to Gettysburg. Dead trees. Dead horses. Dead soldiers. The realities of war were on full display, showing the public brutal truths that the partisan newspapers could not. Or at least so viewers thought. Technology limited Gardner to taking photos after the battles had ended. Gardner, one of photography's early pioneers, wanted to create something more alive. Something with motion. That chance would have to wait.

Regardless, the war was good for business. Soldiers wearing both blue and gray flocked to photography studios before they hit the battlefield. It was, if prayers went unanswered, the last chance to give their worried families a memory before they died. Gardner had broken away from Brady and established his own studio with help from some other Brady apprentices. Now his best photos, unlike in the past, weren't branded "Photo by Brady."

As the war wound down, Gardner spent more time in Washington, building relationships and preparing to photograph the aftermath. Connections were important in getting access to the best subjects

and events. And Brady, Gardner's old mentor, still had a lot of them. The two were rivals now. Although Gardner had photographed Lincoln more than anyone else, he hadn't done so recently.[9] Lincoln's tall shadow hadn't graced Gardner's lens since 1863.

Lincoln was a popular subject—and a vexing one. John Nicolay, Lincoln's private secretary, later wrote: "Graphic art was powerless before a face that moved through a thousand delicate gradations of line and contour, light and shade, sparkle of the eye and curve of the lip, in the long gamut of expression from grave to gay, and back again from the rollicking jollity of laughter to that serious, far away look that with prophetic intuitions beheld the awful panorama of war, and heard the cry of oppression and suffering. There are many pictures of Lincoln; there is no portrait of him."[10]

Lately, Lincoln had been sitting at Brady's studio on Pennsylvania Avenue, built near the place where Revolutionary-era portrait artist Gilbert Stuart enshrined the likenesses of America's founding fathers in oil paint. Gardner had opened the studio for Brady, a New Yorker, there in 1858. Washington was the epicenter of the war, and the war was the epicenter of photography. Brady began spending a lot of time in the city, often living at the National Hotel and sending his camera operators, including Gardner, into battle. The stretch of Pennsylvania Avenue was aptly nicknamed "Photographer's Row."

Brady fashioned himself an artist and identified with the painters who came before him. He viewed his work more as commemorative rather than capturing history as it happened. Thus, he had long-lasting friendships with portrait artists, especially Francis Bicknell Carpenter, a painter who gained Lincoln's trust and lived at the White House for six months. The result was an American masterpiece: 1864's *First Reading of the Emancipation Proclamation of President Lincoln*, depicting the president and his cabinet with the document that freed America's slaves. Carpenter labeled Lincoln's pen stroke "an act unparalleled for moral grandeur in the history of mankind."[11]

While at the White House, Carpenter made sketches of Lincoln and his cabinet at work. He often invited Brady and his new Washington studio operator, Anthony Berger, Gardner's replacement, to come over and photograph Lincoln. He would use the results as an aid. The White House was an often chaotic environment to take pictures, a painstaking process. Berger used a closet at the executive mansion as a darkroom. One day Lincoln's son Tad locked Berger out of the closet

during a photo shoot and ran away with the key. Lincoln jumped from the chair, left the room, found his son, and returned with it.

But Tad gave Brady and Berger an enduring image. In 1864 Berger captured a heartwarming portrait of a bespectacled Lincoln reading from a book to his youngest son. As always, Berger's boss, Brady, got the credit. "No greater compliment can be paid an artist than so often paid to M. B. Brady, the first of photographists, . . ." wrote the *Washington Morning Chronicle*. "What a world of significance is in the picture which will appear in our Weekly Chronicle of tomorrow, in which our . . . [president] is seen in the company of his son, examining an album. Both picture and album are the works of Brady. In fact, the studio of the artist . . . is overflowing with gem pictures, and an hour is well spent in viewing them."[12]

The forty-three-year-old Gardner did not take a picture of Lincoln the entire year of 1864. But he had his chance on that cold February day. With Tad in his studio, he sought to create his own image of Lincoln as father. It was his chance to outdo his rival. Navy Secretary Gideon Welles had commissioned a new portrait of Lincoln from artist Matthew Wilson. The busy president opted to sit for Gardner and have the artist work from the images. That day, as one researcher would note, Lincoln looked "steadily toward the camera but his hands fiddle impatiently with his eyeglasses and pencil as if to remind the photographer that he had more important things to do."[13]

He did have better things to do. That evening Lincoln planned an important cabinet meeting. He had just returned from the Hampton Roads peace conference in an attempt to end the war. At the meeting, Lincoln intended to float a controversial idea: to compensate slaveholders in return for freeing their slaves. Peace was within reach. And despite Lincoln's outward appearance, there was a hopeful glint in his eyes to match his prairie-lawyer smile.

Gardner moved the camera and directed the president, attempting to capture him at his best. Tad leaned on an ornate wooden table looking toward his father—almost like an adult. Lincoln held a book in his hand. Gardner captured the moment. But his most memorable photo from the day was yet to come. The photographer made a close-up of the president, focusing on his shoulders, chest, and head. Finally, the president was done. Time for him to scurry out onto Washington's unpaved streets, where enemies were all around. No one could be sure how the pictures would turn out. Gardner hoped for the best.

Soon Lincoln would start having nightmares, envisioning his own death.[14] Soon the investigators would come to Gardner's studio, seeking photos of Booth. Soon they would be printed and placed on posters across the country. And soon Gardner and his rival Brady would be thrown into their own chase of history, playing a role in capturing Lincoln's enemies who stirred about Washington and enshrining the heart-stopping moments for centuries to come.

But for the moment, Gardner's job was to develop his pictures. He put on the large coat he customarily wore to protect himself from the harsh chemicals used in photo production. He drenched the photos in a chemical bath, bringing the images to life. At one point, a glass plate of his final close-up cracked. Gardner fitted the fractured glass pieces back together and made one print. He threw the negative away. In the photo, a line moving left to right traced over the top of Lincoln's head. Soon, so would a bullet.

1

The Great Exhibition

— July 1851 —

MATHEW BRADY WAS somewhere across the Atlantic and didn't yet know the fate of Louis Daguerre. The twenty-nine-year-old Brady was making the ocean voyage to London from his home in New York, intent on later traveling to France to meet Daguerre, the father of modern photography—an old man now known to the world as a magician. Brady, already a celebrated photographer in America, was a student of Samuel Morse, of telegraph fame. And Morse was a friend of Daguerre, whose name is synonymous with the most popular photographic process of the day: the daguerreotype. Brady had become a master of the Daguerre magic, a process dictionary pioneer Noah Webster said made images appear "as if by enchantment." The technique uses silver plates and chemicals to create sharp images. Before Daguerre, people remembered their loved ones through portraits or memory. Now they had pictures.

The Great Exhibition in London tugged Brady on his travel to Europe, where his daguerreotypes were part of the first-of-its-kind international competition. Two of his competitors back in the States—M. M. Lawrence and John A. Whipple—would be there, along with dozens more from around the world. Brady wanted to win. The competition, he hoped, would be a crowning achievement that cemented his reputation in America and stretched it across the globe. Plus, it would give his studio back home a financial boost—something that was always needed to flush his ambitious and luxurious pursuits with cash—and give the busy Brady a chance to rest. A visit with Daguerre

would be an added treat, if not a necessity. Brady loved to use famous names in advertisements for his growing gallery back home. What could be better than an endorsement from Daguerre? And maybe, just maybe, he could make a picture of him, providing his gallery with a dash of international flair. That wasn't to be.

The waves crashed in the North Atlantic as Brady's steamship headed toward England. He hoped his time away from New York brought healing to his weak eyes and a brighter future to his business. Everything seemed as limitless as the deep water floating beneath him. "Mr. Brady is not operating himself, a failing eyesight precluding the possibility of his using the camera with any certainty," wrote the *Photographic Art Journal*, before Brady left. "But he is an excellent artist, nevertheless, understands his business perfectly, and gathers about him the finest talent to be found." Brady left his study in the hands of George S. Cook, a talented South Carolina photographer who would later capture his own fame as the "Mathew Brady of the South."

Brady traveled in luxury with his newlywed wife, Julia, a golden pedigreed young woman distantly related to George Washington. Brady, who himself came from Irish immigrants, was married to a patrician. Nothing but the best for the great Brady of Broadway. "[Brady] likes to live pretty fast life & spends money freely," reported R. G. Dun & Company.

His fast life was also one of mystery. Even his year and place of birth were shrouded in myth. He himself placed the date between 1823 and 1824, but he didn't like the subject. "Never ask that of a lady or a photographer; they are sensitive," Brady once told a reporter. "I will tell you, for fear you might find it out, that I go back to near 1823–'24; that my birthplace was Warren County, N.Y., in the woods about Lake George, and that my father was an Irishman." Civil War draft records show Brady originally said his birthplace was Ireland but later changed it. Why? Brady needed people to think he was a red-blooded American. It was better for business in a city struggling with immigration. In the 1850s, the Know-Nothings stalked the streets of New York, and American politics frothed with anti-Irish sentiment.

But Brady appeared to tell the truth about his occupation. On the same draft records, he listed himself as an "artist," which is how he identified ever since he was a kid. On the ship to England was William Page, a noted American painter and portraitist whom Brady had known since he was young in rural New York. "He took an interest in

me and gave me a bundle of his crayons to copy. This was at Albany. Now Page became a pupil of Prof. Morse in New York City, who was then painting portraits at starvation prices in the University rookery on Washington Square. I was introduced to Morse; he had just come home from Paris and had invented upon the ship his telegraphic alphabet, of which his mind was so full that he could give but little attention to a remarkable discovery one Daguerre, a friend of his, had made in France."

Also on the ship was James Gordon Bennett, the founder of the *New York Herald* and a major figure in journalism. Brady was a collector of great friends. He always enjoyed the company of the important and influential. They were his lifeblood. Famous names and faces were important to his success. Brady's easy hand and pleasing style lured them into his studio. "In those days a photographer ran his career upon the celebrities who came to him, and many, I might say most, of the pictures I see floating about this country are from my ill-protected portraits," Brady later remembered.[1]

Daguerreotypes were a booming business. Galleries were springing up all over America, with people clamoring to sit and have their pictures taken. First, they were frequented by the rich. Then by just about everyone. Life expectancy being what it was—thirty-eight years old—it was the perfect way for a mother to remember a dead child or a son to remember his father headed off to war. Death was always on the mind.

In 1840, just a year after Daguerre shocked the world with his tantalizing photographic process, zero people labeled themselves as professional photographers. By 1850 there were 938, a number that would triple by the end of the decade.[2] They were known to households across the nation. In 1851 Nathaniel Hawthorne made a photographer the protagonist in *The House of the Seven Gables*.[3]

While photography was considered a science, it was also quickly becoming an art form. Brady was leading the way. He had distinguished himself from the other photographers by making pictures of great Americans. Everyone who was anyone. Presidents. Senators. Generals. Actors. Writers.

Brady had planned to show his images to Daguerre. The *Daguerrean Journal* reported that Brady had brought along "some exquisite specimens of daguerreotypes for Daguerre . . . [that] will establish his reputation for exquisite pictures in Europe as generally as it is here."

Perhaps Brady would show him his portrait of popular author James Fenimore Cooper, who Brady later claimed had planned to put him in a novel.[4] Or perhaps he would showcase his unpublished daguerreotype of Dolley Madison, the wife of President James Madison, who famously saved Gilbert Stuart's legendary painting of George Washington before the White House was torched by the British in the War of 1812. Or maybe he would show him the White House itself. Brady had taken its first-ever picture.

Daguerre would have had an interest in seeing pictures of the men who lived in that house. He had lived through the French Revolution, the upheaval that came after the American rebellion—events that enabled modest men like Brady and Daguerre to achieve extraordinary heights. Perhaps Brady could show him his portrait of John Quincy Adams—the first president photographed—who was just a schoolboy during America's independence but lived until 1849. "Had he been thirteen years earlier he could have got John Adams and Jefferson, too; and he missed the living Madison and Monroe and Aaron Burr by only four or five years," reporter George Alfred Townsend once observed. Maybe Brady could show Daguerre former president Andrew Jackson, a photo Brady had arranged a few years back, just before Old Hickory died. "I sent to the Hermitage and had Andrew Jackson taken barely in time to save his aged lineaments to posterity," Brady told Townsend, knowing his job was to preserve history.

And then maybe Brady could convince Daguerre to sit for that daguerreotype. It wouldn't be easy. Ironically, the father of photography was camera shy. But Brady had his ways. He had spent years learning how to cajole powerful and accomplished men. He was always deferential. Almost servant-like. "I never had an excess of confidence, and perhaps my diffidence helped me out with genuine men," Brady remembered.[5]

None of that was to be with Daguerre. The burgeoning master of the art would never meet its inventor. As Brady drifted across the Atlantic, daydreaming about the future, and crowds admired daguerreotypes at the Great Exhibition, Daguerre was taking long walks and tending to his garden at his home in the Paris suburb of Bry-sur-Marne. In his early sixties, Daguerre had largely retreated from public life. On July 10, he unexpectedly collapsed while eating lunch with his family.[6] Within an hour he was dead from an apparent heart attack.

Brady arrived in London and was greeted with the news, which made few waves in the busy city. While France mourned Daguerre's death—and the entire village of Bry-sur-Marne attended his funeral—it took more than a month for American newspapers to notice. And when they did, they mentioned a sad coda to Daguerre's life: he was broke. Despite Daguerre's creating a revolution of the age, poor financial decisions surrounding his invention had rendered him destitute. The French gave him a bailout in the form of an honorary pension of ten thousand francs a year.[7] They made sure the patriarch of photography wasn't a peasant. Daguerre's misfortune should have been a warning for the fast-spending Brady. Fame, which Brady lusted, didn't make Daguerre rich.

None of that mattered at the time. There was a competition to win.

—◆—

THE SHARP-DRESSED MATHEW Brady arrived in London and stayed at the city's best hotels. Rich Americans opted for Minart's or Fenton's or Morley's, all charging five to ten dollars a day, whereas a good boardinghouse was ten to fifteen dollars a week. Brady soon made it to Hyde Park, a large park near Kensington Palace with green grass, lush gardens, and a brand-new building. His bad eyes squinted through his thick eyeglasses. He was looking at the future.

Its skin of plate glass, stitched together with cast iron, projected the wonder of the day. Some said its mere existence was akin to the same magical powers used to create pictures. The building towered over the park like a fairy-tale giant. A sight to behold, unlike anything Londoners had ever seen or imagined. The clear walls and ceilings reached 128 feet tall, with a rotunda that exceeded the size of St. Peter's in Rome. On cloudy days, the hulking mass looked ghostly. But when the sunlight hit the structure just right, it earned its name: the Crystal Palace.

Built for the Great Exhibition of 1851, the Crystal Palace was said to rival the Great Pyramids of Egypt in terms of its construction.[8] Sir Joseph Paxton, an English landscape gardener noted for building greenhouses, was its architect. His aim: to connect nature with form and function while showcasing the power and might of the expanding British Empire.

Brady was more refined than the backwater Americans often depicted in the British press. He recognized the use of glass construction. In fact, he used it himself. Large skylights lit his posh Manhattan studio, enabling him to use the sun's bright rays as a paintbrush to take photographs of prominent citizens and turn them into famous faces. Paxton's Crystal Palace, of course, was on a much grander scale than Brady's studio on Broadway—or anything else in America. One observer wrote that the building "combined advantages of lightness, strength, and security, without the aid of brick, stone, or mortar ! their places more efficiently and more economically filled by wood, iron, and glass. Yet so it was; a self-taught genius waved the wand with which he had before effected wonders, and up rose The Crystal Palace."[9]

The exhibition, organized by Prince Albert, husband of Queen Victoria, was the first of what would become the World's Fair, a celebration bringing geniuses from every corner of the globe to showcase their craft. And like all things British, it had a fancy, formal title: "the Great Exhibition of the Works of Industry of All Nations."

London shimmied with excitement as foreign breath mixed with the misty fog. Revelers included peasants, celebrities, and the well-bred. "The tremendous cheers, the joy expressed in every face, the immensity of the building, the mixture of palms, flowers, trees, statues, fountains,—the organ (with 200 instruments, and 600 voices, which sounded like nothing), and my beloved husband the author of this 'Peace-Festival,' which united the industry of all nations of the earth—all this was moving indeed, and it was and is a day to live for ever," Queen Victoria wrote in her journal after the exhibition's opening in May 1851.[10] The queen had every right to be impressed. The exhibition included a large zinc statue of herself, and other busts of her image were scattered about the hall. This, after all, was the dawn of the Victorian age.

Brady had arrived months after the official opening and after millions had already traipsed through the exhibition. There, Brady experienced a grand hall of whimsy. Steam engines shook the floors. Exotic soaps and perfumes scented the air. Great sculptures lined the halls. Organs—including the largest ever built—blasted with pomp and circumstance. Just about every flag of every nation was flown. The Swiss sent gold watches. The Chinese sent Mandarin robes. The Russians sent fine porcelain. The building included food courts with international fare and public lavatories—uncommon for the age. "Whatever

human industry has created you find there," wrote Charlotte Brontë, the English author of *Jane Eyre*. "From the great compartments filled with railway engines and boilers, with mill machinery in full work, with splendid carriages of all kinds, with harness of every description, to the glass-covered and velvet-spread stands loaded with the most gorgeous work of the goldsmith and silversmith, and the carefully guarded caskets full of real diamonds and pearls worth hundreds of thousands of pounds. It may be called a bazaar or a fair, but it is such a bazaar or fair as Eastern genii might have created." The crowds came and stamped across ten miles of exhibits. Special machines were made to sweep the dust from the floors, but they weren't needed. One person remarked that "the trailing skirts of the women visitors did the job splendidly."[11]

The British, of course, took up nearly half of that floor space. They packed it with shiny locomotives, iron, steel, and textiles. They also included loot from their expansive empire, from Canada to Australia. And then there was the United States. Despite having been given prominent space on the eastern end of the hall, the young nation, just a generation removed from independence, felt little need to show off on an international scale. The government, unlike most of its competitors, provided no money to sponsor exhibitors. Some American newspapers chalked the whole event up as a show of Britain's selfishness. The *New York Herald* opined that the exhibition was a "trick to make the rest of the world contribute to England's wealth; that as far as arts and manufactures are concerned, it will be a failure; and that, on the whole, it looks like a gigantic humbug."

Still, Americans, through their own sense of pride, made the exhibition their own. The display was marked by a massive eagle, with its wings extended, clutching an American flag in its claws. The rest was a ragtag assortment spread across a space much too large. When the exhibition started, many of the United States' exhibits were still in boxes, cluttered about the space. Representative that the very idea of America was still half finished. "I think myself it was meagre, compared with what it might have been. But it well represented our country, being a large space only partly filled," an American visitor wrote.[12] The *New York Evening Post* simply said it was a "national disgrace."[13]

Of note at the time, the United States, seventy-five years old, still didn't have a national anthem. The London newspapers were downright smug and poked fun at Britain's cousin across the Atlantic. "She

is proud of her machinery, which would hardly fill one corner of our Exhibition, and upon the merits of which our civil engineers would not pronounce a very flattering opinion," the *Times* of London noted.

The larger issue of international scorn was the United States' continued practice of slavery. Notably, a businessman encouraged Londoners to buy Irish linen instead of "American slave cotton." "The iniquitous system of slavery in America needs reprobation and discouragement: cotton is its main support," wrote Richard Allen of Dublin.[14]

Back in America, there was an increasing beat of rebellion. South Carolina was considering secession. Newspapers were filled with the dreaded word: *slavery.* "It has been latterly said the south would dissolve the Union if fugitive slaves were not sent back when called for," the *New York Herald* wrote.[15] The issue had simmered ever since the country broke from the British. Ironically, the United States' most popular exhibit at the fair was sculptor Hiram Powers's statue *The Greek Slave*, which depicted an undressed white marbled woman with chains around her arms. Many drew parallels to America's plantation slaves.

While slavery was slowly ripping the United States into two, other sleek items were on display that would fuel the inevitable fight: guns. Namely, Samuel Colt's guns. Colt, a Connecticut inventor who revolutionized firearm design, arrived at the exhibition intent on making a splash. Colt was a showman known for doing live demonstrations of his weaponry. He wowed the audiences with his intricate rapid-firing revolvers. When he won a medal, the *New York Times* said, "Colt's guns and pistols far exceeding anything presented by the ingenious mechanics of France and England, nations whose whole existence has been to make war a pastime; yet the ingenious son of a peaceful America has gained the prize even in the munitions of war."[16] America wouldn't remain peaceful for long—something that would benefit the businessmen at the exhibition and help make Colt very rich. Colt knew this. He had sold guns for the Mexican War.

While America's guns were popular, so were its photographs. "There . . . is a fine collection of daguerreotype miniatures, in which all of the great men of the States, in science, in literature, in politics, in arms, have their lineaments accurately represented," the *Times* of London said. Much of that popularity could be attributed to Mathew Brady and his *Gallery of Illustrious Americans*, a lithographic series of portraits of the famous Americans that Europeans both abhorred and

appreciated. Brady had originally released the photos as part of a book with minibiographies. He advertised it as the "Gift-Book of the Republic."[17] It was a financial failure. The book had a list price of three hundred dollars.

Regardless, the book was a critical success—one that Brady thought would translate well across the ocean. He added to it and submitted forty-eight daguerreotypes to the exhibition. Now, fairgoers in Europe could see the rough-and-tumble faces that shaped the wild country to the west. There was John C. Calhoun, the South Carolinian with his long gray hair and monster-like eyes. "Calhoun's eyes glowed before the camera like those of the tiger in the jungle," Brady later remembered. "They looked like balls of fire." There was Zachary Taylor, the scowling twelfth president, who unexpectedly died from food poisoning the year before. There was Henry Clay, the famous senator whose face looked like a map of Kentucky. "His head was a very remarkable one," Brady said. "It was shaped like a sugarloaf." And there was Daniel Webster, the former secretary of state who looked lifeless. "He had a grave, noble, dignified face: large, piercing, dark eyes, full of luster, and a broad, high, full forehead." Brady always displayed a bit of braggadocio. He later remembered Webster saying to him, "'Use me as the potter would the clay, Mr. Brady,' . . . and he was more than pleased with the result."[18]

The European press remarked, "America stands alone for stern development of character. . . . [T]he likenesses of the various distinguished Americans by Mr. Brady are notable examples of this style of art. . . . The American daguerreotypes are pronounced the best which are exhibited."

Brady enjoyed the embrace of Europe. So much so that he went on to spend the rest of the year there. "I went through the galleries of Europe and found my pictures everywhere as far as Rome and Naples," Brady remembered. That year he took photos of Cardinal Nicholas Wiseman in England. While in France, he got a taste of political turmoil and photographed poet and writer Alphonse Lamartine, who played a significant role in the French Revolution of 1848; General Louis-Eugène Cavaignac, who had stamped out the "June Days Uprising" in 1848; and Louis-Napoleon Bonaparte, who had just become president of the French Second Republic that year. Years later, a journalist would say Brady looked like Bonaparte. "His hair is thick and bushy," wrote Frank G. Carpenter. "It is combed well up from the

forehead. . . . He has bright blue eyes, and these smiled through blue spectacles."[19]

When the exhibition concluded, five awards were given for daguerreotypes. Americans won three of them, including Brady, who was honored for the "general excellence of his entire collection." The jury said that Brady's photos were "excellent for beauty and execution. The portraits stand forward in bold relief, upon a plain background." Horace Greeley, the founder of the *New York Tribune*, visited the exhibition and put it more plainly: "In Daguerreotypes, it seems to be conceded that we beat the world."[20] The British press, representing a country not known for giving unadulterated praise, argued that American photos were superior simply because the sun was brighter across the ocean.

In the audience was an unkempt editor from Scotland named Alexander Gardner. Gardner was a scholarly man who had studied botany, astronomy, and chemistry.[21] He looked around the exhibition and wasn't impressed. He was a populist, hell-bent on fighting for the growing working class, and saw the world through a dark lens. He wrote of the event: "The scene was typical of the world's condition—a wet assemblage of powers as yet unmeasured in their capacity but half reduced to order, armed force still watching to supply the defeat in the organization of society; society half starved by its own toil, some rolling in luxury some weary and afoot, dusty, hungry, envying and dangerous."

But Gardner, who was fascinated by both politics and chemistry, was impressed by Brady and captivated by the power of photography. Perhaps it could be used less as art and more as journalism? "His chief desire was to convince the understanding, arouse the conscience, and affect the heart," a friend remembered.[22]

The new medium of photography would become Gardner's too. In that pursuit, Gardner would see Brady again. In America, where friends became foes. They would be thrown into a great drama and document the most historic events in the history of their new nation. They would forge a new industry, born out of the ingenuity promised by the Great Exhibition. They would make pictures seen by nearly every American. And their new industry would be burned onto paper in the bloodshed of six hundred thousand Americans and, eventually, the country's president.

2

The Making of a President

— February 27, 1860 —

WHEN ABRAHAM LINCOLN moved through the crowded streets of New York, he was viewed more as a circus act than a politician—a strange sight to behold from far-away Illinois. The journalists and photographers and plain passersby treated him like a zoo animal. "We found him in a suit of black, much wrinkled from its careless packing in a small valise," wrote journalist Richard C. McCormick, who accompanied him throughout the city. "He received us cordially, apologizing for the awkward and uncomfortable appearance he made in his new suit. . . . His form and manner were indeed odd, and we thought him the most unprepossessing public man we had ever met."[1]

The suit was made for the trip. Lincoln, fresh from the frontier, had ordered the one-hundred-dollar threads from Springfield, Illinois, tailor Woods & Henckle.[2] Publisher George Haven Putnam, who saw Lincoln that day, wasn't impressed with the tailor's work—or Lincoln's appearance. "The first impression of the man from the West did nothing to contradict the expectation of something weird, rough, and uncultivated," Putnam wrote.

> The long, ungainly figure upon which hung clothes that, while new for this trip, were evidently the work of an unskillful tailor; the large feet, and clumsy hands of which, at the outset, at least, the orator seemed to be unduly conscious; the long, gaunt head, capped by a shock of hair that seemed not to have been thoroughly brushed out,

made a picture which did not fit in with New York's conception of a finished statesman. The first utterance of the voice was not pleasant to the ear, the tone being harsh and the key, too high.[3]

Poorly made suit or not, perhaps the most notable thing was Lincoln's height. It was impossible for New Yorkers to ignore Lincoln passing on a busy street. "He was tall, tall—oh, how tall, and so angular and awkward that I had, for an instant, a feeling of pity for so ungainly a man," wrote a reporter for the *New York Tribune*.[4]

It was a special occasion for Lincoln to be in New York, square in the epicenter of the East Coast, far from the ground he usually tramped as a country lawyer. He was there to speak to a large, sophisticated audience. If he did well, it could propel his burgeoning political career and possibly give him a chance at the White House.

Lincoln had been invited to take part in a series of lectures to the Young Men's Central Republican Union. He had spent considerable time preparing for the speech, but apparently spent little time fussing over his personal appearance. Anticipation of Lincoln's visit had brought demand. Organizers moved the paid event from Brooklyn to the Cooper Union in Manhattan.

He arrived in New York two days early and stayed at the Astor House, a five-story luxury hotel at the corner of Broadway and Vecsey Streets in Lower Manhattan. Some said it was the most prestigious hotel in the United States. A place where the country's literati hobnobbed with statesmen at a richly carved bar or in a large courtyard with trees and fountains covered by a rotunda.

Lincoln did little socializing in New York. The day before, Lincoln left the hotel and went to Brooklyn with Henry C. Bowen, the owner of the antislavery newspaper the *Independent*, to hear famed antislavery preacher Henry Ward Beecher. When they returned to Manhattan, Bowen invited Lincoln to his home. Lincoln declined. "I am not going to make a failure at the Cooper Institute tomorrow night, if I can possibly help it," Lincoln reportedly told him. "I am anxious to make a success of it on account of the young men who have so kindly invited me here. It is on my mind all the time, and I cannot be persuaded to accept your hospitality at this time. Please excuse me and let me go to my room at the hotel, lock the door, and there think about my lecture."[5]

The next morning Lincoln walked out of the hotel with several Young Republicans in tow and experienced Broadway. Rain and snow

made travel difficult, according to Putnam, but Lincoln made it down the street to Knox Great Hat and Cap Establishment. He got a new top hat, which was perfect for the bad weather—and a symbol "of prestige and authority."[6] His political image was taking shape.

In the snow and slop, that day's *New York Times* notified readers of Lincoln's appearance in the city, saying, "Hon. Abraham Lincoln, who is to speak this evening before the Republican Association at Cooper Institute, is a lawyer and distinguished politician in Illinois, where he is exceedingly popular. He won his principal distinction in the canvass against Mr. Douglas in that State a year ago. He will be warmly urged by the Republicans of Illinois, as their candidate for the Presidency. They believe that with him that State may be carried even against Judge Douglas. He is a man of unimpeachable character, a good lawyer, and an excellent speaker."[7]

In the *New York Tribune*, powerful editor Horace Greeley told readers, "Remember Abraham Lincoln's address at the Cooper Institute tonight and ask your friends who are not Republicans to accompany you to hear it. It is not probable that Mr. Lincoln will be heard again in our city this year, if ever."[8]

Lincoln was new to New York. He saw a city teeming with excitement—but also one with a deep underbelly. The *Times* that day included anecdotes of accidental fires and dead bodies floating in the East River, including a "homeless Irishman" who had drowned while intoxicated. Stabbings, thefts from grocery stores, robberies in "disreputable houses," the fatal death of a man caught in a machine's belting at the Atlantic White Lead Works, and, ironically, someone counterfeiting a then faceless five-dollar bill.

The *Tribune* included advertisements for the higher-minded: notice of Henry Ward Beecher's oration, poetry by Thomas Hood called "Whims and Waifs," and a pamphlet edited by Horace Greeley called *The Case of Dred Scott*, which discussed an issue looming over the country and Lincoln's very appearance in New York. And for housewares, department store Lord & Taylor showcased camel-hair shawls from India, spring dresses, and lace curtains.

Fittingly, one large advertisement came from P. T. Barnum, the city's great showman and entertainer who celebrated everything from hoaxes to the macabre. Barnum's "American Museum" was located on Broadway and Ann Street, right across from Lincoln's hotel. That week Barnum promised visitors the chance to see a "huge and savage"

black sea lion and a three-thousand-pound grizzly bear. But his main advertisement announced an "extraordinary living creature" that had just arrived from the "wilds of Africa." "Is it a lower order of man?" the ad asked. "Or is it a higher development of the Monkey? Nothing of this kind HAS EVER BEEN SEEN BEFORE! It is alive." If Lincoln got too close to the museum, judging by his press, Barnum would have attempted to put him on display.

Lincoln went up Broadway to another destination: the studio of Mathew Brady. Brady had cultivated his own showman skills in the shadow of Barnum and used Barnum's popularity to his own benefit. Many New Yorkers remembered how Barnum made opera singer Jenny Lind a star—and Brady played a critical part. Would he do the same for Lincoln? Could he?

A decade before, in 1850, Barnum had brought Lind, known as the "Swedish Nightingale," to the United States. He publicized a series of concerts in New York and then across the nation, advertising her as a simple woman with a God-given voice. Barnum recognized the power of the press. The enthusiasm drummed up by Barnum caused the press to label the woman's visit "Lindmania."

Barnum paid Lind the unheard-of sum of one thousand dollars for 150 nights. His gamble worked. "'The public' is a very strange animal, and although a good knowledge of human nature will generally lead a caterer of amusement to hit the people right, they are fickle and oft-times perverse," Barnum would say.

She was a celebrity before she stepped foot in the United States. When she arrived on New York's waterfront, thirty thousand people showed up to get a glimpse of her. Lind eventually made it to Brady's Broadway studio, where she posed for a daguerreotype. There was a lot of competition to nab her image. "P. T. Barnum was opposed to me, and he did all he could to have her go elsewhere," Brady asserted.[9]

Brady said New York daguerreotypers schemed for weeks to get her picture. Brady's scheme won out. "Jenny Lind? . . . ," Brady would later say. "I found . . . an old schoolmate of hers in Sweden who lived in Chicago, and he got me the sitting."[10] Brady allegedly paid Johan Carl Frederic Polycarpus von Schneidau, Lind's friend who had taken an early photo of Lincoln, to come to New York and take the daguerreotype of Lind at his studio.

"She was not a beautiful woman, but her face was a pleasant one," Brady later said. "She had a glint of gold in her hair under the camera,

and she took an excellent picture." That was high praise from Brady, who said "the camera is very destructive of ordinary beauty. It brings out every line of feature, and there is no powder or rouge which will stand its scrutiny."[11]

Lind's visit to Brady's studio became a full-fledged event. "As soon as it was known she was there, a large crowd collected around the place, which continued to increase to such a degree, that it became rather formidable to face it by the time the likeness was completed," the *New York Herald* wrote. "A ruse was accordingly resorted to, and she was conducted out of the door in Fulton Street, instead of Broadway; but the crowd were not to be outwitted so easily. The moment they perceived the movement, they made a rush, and one of the hard-fisted actually thrust his hand into the carriage and held it, swearing that he must see Jenny Lind. The carriage was completely surrounded, and the driver whipped the horses, when one or two persons were thrown down, but were not severely hurt."[12]

The news got Brady's attention, and there was high demand for copies of her photograph and anything else associated with the singer, giving Brady something to exploit. "I put them on exhibition and the people came by thousands to see them," Brady remembered. "I sold copies of them to the country daguerreotypers, and in this way the pictures became scattered all over the United States."

Lind later came back for a second session. Brady camera operator Luther Boswell made the exposure. The operator had invited his wife to the studio to see Lind. Boswell's wife later remembered: "She gave me her picture and she gave Luther and me tickets to go to the concert and she sang 'Home Sweet Home.' There was hardly a dry eye in the audience." Of course, Brady himself got credit for the picture.

Brady learned from Barnum, and he too attempted his own publicity stunts. Most were unsuccessful. Brady said he and Horace Greeley, the *New York Tribune* founder, attempted to bring Charles Dickens back to America after his scathing report of the country in his book *American Notes*, published in 1842. The book lambasted the United States, particularly on the issue of slavery. But Brady sought a return and promised to manage the traveling Dickens show. "Dickens feared he might be mobbed if he came back to the United States," Brady said. "Then his troubles with his wife arose, and he could not leave, fearing a lawsuit." (Dickens separated from his wife in 1858, generating significant publicity.) Brady added ominously, "The matter was put off until

the war broke out and he could not come." The war would give Brady plenty to show.

———•———

WHEN LINCOLN ARRIVED in Manhattan, Brady was at work planning his "Broadway Valhalla," a lavish studio he would move into later that year labeled the "American Portrait Gallery."[13] But in February, he was in a temporary space at Broadway and Bleeker Street.

Brady was all about celebrity. His galleries showcased the wealthiest Americans and cared very little for those struggling in New York's tenement houses or brothels. Brady preferred to focus on the well known instead of the forgotten. His gallery had images of presidents but not peasants, the very people building the vibrant city.

The gallery was propelled by the "carte de visite" craze of the late 1850s. Cartes de visite were small images, four-by-two-and-a-half inches, printed on card stock. They were sold to the public featuring pictures of the celebrities Brady knew and loved.

Suffice to say, if someone wanted to be famous, there was no better place to visit than a Brady studio. To capitalize off his success, Brady had opened a studio in Washington in 1858. He had previously had a studio there, making it a convenient place to coax powerful politicians into taking pictures. The studio was helmed by Alexander Gardner, the Scottish immigrant who became infatuated with photography at the London exhibition.

Gardner had moved to New York in 1856 and joined Brady's studio, before being shipped to Washington. Gardner, a quick learner, had studied under Brady. He was an experimentalist whose goal was to advance photography's position in American culture. The Washington studio was a perfect place for that, with Brady largely out of his way.

That year, Hiram Fuller, a journalist writing under the name Belle Brittan, wrote:

> Brady's photograph gallery, recently opened, has become one of the most attractive and fashionable lounging resorts in Washington. It is a famous place to meet all that is *beau* and *belle* in the metropolis; not only pictorially but personally. Brady stands at the very head of his art in America, if not the world. Industrious, ingenious, artistic, ambitious, he is constantly making improvements in photography;

and his latest productions, always the best, seem to be absolutely perfect. The portraits of "New York Celebrities," in a late number of the Illustrated London News, are "done to life" by Brady. His walls are lined with the beauties and the celebrities of the capital; and persons who call for their portraits, like applicants for interviews with the President, have to observe "the miller's rules."[14]

Brady's fame grew and grew throughout the previous decade. He had won a medal at the Great Exhibition and successfully exploited it through newspaper ads. And he was also propelled by illustrated magazines, like *Frank Leslie's Illustrated Newspaper* and *Harper's Weekly*, which prospered in the 1850s. They used woodcut images of pictures to introduce audiences to faces and places.

Frank Leslie was an English-born engraver who came to the United States and worked for Barnum making woodcuts for the short-lived *Illustrated News*. Then he created his own illustrated journal, merging pictures with news. The first issue, published in 1855, used a woodcut from a Brady photo of Arctic explorers on its cover.

Brady took credit for Leslie's success. "He was very poor and he had a hard time to get along," Brady said years after Leslie died. "I suggested to him the idea of taking my daguerreotype, engraving a picture from Jenny Lind from it and putting the engraving on the back of a program which should be used as an advertisement and sold in theatres. He did this and traveled with the Jenny Lind company from city to city. When he began his newspaper work I gave him hints as to the characters the Americans would like to see sketched." That's how Brady viewed his subjects. As characters to be publicized and promoted. And there was no better material than Abraham Lincoln.

Lincoln wasn't a celebrity in February 1860. He didn't arrive in New York to a massive audience of tens of thousands, like Jenny Lind years before. But all signs showed he could be a celebrity. He had famously debated Stephen Douglas throughout Illinois in a battle for the U.S. Senate—and he hoped for a bright future. He wasn't a hard-line abolitionist, but he was known for the power of his words. In Springfield he had delivered a speech saying, "A house divided against itself cannot stand."

Why Lincoln, or his men, chose Brady to take his picture that day is unclear, but the choice seemed obvious. Lincoln was in New York,

and Brady was already the most famous photographer in the country. A visit to Brady's studio was validation of Lincoln's swift rise to political prominence. A photo journal from the time noted, "Few men among us who have attained great eminence and success in business pursuits are more deservedly popular than Mr. Brady, from claims purely personal; for none can be more distinguished for urbanity and geniality of manners, and an untiring attention to the feelings and happiness of those with whom he comes into contact."[15]

As the snow continued to fall, Lincoln arrived at Brady's studio and was greeted by historian George Bancroft. His book *History of the United States of America, from the Discovery of the American Continent* was a multivolume pursuit that was first published the previous decade, giving everyday Americans a chance to learn about their young country.

The difference between the two men was noteworthy: Lincoln, a tall, giant woodsman; Bancroft, a small, effete writer. McCormick, the journalist, said: "The contrast in the appearance of the men was most striking—the one courtly and precise in his every word and gesture, with the air of a trans-Atlantic statesman; the other bluff and awkward, his every utterance an apology for his ignorance of metropolitan manners and customs."

Lincoln and Bancroft exchanged words. Lincoln joked with Bancroft, saying he was on his "way to New Hampshire where he had a son in college, who, if reports were true, already knew much more than his father."

Then it was time for a picture. "I was not pleased with the prospects of a good picture when I saw him," Brady recalled. "He was so tall, gaunt and angular that I knew it would be hard to get a natural picture. His neck was very long, and when I got him before the camera I asked him if I might not arrange his collar. . . . With that I began to pull the collar upward, and as I did so [Lincoln] said: 'Ah! I see you want to shorten my neck.' 'That is just what I'm trying to do,' I replied, and we both laughed." Brady also noted—much later—that Lincoln had no beard.

His image of Lincoln was much different from the ones that would come later. He photographed Lincoln standing, rare for the time, which accentuated his height. Lincoln touched a book (Brady liked to use props). Still, Lincoln looked a bit like a wild frontiersman. But you could see the flashes of the statesman he would become.

Lincoln left the studio and headed to the Great Hall of the Cooper Institute. New Yorkers filled the large space, paying twenty-five cents apiece to attend. Lincoln gave them a show. Journalist Henry J. Raymond said, "Mr. Lincoln was quite warmly received, and delivered an address which at times excited uncontrollable enthusiasm. It was at once accepted as one of the most important contributions to the current political literature of the day."

Lincoln's speech was a powerful examination of the problems facing the North and South. George Putnam, who made fun of Lincoln's physical appearance, had a change of heart when he heard him speak:

> As the speech progressed . . . the speaker seemed to get into control of himself; the voice gained a natural and impressive modulation, the gestures were dignified and appropriate, and the hearers came under the influence of the earnest look from the deeply-set eyes and of the absolute integrity of purpose and of devotion to principle which were behind the thought and the words of the speaker. In place of a "wild and wooly" talk, illuminated by more or less incongruous anecdotes; in place of a high-strung exhortation of general principles or of a fierce protest against Southern arrogance, the New Yorkers had presented to them a calm but forcible series of well-reasoned considerations upon which their action as citizens was to be based.

"By evening the weather grew worse," wrote Putnam. "It was snowing heavily. Nevertheless, fifteen hundred people came to hear Lincoln speak at the Great Hall of the brownstone building on Fourth Avenue and Eighth Street erected by the eccentric industrialist Peter Cooper for the betterment of the working class. Each person in attendance that evening paid twenty-five cents for the privilege, and the audience was generally sympathetic."

The speech was so successful, New York's newspapers printed it in full. Those who couldn't see or hear Lincoln were able to read his eloquent words. Journalist Noah Brooks exclaimed: "He's the greatest man since St. Paul."

Lincoln left New York and continued his speaking circuit, even visiting his son Robert in New Hampshire. Robert recalled, "The news of his speech had preceded him, and he was obliged to speak eleven times before leaving New England."[16] When he did leave, there was a growing expectation that he would run for president.

A few months later, Lincoln won the Republican nomination for president. Brady's picture was made into a woodcut engraving and placed on the cover of *Harper's Weekly*, one of the most popular and influential periodicals of the time. There he was in all of his confidence and contradiction. Brady had retouched his negative, creating a picture free of "harsh lines." In doing so, he helped Lincoln look like a leader. Brady said the picture had a "wide sale."[17] It was placed on campaign buttons throughout the country and sold by lithographers Currier and Ives as prints by the thousand.

Later that year, Lincoln won the presidency. *Harper's* again placed the picture on its cover, this time changing the direction of his face and transposing a draped balcony with wild buffalo roaming in the distance. Part news, part propaganda.

Brady believed he made Lincoln president. Francis Bicknell Carpenter, Brady's friend and portrait artist, would give his claim some credence. "[Brady] insisted that his photograph of Mr. Lincoln . . . — much the best portrait, by the way in circulation of him during the campaign,—was the means of his election. That it helped largely to this end I do not doubt. The effect of such influence, though silent, is powerful."

Years later, in an interview, Brady would say that Ward Hill Lamon, the U.S. marshal for the District of Columbia, thought Lincoln and Brady had not met and attempted an introduction. "Mr. Lincoln answered in his ready way," Brady said. "Brady and the Cooper Institute made me President." The quote would be used for decades and centuries to come, but Brady is the only known source.

Meanwhile, Lincoln's focus turned from New York to Washington, where Gardner had firmly planted Brady's satellite studio along "Photographers' Row" on Pennsylvania Avenue, where a half-finished Washington monument loomed in the background. While people would say Brady's photo of Lincoln was a work of art, Gardner had developed a more workmanlike reputation.

After traveling to Washington from Springfield for his inauguration—and evading an assassination attempt in Baltimore—Lincoln quickly went to Brady's studio in Washington for another picture. "President Elect Lincoln will visit the gallery on the 24th," Brady wrote to Gardner. "Please ready equipment." President-Elect Lincoln arrived at the studio, accompanied by Lamon, who served as a bodyguard.

George Henry Story, an artist who would eventually paint a well-known portrait of Lincoln (and go on to become a curator at the Metropolitan Museum of Art), had an office at Brady's studio. He said Gardner would often enlist his help in posing important subjects. "Gardner knew nothing about art, and used to pose his patrons all one way," Story later said. "If there were a Senator, he would have him standing erect with his hand in the breast of his frock-coat, and the other hand resting on a pillar, or a table. It was laughable. I used to say, 'Gardner, why don't you change your pose?' But he would say, 'Oh, it's good enough. They don't know the difference.'"[18]

On that day, Story said Gardner came and said, "Lincoln's here. Come and pose him." Story said he found a quiet Lincoln, "carelessly seated at a table." "It was so characteristic of [Lincoln]," Story said. "I said, 'Take him as he is.'"

Gardner took five photographs of Lincoln on that day. They would become the first of many. The photos show Lincoln seated in Brady's chair, looking off to the side, completely unconcerned with what was going on around him. His long face bore the whiskers of his now-trademark beard.

A closer look at the photo reveals the truth. Lincoln was deep in thought. A war was coming.

3

The Battlefield

— July 22, 1861 —

MATHEW BRADY WENT to war dressed for a Sunday stroll. He wore a white linen duster over his thin frame. A gold watch dangled from his waist. A straw hat topped his wavy hair. A cross tie was knotted over his white shirt. Some said he looked like a French landscape painter.[1] From the outset, it looked like he wasn't ready for battle.

A closer look revealed mud and muck on his boots—and dirt on his duster. And a much closer look revealed a sword at his hip, signaling he had seen heavier business than a picnic in the park. But Brady memorialized this image of himself not on the bloodstained battlefield in Virginia, where hundreds of men had just died, but rather at his posh studio in Washington. The master of promotion knew it was important to show everyone that Brady of Broadway was now Brady of Battle.

When he returned from the first Battle of Bull Run, after trudging through the country dirt roads of devastation, he made sure his picture was taken. White ink written on the photo included these words: "Photo taken July 22, 1861. Brady the Photographer returned from Bull Run."

Like so much with Brady, the events of that day, and his courage during battle, remain a mystery. But one thing is true: he was there, and he knew how to get credit for it.

MATHEW BRADY, LIKE so many others, had never seen war. But he had heard the warnings. Brady often recalled his visit with a dying John C. Calhoun. One day Brady said he visited Calhoun, a former vice president who had fought to protect the South while preserving the Union, at his plantation house in South Carolina. Calhoun, born during the Revolutionary War, was sick. "The servants would hardly admit me," Brady remembered. "But I over persuaded them and the conversation I had with Mr. Calhoun lasted for two hours beginning with daguerreotyping."[2]

Brady had great affection for Calhoun. He said he had the most remarkable face of any man he had ever known. Significant praise coming from a photographer who had seen a thousand faces. "He had high cheek bones and hollow jaws, and his face seemed the personification of the intellectual," Brady said.

As Brady visited the southern gentleman, their talk turned toward the fate of the United States. "He told me that he feared a war between the two sections and spoke feelingly of the horrors it would entail upon this country."

The year was 1849. Now, more than a decade later, the war was finally here. The horror was about to begin.

For most of the nineteenth century, there was a growing divide between the North and South. With soaring rhetoric, the politicians debated states' rights and slavery, while businesspeople were reminded that "cotton is king." The issue touched everywhere, from public halls to plantations. Just about anyone who cared could see the war coming ever since America was founded. The great experiment of Washington and Jefferson was ready to face its greatest test.

Guns were made. Cannons lined the fields. Brass buttons were sewn onto uniforms. And soldiers, at least the ones who had any money, headed to studios to get their pictures taken before war.

Mathew Brady had been in the company of the nation's powerful for decades. He knew politicians from both North and South. Despite his firm place in New York, though, he never displayed a political bent. That was his way. War was about business to him, and business was about to be good.

Brady's Washington studio became his most important. It was located at the apex of power and near many of the battlefields. Troops camped in Washington by the thousand, and they flocked to Brady's

studio for their pictures. Sometimes demand was so strong, they had to wait in line for two hours.[3]

The soldiers, however, wouldn't remain camped in Washington forever. So Brady and countless reporters and editors and other photographers had begun making plans for how to cover the war—or, in Brady's case, how to capture it. They knew the first skirmish would be in Virginia, where the Confederates had placed their capital, not far from Washington. The location would give them easy access, and the press seemed to think they wouldn't be put into danger. "A battle scene is a fine subject for an artist-painter, historian, or photographer," wrote the *American Journal of Photography.* "We hope to see a photograph of the next battle. . . . There will be little danger in the active duties, for the photographer must be beyond the smell of gunpowder or his chemicals will not work."[4]

The Northern public, fueled by eager newspaper editors, demanded a swift attack on the rebels. The *New York Tribune* printed daily headlines that read "Forward to Richmond! Forward to Richmond!" And there was heavy demand to see the battle up close—at least through pictures. Brady said he had a "good deal" of trouble convincing military leaders to allow his cameras into battle. He said intended to enlist the help of General Winfield Scott to get him access.

There was one problem. Scott, whose military service dated back to the War of 1812, was sick with gout, rheumatism, and dropsy. His body had grown so heavy, he couldn't mount a horse. He could not possibly lead an army into battle. "I had long known General Scott, and in the days before the war it was the considerate thing to buy wild ducks at the steamboat crossing of the Susquehanna and take them to your choice friends, and I often took Scott, in New York, his favorite ducks," Brady remembered years later. "I made to him my suggestion in 1861. He told me, to my astonishment, that he was not to remain in command. Said he to me: 'Mr. Brady, no person but my aide, Schuyler Hamilton, knows what I am to say to you. Gen. McDowell will succeed me tomorrow.'"[5] Brady said that with a touch of gossip, his common trait during interviews. He loved to know information before anyone else—and to brag about it.

Brigadier General Irvin McDowell, a West Point graduate who served in the Mexican War, was put in charge of the Union troops in northern Virginia. McDowell thought the troops were too green and

not ready. President Lincoln pushed forward anyway. McDowell, see-ing an inevitable tangle coming, made deals with the press to cover the unfolding saga.

Brady said he had "much trouble" arranging for his cameras to hit the battlefield, and many "objections were raised." He ultimately was successful. "I have made arrangements for the correspondents of our papers to take the field under certain regulations," McDowell said, with those regulations generally being for them to stay out of the way, "and I have suggested to them they should wear a white uniform, to indicate the purity of their character." Thus, Brady put on his white duster and joined the fray, along with about two dozen reporters. "My wife and my most conservative friends had looked unfavorably upon this departure from commercial business to pictorial war correspon-dence, and I can only describe the destiny that overruled me by saying that, like [an] euphorian, I felt that I had to go. A spirit in my feet said, 'Go,' and I went," Brady said.[6]

No one in the North seemed to have much confidence in the Con-federate army. Before the first shots were fired, it looked like they were headed to a Broadway show. "The troops on foot started off as joyfully as if they were bound upon a New England picnic, or a clambake," one observer wrote, "and not the slightest exhibition of fear or uneasiness, even, as to what might possibly be in store for the brave fellows, (thus really setting out upon an expedition from which in all human proba-bility hundreds of them will never return!)."[7]

It wasn't all perfect. Early reports from the field said half-drunken soldiers would stray to the back of the line and loot and pillage houses along the way. "It would be better, in fact, if they were in the ranks of the rebels themselves," the *New York World* reported.

Brady was now in the middle of this odd tableau. A considerable change from the velvet-carpeted photo salons where he spent most of his days with the rich and famous. It was hard to say what he expected. Or if he was nervous.

The year 1861 was the first time most of the reporters or photog-raphers had ever seen war. It was as new to them as a schoolboy's first dance. They didn't know what to do, but they played the part.

Brady traveled with a group that included noted sketch artist Al-fred Waud, the *New York Tribune*'s Ned House, and the *New York Eve-ning Post*'s Richard C. McCormick—the man who brought Lincoln to Brady's studio in New York for the first time the year before.

Leroy Pope Walker, the Confederacy's secretary of war, issued an "appeal to correspondents," requesting they not publish "such intelligence as might be detrimental to the great cause." "You are aware of the great amount of valuable information obtained by us through the medium of the enterprising journalists of the North," Walker wrote. "And we may derive profit from their example by an unremitting and judicious reserve in communications for the Southern journal."

Soon, the admonishment "Avoid the camera" would also become common. Right now, however, soldiers were still getting used to it. Cameras were like foreign objects. Initially, according to *Humphrey's Journal*, some mistook Brady's camera "for a great steam gun discharging 500 balls a minute."

Brady's group left Washington on July 16 and followed the Union troops. They rode through the Virginia countryside, and "the singing and banter of the troops in their ears was such a cavalcade as had never been seen."[8]

Washington seemed prepared for war, but not ready for it. The *Washington Evening Star* showcased a town changed by circumstance. It included notes on "sea bathing and safe retreat" in the Potomac River—a crossing point to the now Confederate Virginia—and advertisements of "boots and shoes to fit the times."[9]

Brady said his group slept overnight at Centreville, Virginia, and then got as far as Blackburn's Ford, along the route to Manassas. There, a Union brigade tested a waiting Confederate force to see if they would retreat. They did not. House and McCormick, in Brady's group, viewed the event from an elevated area near the crossing. They came under fire, but Brady was apparently separated from the group. The event was labeled a "skirmish." Tension steadily mounted.

The incident served as a warning to everyone that the coming days wouldn't be a jolly singsong. William Tecumseh Sherman said, "For the first time in my life I saw cannonballs strike men and crash through the trees and saplings above and around us, and realized the always sickening confusion as one approaches a fight from the rear."

Three days later, on Sunday, July 21, the real battle began at Manassas, near a stream called Bull Run. It was the first official fight of the Civil War, a fight where poorly trained troops on both sides maniacally fought, and both sides thought they would easily win. The day was hot, in that suffering, suffocating, humid way. Heat so full and strong that it could put a man's lungs in a straitjacket.

Brady's whereabouts on that day remain unclear, but eyewitnesses say he was in the thick of it. William A. Croffut, a *Tribune* reporter who watched the battle with Massachusetts senator Henry Wilson, wrote in his memoirs that he ran into Brady the morning before the battle began and that "strapped to his shoulders was a box as large as a beehive." Croffut asked him if he was with the commissary. "No," Brady reportedly said. "I am a photographer and I'm going to take pictures of the battle." Croffut said he later saw Brady "dodging shells on the battlefield." "He was in motion, but his machine did not seem effective," he said.

Bull Run was the first time someone attempted to make photographs of an American battle. Technology required cameras to remain still, which certainly couldn't happen during an infantry charge or a cannon blast. Brady's quest and risk of life seemed almost futile, aside for his need to be at the first battle of the war.

But quite a picture Bull Run would have been. One observer wrote of the battle, "As the thirty-five thousand bayonets moved forward in the uncertain light, with that billowy motion peculiar to the step of troops, the stirring mass looked like a bristling monster lifting himself by a slow, wavy motion up the laborious ascent."[10] After hours of back-and-forth, the shocked Union troops were forced to retreat. Their Confederate enemies had stood their ground.

Brady appeared caught in the frenzied retreat, attempting to shield his equipment during the chaotic scene. At one point, a member of the New York Fire Zouaves handed Brady a sword, which he later showcased heroically at his side. "As we gained the cover of the woods the stampede became even more frightful, for the baggage wagons and ambulances became entangled with the artillery and rendered the scene even more dreadful than the battle, while the plunging of the horses broke the lines of our infantry, and prevented any successful formation out of the question," an observer wrote.

Brady returned to Washington safely, where worries grew that the city could be sieged at any moment. Publicly, Brady said very little about what he saw that day at Bull Run, but rumors surfaced that he had captured the battle with his camera. "The public is indebted to Brady of Broadway for numerous excellent views of 'grim-visaged war,'" wrote a gushing *Humphrey's Journal*. "He has been in Virginia with his camera, and many and spirited are the pictures he has taken. His are

the only reliable records at Bull's Run."[11] The journal compared Brady to Flemish painter Adam Frans van der Meulen, who famously painted battle scenes from the wars of Louis XIV. History was now his canvas.

A *New York Times* article followed suit, saying, "We saw [Brady] constantly, at every point, before and after the fight, neglecting no opportunity and sparing no labor in the pursuit of his professional object." It continued, "As the result of his arduous and perilous toil, he has brought back a very large collection of pictures which will do more than the most elaborate description to perpetuate the scenes of that brief campaign. Mr. BRADY was the only photographer on the field, and is entitled to the highest credit for the energy and enterprise which he displayed. This series of pictures has been added to the magnificent collection at his Photographic Gallery, corner of Tenth-street and Broadway."[12]

The rumors weren't true. Brady never displayed a photo of the Battle of Bull Run. He didn't have any. The truth came out later. Perhaps Brady just circulated the tales for publicity. "We made pictures and expected to be in Richmond next day," Brady said in an interview late in life. "But it was not so, and our apparatus was a good deal damaged on the way back to Washington; yet we reached the city."[13]

In 1869 a different explanation was given to *Harper's New Monthly Magazine*. "The battle of Bull Run would have been photographed 'close up' but for the fact that a shell from one of the rebel field-pieces took away the photographer's camera."

Regardless, Mathew Brady had attempted the unthinkable. Perhaps it was unknowing courage—not knowing what to expect. But dodging bullets and avoiding a stampede were much different from anything he had ever experienced before.

His reputation was now cemented. His legacy secure. By August 1, the *American Journal of Photography* was citing Brady as an "irrepressible photographer" who "sniffs the battle from afar." "He got as far as the smoke of Bull Run," the journal said, "and was aiming his never failing tube at friends and foe alike, when with the rest of our Grand Army they were completely routed and took to their heels, losing their photographic accoutrements on the ground, which the Rebels no doubt pounced upon as trophies of victory. Perhaps they considered the camera as an infernal machine."[14] The loss of his camera foreshadowed how expensive it would be to cover the war.

Bull Run was just the beginning. Now Brady was a mogul prepared to spend one hundred thousand dollars on covering the war. "After that I had men in all parts of the army, like a rich newspaper," he said. Years later, Brady would say, "No one will ever know what I went through in securing these negatives. The world can never appreciate it. It changed the whole course of my life. Some of these negatives nearly cost me my life."[15]

Brady invested in a special wagon to aid production in the field. It was called Brady's What-Is-It Wagon. "[It was an] ordinary delivery wagon of the period, much like the butcher's cart of today," described Civil War photographer George G. Rockwood. "A door was put on at the back, carefully hung so as to be lightproof." He added, "With such a wagon on a larger scale, large enough for men to sleep in front of the darkroom part, the phenomenal pictures of Brady were made possible. Brady risked his life many a time in order not to separate from this cumbrous piece of impedimenta."[16] Brady's What-Is-It Wagon would hit the road, but Brady himself would not return to a battlefield for at least another year.

———————

BRADY HAD EMPLOYED dozens of men and had them hit the battlefield, while Gardner stayed behind in Washington. But after Bull Run, Brady spent most of his own days at his studio. He quickly began selling cartes de visite of Union and Confederate generals as they came in and out of fashion. They were the trading cards of war. One of the first was Thomas Jackson, who earned the nickname "Stonewall" during Bull Run for pumping the Confederates with reinforcements, enabling them to win the first battle of the war.

The month after Bull Run, the gallery had an important visitor: General George B. McClellan.

Several military units had been folded into McClellan's Army of the Potomac, a principal force of the Union and responsible for Washington's security. "I find myself in a new and strange position here— Presdt, Cabinet, Genl Scott & all deferring to me—by some strange operation of magic I seem to have become the power of the land, . . ." McClellan wrote to his wife. "I almost think that were I to win some small success now I could become Dictator or anything else that might please me—but nothing of that kind would please me—therefore I won't be Dictator. Admirable self-denial!"

McClellan took time away from all of that power—and the war—to have his picture taken in his neatly pressed navy-and-brass outfit. It was important that he looked good. To project an image of strength at a time when it appeared the war would last much longer than anticipated.

But McClellan, the newly appointed commander of the Army of the Potomac, also had another motive: he wanted Gardner to work for him. Gardner, who believed in the war, accepted and, by November, was working for Allan Pinkerton's secret intelligence unit. Gardner was now a spy. Pinkerton and Gardner shared a bond: they were both Scottish, and they both had special investigative skills.

Pinkerton got interested in criminal work while tracking a band of counterfeiters in Illinois. He became a Chicago police detective and then formed a private investigative unit that solved a series of train robberies involving the Illinois Central Railroad, which brought him into the company of George McClellan, the railroad's chief engineer, and Lincoln, the railroad's lawyer. His agency was called Pinkerton's National Detective Agency. It used the motto "We Never Sleep," with an unblinking eye as its logo—thus coining the term *private eye*.

Gardner too was interested in sleuthing—and counterfeiting. While working at Brady's studio in New York, Gardner experimented with ways of photographing a check to make a copy. He took one to the bank, and they agreed to cash it. Gardner summoned the bank president. "Is anything wrong with this check, sir?" Gardner asked. "If it isn't genuine, Mr. Gardner, I'll eat it," the bank president reportedly said. Gardner responded, "You had better start eating then. This is a photographic copy and here is the real check." The bank president called a meeting with other bankers, where Gardner demonstrated his counterfeiting skill. They quickly devised a "formula where a check could not be photographed."[17]

Those skills spurred Pinkerton to lure Gardner into the employ of the Army of the Potomac—while keeping his public association with Brady's studio. "It was during the winter of 1861–1862 that Gardner became attached to the Secret Service Corps, then under my father," wrote Pinkerton's son William. "I was then a boy, ranging from seventeen to twenty-one years of age, during all of which time I was in intimate contact with Gardner, as he was at our headquarters and was utilized by the Government for photographing maps and other articles of that kind which were prepared by the Secret Service. I have quite a

number of his views which were made at that time." He added, "I used
to travel around with Gardner a good deal while he was taking these
views and saw many of them made."

Gardner became known as "Captain Gardner." He was tasked
with copying Confederate and Union maps. And he took pictures of
bridges, roads, railroad tracks, rivers, hilltops, and anything else across
the nation's rugged terrain.[18] His pictures helped identify spies, battle-
fields, and enemy movements. While doing this, he remained under
the cover of Brady's studio. While he wasn't running it, he was still
associated with it.

But Gardner's relationship with Brady appeared to be frayed.
Gardner had always opposed Brady's branding of photographs, regard-
less of who actually made the image. He also had tightened Brady's
lavish spending in Washington, helping the studio remain profitable.
And while Brady publicly claimed he himself procured his dangerous
access to Bull Run, others would later attribute it to Gardner and his
relationship with Pinkerton.[19] In fact, Brady had given his plan to cover
the war to Pinkerton and President Lincoln. Lincoln approved as long
as Brady didn't get in the way and paid his own way. He scrawled "Pass
Brady" on a piece of paper.

It remains unknown who snapped the photo of Brady as hero on
his triumphant return from Bull Run, sword by his side. Most likely, it
was Gardner—who was beginning to question the Brady myth. More
battles would come.

4

A Hearse at Your Door

— September 1862 —

ALEXANDER GARDNER SENT an urgent telegram to the Brady studio. "COME RIGHT AWAY TO ROCKVILLE THERE MAKE FOR HEADQUARTERS. BRING CMDR OF TELEGRAPHIC CORPS ONE HORSE."[1]

Assistant photographer Timothy O'Sullivan, working in the Washington studio, received the order and knew what it meant: a battle was coming. Fast. He stopped whatever he was doing and sent Brady photographer James Gibson to help Gardner. Supplies and additional labor were needed for the daring mission. Would Gardner overcome the rough-hewn battlefield obstacles and bring the war to the nation's doorstep? Right now, it was all about preparedness.

As the war beat forward like the steady tap of a drum, Brady and his men—not just Gardner—were embedded in or working for the Union army. The arrangement was the best way to have early intelligence to capture the war on glass. But so far, it had failed to produce the epic pictures they had hoped for. The action of battle proved daunting for the cumbersome equipment and complicated process required to take pictures. Still, the photographers remained undeterred. The men, once looked upon as aliens, had become as recognizable as the balloon, signal, and telegraph operators who helped make war communications hum.[2]

On September 9, Gardner was encamped with McClellan and Pinkerton at their tent headquarters in Maryland, about fifteen miles northwest of Washington, monitoring the war and Confederate

movements. General Robert E. Lee and his Confederates had stormed northward into Maryland, occupied towns, and threatened to encroach on the Union capital. Gardner had learned to study the Union army and its tenor, listening to the generals as they prosecuted the war. McClellan had reportedly obtained a lost document describing Lee's plans. Now, Gardner knew a major confrontation was coming, one that could change the course of the war, journalism—and his career.

Gardner stood in the distance as the Union generals planned their attack and pursuit of Lee, whose army was swelling with troops somewhere in the hidden hills of Maryland. Gibson joined Gardner. They were two nameless men. Simple contributors to Brady's photographic corps. Scottish immigrants working for a famous man's personal brand. Nothing more.

As Gardner and Gibson prepared for war, Mathew Brady took out an ad in the *New York Times* showcasing "Brady's Photographic Views of the War," a compilation of one year's worth of Civil War pictures. "Pictures, unequaled in beauty and fidelity, taken by corps of trained artists, which have accompanied the great Union armies in their several campaigns. Perfect transcripts have thus been obtained of the ARMIES, FLEETS, MARCHES, FORTIFICATIONS, HOSPITALS, ENCAMPMENTS, and BATTLEFIELDS, which have constituted the Scenic History of this thrilling era."[3]

Brady advertised for sale sixteen-by-thirteen-inch photos for $1.50. Eight-by-ten photos were priced at $1.00. He promised photos of the Army of the Potomac, the siege and capture of Yorktown, naval and marine views, and even pictures from Bull Run—the battle Brady failed to capture the year before.

While, the year before, Brady received high praise in the press for the pictures he didn't take at Bull Run, he also received high praise for pictures his studio photographers took everywhere else. His ad featured blurbs from newspapers in New York and London. Brady basked in the admiration. The *New York Times* recognized Brady for "being the first to make Photography the Clio of war," Clio being the ancient Greek muse of history. The *New York Sun* wrote that Brady's "Scenes and Incidents of War" are appealing with "ever-increasing interest to the art-lover, the historian and the patriot—to the eager delight of childhood and the memories of age. Their projector has gone to his work with a conscientious largeness becoming the acknowledged leader of his profession in America."

One final paragraph mentioned the group of men doing the work. "They have threaded the weary stadia of every march; have hung on the skirts of every battle scene; have caught the compassion of the hospital, the romance of the bivouac, the pomp and panoply of the field review—aye, even the cloud of conflict, the flash of the battery, the after-wreck and anguish of the hard-won field." Brady's photographic corps had seen those things. But their pictures didn't produce the drama described.

Brady's star shined brighter than ever in New York, where he often remained cloistered away in his posh studio as Gardner and Gibson lumbered toward a tiny town in Maryland, where they would get a chance to take the kind of showstopping pictures Brady already declared he had.

———————◆———————

PERCHED BENEATH THE Mason-Dixon line and above the Potomac River, the Maryland towns of Frederick, Sharpsburg, and Hagerstown were in the middle of it all. Perhaps there was no more dramatic place for McClellan to attempt a fierce rush to end the war. It was a gamble. Many feared Maryland, a border state, would rally to the Confederacy if Union forces failed.

McClellan pressed his troops through rolling farmlands and approached a confrontation with Lee near Sharpsburg, a small town of several thousand now under Confederate control. The faded Appalachian Mountains loomed in the distance. The battle lines were roughly drawn around Antietam Creek, a meandering stream that begins in Pennsylvania and empties in the Potomac just south of Sharpsburg, about fifty miles from Washington. The scene was one of "bold bluffs, crowned with oaks, and fringed with tangled bushes." Gardner described the environment in quaint terms, saying everything came together to "form a most delightful valley, through which the miniature river, broken here and there by tiny cascades, hurries down to the Potomac."[4]

The weather that September in Maryland, however, was not delightful. It was one of the driest on record. The earth was so parched that soldiers were "choking in dust" on roads clogged with stragglers.[5] The whole atmosphere created a "deathlike stillness."[6] Weather was important for battle—and important for taking pictures. Heavy clouds or rain or wind could make the process impossible. To preserve the

aftermath of battle, or even the battle itself, Gardner needed the aid of a bright sun.

On September 16, McClellan's army camped near the creek. Gardner moved with the army. He took a photo of McClellan's headquarters guard—the Ninety-Third New York Volunteers—dressed in tattered Union blue, lined up before their tents with bayonets at the ready. They would soon need them. That evening, Union brigadier general Joseph Hooker declared: "We are through for tonight, but tomorrow we fight the battle that will decide the fate of the Republic."[7]

Gardner had arrived in early September, sensing Generals McClellan and Lee were headed for a showdown in the Maryland countryside. Cameras needed to be ready. The Civil War had hemmed and hawed for more than a year, but now America would have a chance to see the carnage up close. Brought home like never before.

Gardner's youth was spent as a newspaper editor, and he knew the moment would be a chance to merge news and photography. But that would have to wait. Gardner, who was still performing topological spy work for the Union, wasn't in the major fighting, but there was no way to escape it.

The fighting broke out at dawn on September 17 near a large cornfield with stalks as tall as the long September shadows. Confederates were hiding nearby. "As we appeared at the edge of the corn, a long line of men in butternut and gray rose up from the ground," wrote one Union solider. "Simultaneously, the hostile battle lines opened a tremendous fire upon each other. Men, I can not say fell; they were knocked out of the ranks by dozens."[8]

Gardner is believed to have been with members of the press, watching the battle from the surrounding hills. As the battle unfolded, Gardner became so enthralled with the Union's signal corps that he would later insist on taking their picture at Elk Mountain, which overlooked the Antietam battlefield. Gardner appreciated technological advancement. "At intervals along our line of battle, and on the most prominent points in the vicinity, were stationed the Federal Signal Officers, detecting by their skill, vigilance, and powerful glasses, every movement of the enemy, reporting them instantly by a few waves of their flags to the Union Commander, and in return, transmitting by the same means the orders to the subordinate generals, which were to check or defeat the maneuvers of the enemy," Gardner wrote.[9]

The flags flapped in their unique wigwag. The roar of guns and cannons thundered in the distance. "The Hills were black with spectators," wrote sketch artist Edwin Forbes. "Soldiers of the reserve, officers and men of the commissary and quartermasters' departments, camp-followers, and hundreds of farmers and their families, watched the desperate struggle. No battle of the war, I think, was witnessed by so many people." From there, Forbes sketched the swirl of battle with Sharpsburg's "rooftops and church steeples visible over a ridge."[10] A pastoral scene now caught in a violent struggle.

Danger was everywhere. Streets of nearby Sharpsburg were deserted. Civilians hunkered in cellars as misdirected shell casings fell like sheets of rain. Others hid in caves. In the surrounding woodlands, both armies struggled to tend to their mounting casualties as bullets whizzed in every direction. Colonel Richard A. Oakford, of Pennsylvania's 132nd, was shot in the heart and dropped to the ground. "I am shot," he exclaimed moments before death. "Take my body home."[11]

Gardner and everyone else watching heard the crazy sounds from the distance. The eerie Confederate rally cry, the screams of the dying, the prodding of horses, the unusual cannon blasts. The ragtag Confederates took to firing from their cannons broken railroad iron, blacksmith tools, hammers, and chisels. "Some of these missiles made a peculiar noise resembling 'which-away,'" a *Cleveland Daily Leader* correspondent wrote. When Union soldiers heard the sounds, they dropped to the ground, yelling, "Turkey! Turkey coming!"[12]

The battle continued throughout the day as early-morning clouds parted to make way for a clear sky pocked with smoke and dust. It moved from the cornfield to a well-trod road packed with crouching Confederates. They called it the Sunken Road, carved about five feet deep into the Maryland soil like a trench, weathered from heavy wagon traffic. The road was a perfect place for the smaller Confederate Army to do battle because it offered protection. But after hours of back-and-forth, they became overwhelmed. The road became a death trap. The Sunken Road would soon be named "Bloody Lane."

As dead bodies clogged the road, the battle shifted to its final phase: a stone bridge about a mile from Sharpsburg at Antietam Creek, held by the Confederates. "It was at this point that some of the most desperate fighting of the Battle of Antietam occurred," Gardner wrote.

The focal point was the "Burnside Bridge." Guns and artillery blasted until the sun went down. Union troops amazingly pushed forward in a daring takeover. "The banks of the stream were very steep, and well defended by rifle pits which were covered by the guns of the Confederates on the ridge in the back-ground," Gardner wrote. "The [Union army] suffered heavily as it approached the bridge, and, in crossing, was exposed to a murderous fire, through which it rapidly pressed breaking over the lines of the enemy like a restless wave, and sweeping him from the hillside."

The Confederate Army soon fled into the darkness of Virginia. Lee had escaped.

There was an instant sense that the battle was something historic. Not just in America, but in the world. The newspapers, prone to overstatement, called it the greatest battle since Waterloo.[13] The London *Times* correspondent compared the creek-side terrain to that of Hougoumont, Belgium, the farm site of Napoleon's great loss.[14]

Civil War battles were measured in numbers. And Antietam was the worst yet. The Union army suffered more than twelve thousand casualties, the Confederates more than ten thousand. More than thirty-five hundred men total died in the battle, the single bloodiest day in American history.

The sun rose the next day. Lifeless men had become faceless objects scattered about the countryside. The day before, they fought with zest and valor. The day after, they were just numbers. Newspapers devoted column inches to recording their names, but little else. It all seemed like a blur. "The dead of the battle-field come up to us very rarely, even in dreams," wrote the *New York Times*. "We see the list in the morning paper at breakfast, but dismiss its recollection with the coffee. There is a confused mass of names, but they are all strangers; we forget the horrible significance that dwells amid the jumble of type."[15]

The lists had little significance to American civilians, but Gardner and Gibson had other plans. On September 18, they hitched their wagon and got to work. It was time to document the dead up close. That day, Confederates sent a flag of truce, asking for permission to bury their own. It was granted. By the afternoon, Union and Confederate supporters were mixing together to carry out the macabre task. Wounded soldiers in blue and gray were placed in hospitals, side by side. In death, it seemed like they were all still Americans.

The Union quickly declared victory. They needed good news after a string of missteps. The supportive Northern press gave them a boost. The *New York Times* greatly overstated the number of Confederate dead, then headlined: "The Battle Won by Consummate Generalship."[16] The *Philadelphia Inquirer* printed a large front-page map from a New York newspaper showcasing the FIELDS OF OUR MARYLAND VICTORIES. But there were no pictures. Not yet, anyway.

Gardner would see that the claimed victory was only technical. Lee was able to escape. The Union suffered significant losses as well. The war would go on.

At the White House, Lincoln fumed. The president was angry that McClellan didn't pursue Lee's escape more vigorously. Regardless, the technical victory enabled Lincoln to prepare his plan to publicize the Emancipation Proclamation, which would hit newspapers in a few days.

As Lincoln prepared to free America's slaves, Gardner and Gibson loaded their wagon and hit the dusty, blood-soaked Maryland roads. Mathew Brady's name was emblazoned on the wagon's side. Their thoughts turned to a job as difficult as the doctors attempting to save the mortally wounded. Once and for all, they wanted to capture the reality of war by displaying its brutal carnage.

J. Pitcher Spencer, a photographer who worked with Gardner and other Brady men, described the "immense difficulties" of battlefield photography, from the handling of poisonous chemicals to the steering of a large wagon filled with glass plates that could shatter at any moment on rough and rugged roads. This wasn't photography in the secure confines of a studio—which was already hard enough—this was photography in the chaotic world of war. "When you realize that the most sensitive of all the list of chemicals are requisite to make collodion, which must coat every plate, and that the very slightest breath might carry enough 'poison' across the plate being coated to make it produce a blank spot instead of some much desired effect, you may perhaps have a faint idea of the care requisite to produce a picture," Spencer wrote. "Moreover, it took unceasing care to keep every bit of the apparatus, as well as each and every chemical, free from any possible contamination which might affect the picture. Often a breath of wind, no matter how gentle, spoiled the whole affair." He added, "Often, just as some fine result looked certain, a hot streak of air would

not only spoil the plate, but put the instrument out of commission, by curling some part of it out of shape."[17]

Gardner's first hurdle was getting near the battlefield. His wagon rambled along Hagerstown Pike. He and Gibson had to move slowly because the wagon was full of glass. Not to mention the traffic. The road was packed with stragglers, Union officials, townsfolk attempting to get back home, and family members looking for their loved ones.

Hagerstown Pike also needed to be cleared. Too many dead bodies had dropped in the dirt. The road was impassable. Eventually, people made a pathway by taking the bodies and piling them in stacks along the roadside. "The piles of dead on the Sharpsburg and Hagerstown Turnpike were frightful," wrote Lieutenant Colonel Rufus Dawes, who fought in the Sixth Wisconsin. "When we marched along the turn-pike . . . the scene was indescribably horrible. Great numbers of dead, swollen and black under the hot sun, lay upon the field."[18] Dawes said even his horse was terrified by the scene and "trembled in every limb with fright and was wet with perspiration."

Gardner did not take a picture on the Hagerstown Pike until the next day, September 19. He and Gibson surveyed the terrain littered with bodies and found their best shots. Some were strewn about the roadside up against a wooden fence. Others were lined up together in a jackknifed column awaiting burial.

The signs of suffering were everywhere, like deep scars etched into the parched landscape. One large open hole near a church was filled with discarded amputated limbs. Arms. Legs. Hands. A dead Confederate soldier's body lay alone, but, "in his agony, had kicked away the earth for a considerable space in the vicinity of his feet."[19]

Gardner's exposures took about fifteen minutes for each picture. But the process of preparing the plates and preserving them took much longer. The work had to be done in a hurry. Both to preserve time and to get the best pictures. "Every minute of delay resulted in the loss of brilliancy and depth in the negative," noted one Civil War photographer.[20]

Gardner and Gibson labored at this frenzied pace all day. Gardner would point his stereo camera at a scene, wait for a wet plate to make the exposure, and then hope for the best. Gibson would then handle the glass plates and prepare them for development. Gardner's first day of shooting included the bodies along Hagerstown Pike and the stacks of dead soldiers packed into Bloody Lane.

The next day, Gardner saw the infamous cornfield where so much action had taken place. While he scouted pictures, campfires smoldered in the hills. Others cried when they looked at the bloated bodies. Family members frantically searched for their loved ones and shrieked in horror at different moments. And just about everyone could hear the hacking. Farmers got out their knives and began cutting the corn that survived the battle.[21] After all, life had to go on. In the fields, plowing soon began—which unearthed so many bullets that plumbers eventually melted them down as lead for the plumbing of a large hotel in Hagerstown.

A group of boys, between ages ten to fifteen, scurried about, counting the numbers of steps between the bodies. The battlefield became their perverse playground. They took one corpse and set it upright and hurled pebbles at it for target practice.[22]

Decaying human flesh wasn't the only thing available to shoot. Dead animals were everywhere. One horse stood out near the cornfield where much of the fighting occurred.[23] "The number of dead horses was high," wrote General Alpheus Williams. "They lay, like the men, in all attitudes. One beautiful milk-white animal had died in so graceful a position that I wished for its photograph. Its legs were doubled under and its arched neck gracefully turned to one side, as if looking back to the ball-hole in its side. Until you got to it, it was hard to believe the horse was dead."[24] Gardner did get to it, and he made sure to attempt a picture. It would become one of his most memorable for its incredibly lifelike view.

Dr. Oliver Wendell Holmes, a Boston-based physician who wrote the poem "Old Ironsides," was passing through, looking for his son. He too came across the horse and wrote that it "belonged to a Rebel colonel, who was killed near the same place."

Holmes was disgusted by the overall scene. "There was something repulsive about the trodden and stained relics of the stale battlefield." Holmes wrote. "It was like the table of some hideous orgy left uncleared, and one turned away disgusted from its fragments and muddy heeltaps."[25]

Gardner and Gibson crept through the "hideous orgy" on their mission. They didn't only shoot pictures of the dead; they also took landscapes of the ravaged and wasted terrain. Blasted farm buildings, roofless houses, and battered churches.

In Sharpsburg and nearby towns, churches, stores, and residences were turned into hospitals. The Christian Commission put out an urgent call for supplies: shirts, pants, jellies, cornstarch, lemons, dried beef, and so much more; candles were requested to bring a dim light to the darkness.[26] Able-bodied citizens were ordered to drop everything and help tend to the wounded.

Gardner took pictures of Sharpsburg's desolate Main Street, where the small farm town was nearly ruined by the whole affair. Many residents had fled the town when Confederate forces arrived. They buried carpets and silverware in an attempt to save their most valued possessions. When they returned, everything had been looted and pillaged in a "locust-like visitation from the rebels."[27]

Regardless, the Marylanders developed a fighting spirit and will to win. Gardner took note of their hospitality of soldiers—even in the face of their own devastation. After all, he was a fellow Marylander. "When the army was on the march, many families stood at their gateways with buckets of water for the thirsty men, and filled the canteens of all who had time to wait," Gardner wrote.

Gardner left Sharpsburg around September 22. He later remembered the heroism and bravery he saw. "Localities that would scarcely have been known, and probably never remembered, save in their immediate vicinity, have become celebrated, and will ever be held sacred as memorable fields, where thousands of brave men yielded up their lives a willing sacrifice for the cause they had espoused," he wrote.[28]

He returned to Washington with at least seventy photographic negatives taken within five days of the battle. He needed to keep them safe if he wanted to show them to the world. He quickly copyrighted the images in his own name. He knew they were important. He gave Gibson credit for the negatives he obtained. But neither would get proper attribution from their boss.

———◆———

MATHEW BRADY HAD gone to Bull Run the year before and came back empty-handed. His understudy Gardner, meanwhile, was able to bring the war home to Washington. What Gardner brought back home, however, was taken and neatly packed into Brady's Album Gallery and offered for sale. They included a warning: "The photographs of this series were taken directly from nature, at considerable cost. Warning is therefore given that legal proceedings will be at once instituted against

any party infringing the copyright." In New York, Brady was excited to display the work. He quickly hung a small placard on his Broadway studio's front door, reading, "The Dead of Antietam."

On October 3, the *New York Times* included a notice headlined "Antietam Reproduced." It read:

> Mr. M. B. BRADY, whose collection of National portraits is simply unapproached, and whose battle scenes, procured under circumstances trying to the courage and manhood of his artists, furnish to the time-present, and will exhibit to wondering time yet to come, the most absolute portraiture of the incidents, places and persons of our civil war, has just received from his artists, who were at the battle of Antietam, a series of most interesting views. They comprise pictures of the field of battle, the positions of the several corps, and many thrilling incidents. The public can see and purchase copies at BRADY's Gallery.[29]

While Brady was promoting the Antietam images, President Abraham Lincoln was in Maryland to see McClellan. And Gardner was still at work with his camera in an attempt to shoot Lincoln on the battlefield.

Lincoln's Emancipation Proclamation had hit the newspapers on September 22. It was celebrated in the North, but Lincoln proceeded with a dash of his midwestern caution. "It is six days old, and while commendation in newspapers and by distinguished individuals is all that a vain man could wish, the stocks have declined, and troops come forward more slowly than ever," Lincoln wrote. "This, looked soberly in the face, is not very satisfactory."

On October 1, Lincoln arrived in Harpers Ferry on a special train from Washington. He was given spontaneous applause. Things appeared to be looking up for the weathered president. A few days later, he arrived at the mouth of the Antietam to review the troops and the aftershocks of battle. "General McClellan and myself are to be photographed tomorrow by Mr. Gardner if we can sit still long enough," Lincoln wrote in a telegraph to his wife. "I feel General M should have no problem on his end, but I may sway in the breeze a bit."

Lincoln remained upset with McClellan's inability to quickly pursue Lee's fighting rebels. The war could have been over. Now, he knew, it would drag on. "The evening and night of Thursday and Friday the

President spent at General McClellan's quarters, occupying much of the time in private conversation with him," Gardner wrote. "In this conversation, it is said, that when the President alluded to the complaints that were being made of the slowness of the General's movements, General McClellan replied, 'You may find those who will go faster than I, Mr. President; but it is very doubtful if you will find many who will go further.'"

Gardner took a series of classic images that would be remembered for generations. In one he photographed a giantlike Lincoln towering over McClellan and his men. The image conveyed that Abraham Lincoln was in charge. The long black coat draped over his frame and top hat on his head accentuated his power in a way the most ornate military uniform could not. The next day, Gardner shot a picture of Lincoln and McClellan in private conversation inside McClellan's open tent. The angle gave the public a peek at the machinations of war.

Lincoln headed back to Washington on October 4. Gardner sent a message to Brady's Washington gallery: "Got Prest Genls McClellan McClelland Porter Morrell Marcy & Humphrey Will send negatives tomorrow."

<center>———◆———</center>

MEANWHILE, BRADY FOUND his New York studio flooded with visitors. The place, at 785 Broadway, was unmistakable, with its large sign reading, "Brady's Portrait Gallery." It opened two years earlier, after Brady converted a four-story house into his "palace of light." A writer said it symbolized photography's rise as a colossal industry.[30] True to Brady style, it had expensive carpet, a private "ladies entrance," modern heating equipment, and artistic gas fixtures used almost exclusively by New York's millionaires.[31] *Leslie's Illustrated Newspaper* said, "If Brady lived in England his gallery would be called the Royal Gallery." In some ways, it was. In late 1860, it hosted Albert Edward, the Prince of Wales and heir to mother Queen Victoria's throne.

Passersby entered the building, in the heart of the city opposite Grace Church and the massive A. T. Stewart's department store, to a grand lobby "on Broadway . . . as fine as anything of the kind on that great thoroughfare." They climbed a "stairway of carved wood" and walked into a gallery described by the *New York Herald* as surpassing "every similar establishment in the world."[32] They walked into a large room known as the "Valhalla of Celebrities." This is where Brady

displayed his famous portraits of notable Americans. The pictures that made him an international star more than a decade before.

But in October 1862, the only images anyone wanted to see were the pictures taken by Alexander Gardner in the dusty fields of Antietam. Brady promptly put them on display. They drew immediate praise. A *New York Times* writer said Brady had done what newsprint could not. "Mr. BRADY has done something to bring home to us the terrible reality and earnestness of war," the *Times* said. "If he has not brought bodies and laid them in our dooryards and along the streets, he has done something very like it." The pictures of Antietam were almost like a hearse stopping "at your own door" and dropping off a corpse, the writer noted.

Inside Brady's studio, hushed groups of men and women stood around the "weird copies of carnage," stunned by their depth and reality. "It seems somewhat singular that the same sun that looked down on the faces of the slain, blistering them, blotting out from the bodies all semblance to humanity, and hastening corruption, should have thus caught their features upon canvas, and given them perpetuity for ever," the *Times* said. "But so it is."

The display was unknowingly changing the very idea of journalism. Men with cameras were becoming just as powerful as men with pens. *Humphrey's Journal* said the Antietam images were crucial "contribut[ions] to the historical memorials of our time." "They possess a value far beyond that of any written descriptions," the journal stated. "For they offer to the eye the dreadful actualities of scenes which the pen of the most skillful writer could only reproduce with a remote degree of accuracy."[33]

The Antietam photographs were evidence of a previous mantra of *Humphrey's*, a photographic journal that had a distaste for the lack of objectivity displayed by newspapers. "The correspondents of the rebels newspapers are sheer falsifiers, the correspondents of the Northern journals are not to be depended upon, and the correspondents of the English press are altogether worse than either; but Brady never misrepresents."[34]

Oliver Wendell Holmes, who returned to New York from Antietam after finding his son, found the images a powerful mirror of his memory. He believed in Brady. In the *Atlantic Monthly*, Holmes wrote: "These terrible mementoes of one of the most sanguinary conflicts of the war, we owe to the enterprise of Mr. Brady of New York. We

ourselves were upon the battlefield upon the Saturday following the Wednesday when the battle took place. The photographs bear witness to the accuracy of some of our sketches . . . the 'ditch' encumbered with the dead as we saw it . . . the Colonel's gray horse . . . just as we saw him lying. . . . [L]et him who wishes to know what war is, look at these series of illustrations."[35]

The October 18 issue of *Harper's Weekly* included eight woodcut engravings of the Antietam photographs. "We reproduce on pages 664 and 665 a number of photographs of the Battle of Antietam, taken by the well-known and enterprising photographer, Mr. M. B. Brady, of this city," *Harper's* wrote in an introduction. Brady never stepped foot in Sharpsburg or the Antietam battlefield. *Harper's* didn't bother to make even a tacit mention of his photographic corps.

Yet despite all outside appearances, Brady's financial situation had grown as gloomy as the brittle war. At the beginning of 1862, *Humphrey's Journal* noted that war was good for the cash registers of Northern photographers. "The Photographic art here at the North is flourishing finely, and we positively hear no complaints of hard times among operators. A few galleries have been sold out to other parties, but we have heard of none being 'slaughtered'; they have brought good prices. Whether business will continue to be good after the holidays is an open question."[36]

Sales often depended on the whims of war. If there was a great Northern victory, or ready-made hero, sales were brisk. Brady almost always benefited because he was a master of promotion. But his business model couldn't support his grand desires. The cost of sending platoons of photographers to the battlefields wasn't offset by revenue brought back from the pictures—if they were able to get any pictures at all. Lavish spending took its toll. By the outbreak of Bull Run, R. G. Dun & Company reported Brady's credit as "weak." And it got only weaker while Brady attempted to cover the war like a "rich newspaper."

Alexander Gardner was a bright spot for Brady. He had run the Washington gallery well and had built the relationships necessary to obtain some of the best pictures of the war. But Gardner wasn't getting public credit for the pictures he had taken.

A month after Gardner's Antietam pictures went on display, Lincoln fired McClellan. Pinkerton, Gardner's old friend, went with him. The move meant Gardner wouldn't enjoy the same access he once had with the Army of the Potomac. His job would be more difficult.

Gardner returned to Washington, knowing things would be different. Now, after six years of working for someone else, he thought about leaving Brady's studio and starting his own. A bold move that could transform him from Brady's biggest unknown star to his biggest known rival.

The Breakup

— July 1863 —

THE BODY WAS baked in the hot sun, heavy with the bloat of death. Alexander Gardner, joined by assistants James Gibson and Timothy O'Sullivan, said he had come upon the dead man while traveling with a burial party searching for bodies in the nooks and crannies of the wasted Gettysburg battlefield. He was a Confederate sharpshooter, Gardner remembered, lying flat on his back as he fell from a fatal bullet to the head. "How many skeletons of such men are bleaching to-day in out of the way places no one can tell," Gardner wrote. "Now and then the visitor to a battle-field finds the bones of some man shot as this one was, but there are hundreds that will never be known of, and will moulder into nothingness among the rocks."[1]

Gardner and his men found him in an area nicknamed Devil's Den, a rocky ridge packed with boulders. "There were several regiments of Sharpshooters employed on both sides during the war, and many distinguished officers lost their lives at the hands of the riflemen," Gardner wrote. And, he noted, they could aim their rifles and "snuff a candle at a few hundred yards."

THE BATTLE IN the hot sun of the first three days of July had resulted in more than seven thousand dead bodies littered throughout the rocks, ridges, and ravines of the chestnut oak–studded terrain. It was the bloodiest battle of the Civil War—worse than the one-day battle of Antietam. The Union had vanquished Lee, causing the Old General

to look at the carnage and whisper, "This was all my fault."[2] That fault left behind a big mess.

Gardner and his men came as soon as they heard about the fighting. Speed was important. They needed to get there before the armies could bury their dead. The trip wasn't easy, but they had a good jump-start on other photographers. By July 5, two days after the battle had ended, they passed through Emmitsburg, Maryland, near the Pennsylvania border, on their way north with two photographic wagons. Gardner knew the town well. One of his sons, Lawrence, was enrolled there at Mount Saint Mary's boarding school.

Gardner and company got there at dawn. One of the men, it was never revealed who, was briefly captured by Confederate forces at the Farmer's Inn and Hotel. It wasn't a major inconvenience. They were back on the road by the afternoon.

They traveled with Charles H. Keener, of the United States Christian Commission and superintendent of an institute for the blind. Gardner admired the Christian Commission and agreed to give Keener a ride. The commission arrived after battles to treat the wounded and give spiritual support to the dying. Gardner called them "one of the most striking evidences of the patriotism of the American people."

The group passed through the battlefield's edge along Emmitsburg Road and made it to Gettysburg by nightfall. There was a tinge of good news for them amid all the bad. They had arrived before any of their competitors. Then reality sank in. "First we saw the smoking ruins of a house and barn; fences were all leveled; breastworks were thrown up on all sides; the road barricaded; dead horses laid about by dozens, and filled the road with a horrible stench. Though our army had held the field but 24 hours, we saw but one dead on the road, and all the wounded were in houses and barns," Keener wrote. That was bad news for Gardner and his photographic team. They needed—wanted—dead bodies for their pictures. It provided an emotional punch that nothing else could. Antietam taught them that. Battlefield photography was a macabre art.

They spent the night in Gettysburg, where wounded men were packed into anything with a roof. Hooks and knives and hacksaws were all around. Keener sat up all night with officers who had limbs amputated after battle.[3] Gardner spent his time readying his own tools—lenses, chemicals, and glass—while figuring out where he could

find corpses. Gardner had watched the Battle of Antietam and knew its layout well. At Gettysburg, he was working with little firsthand information. It was all instinct until they enlisted the help of burial parties who knew the countryside much better.

Gettysburg, the county seat of Adams County, was a small town of about four thousand. It had a handsome courthouse and modest, tidy homes. It was ringed with copper mines and had a number of carriage manufacturers. "The town suffered considerably from the fire of our artillery, and the houses in some parts of the place were covered with indentations of musket balls," Gardner wrote. "Very few of the inhabitants were injured, however, most of them taking refuge in their cellars and other sheltered places."

The next morning, July 6, the real work began. The weather wasn't good. It had rained and poured, leaving behind a misty humidity that hung in the air like a grim reaper. Clouds blanketed the sky, but the weather was good enough to make a picture. Gardner and his men meandered about, surveying the battlefield. They could have simply found their subjects by sniffing the air.

The smell was terrible. The normal summertime scents of wild plum and magnolia were replaced with rot. Cornelia Hancock, a volunteer nurse who arrived at Gettysburg around the same time, described it like this:

> A sickening, overpowering, awful stench announced the presence of the unburied dead, on which the July sun was mercilessly shining, and at every step the air grew heavier and fouler, until it seemed to possess a palpable horrible density that could be seen and felt and cut with a knife. Not the presence of the dead bodies themselves, swollen and disfigured as they were, and lying in heaps on every side, was as awful to the spectator as that deadly, nauseating atmosphere which robbed the battlefield of its glory, the survivors of their victory, and the wounded of what little chance of life was left to them.[4]

Gardner pressed forward, passing throngs of injured men, but that's not what he was looking for. Animosity had grown throughout the war. The North showed little sympathy for their wounded and unwanted Southern visitors. "The gentle citizens of Gettysburg . . . pass and repass these wounded rebels day after day, and pay no more attention to them than so many dying dogs," the *Raleigh Register* wrote.[5]

The sunless morning created a unique setting. "Through the shadowy vapors, it was, indeed, a 'harvest of death' that was presented," Gardner wrote. "Hundreds and hundreds of torn Union and rebel soldiers—although many of the former were already interred—strewed the now quiet fighting ground, soaked by the rain, which for two days had drenched the country with its fitful showers."[6]

Gardner passed open graves half finished, left behind in the haste of the retreating rebels. He passed dead Union men who looked as if they would come back to life. Their demeanor unquestionably left an impression on the photographer. Some looked like they had suffered, some looked calm, some looked like they died in prayer. "Others had a smile on their faces, and looked as if they were in the act of speaking," Gardner wrote.

> Some lay stretched on their backs, as if friendly hands had prepared them for burial. Some were still resting on one knee, their hands grasping their muskets. In some instances the cartridge remained between the teeth, or the musket was held in one hand, and the other was uplifted as though to ward off a blow, or appealing to heaven. The faces of all were pale, as though cut in marble, and as the wind swept across the battle-field it waved the hair, and gave the bodies such an appearance of life that a spectator could hardly help thinking they were about to rise to continue the fight.

Finally, Gardner stopped at Devil's Den, where he found what he called the "covert of a rebel sharpshooter." The dead soldier, dressed in familiar tattered gray, died with his boots on. Deep in battle. His cap and gun lay near his head, possibly thrown behind him during a swift shock. His head was puffy, swollen with a great gush of blood. His mouth was agape, perhaps in utterance of his final terrified words. No one was there to record them, whatever they were. A blanket was nearby, which Gardner said indicated that "he had selected this as a permanent position from which to annoy the enemy."

It's no surprise the man was a Confederate. They were often the last soldiers to be buried on Northern battlefields. And the man before them looked every bit a Confederate, with his ragged clothes and devil-may-care look.

The crew hovered over the body like maggots. They used a double-lens stereographic camera to record the man in amazing depth. But

then Gardner, or one of his associates, had an idea. A better picture could be had if the body was positioned differently. The whole thing could use a better backdrop, something more theatrical, they thought. So they took the nearby blanket and had the man's stiffened flesh lugged about seventy yards to a nearby stony hill. It would have taken several men to help with the move—especially struggling for breath in the heavy, humid air.

The body was arranged just so. The head was rolled over to face the camera. The rifle was prominently propped up against the Devil's Den boulders. This Confederate sharpshooter had become a prop. If he was a sharpshooter at all. The rifle most likely belonged to Gardner or his men. It appeared in several other pictures.

The result was a photo Gardner titled *Home of a Rebel Sharpshooter.* Gardner gave the man a fascinating, valiant story. He said the man had built up a lookout among the rocks and "picked off" Union officers before he was caught in fire. "The trees in the vicinity were splintered, and their branches cut off, while the front of the wall looked as if just recovering from an attack of geological small-pox," Gardner wrote. "The sharpshooter had evidently been wounded in the head by a fragment of shell which had exploded over him, and had laid down upon his blanket to await death."[7]

Then, Gardner wondered how the man whose body he had moved felt when he died. "There was no means of judging how long he had lived after receiving his wound, but the disordered clothing shows that his sufferings must have been intense. Was he delirious with agony, or did death come slowly to his relief, while memories of home grew dearer as the field of carnage faded before him? What visions, of loved ones far away, may have hovered above his stony pillow! What familiar voices may he not have heard, like whispers beneath the roar of battle, as his eyes grew heavy in their long, last sleep!"

Gardner didn't spend too much time worrying about the rebel. He had more work to do. He and his men went about their day. Later, they came across a dismembered body alone in a field. Gardner draped a rifle over the soldier's knee. He titled it *War Effect of a Shell on a Confederate Soldier at Battle of Gettysburg.* Others would later opine that the dismemberment didn't occur from battle, but rather that the soldier had been "used as a meal by the wild pigs."[8]

They stayed in Gettysburg overnight. The next day, he took landscape scenes of the town, but quickly made preparations to return to

Washington. They took a total of sixty pictures. Now it was time to get them safely home. Gardner left for Washington early as his men headed to the headquarters of the Army of the Potomac in Frederick, Maryland.

Communication was important to Gardner. He used the field telegraph system as a way to stay in touch with his men. It was the best way to move fast and take pictures before anyone else. He would later remark that the system was a great triumph and "exceeded the most sanguine expectations."

When he arrived back in Washington, Gardner sent a telegraph to O'Sullivan at the Army of the Potomac. "I have just got back from Gettysburg. Woodbury & Berger were there, if they come your length I hope you will give them every attention. Tell Jim that McGraw is dead I will write." Gardner was talking about David B. Woodbury and Anthony Berger. They were fellow photographers. Two men who were working for Mathew Brady, now Gardner's rival.

Earlier in the year, Gardner had broken away from his longtime master, Brady. He took with him countless photo negatives—as well as a number of Brady's prized photo operators. The move lit a new sense of competition between the two and made Gardner watch Brady's movements just like a competing army.

The telegraph could be viewed as a warning. Perhaps Brady himself was headed for the battlefield. He was.

———❖———

THE YEAR 1863 had begun with little hope. In December, the Union army had suffered a significant defeat in Fredericksburg, Virginia. Officials, including President Lincoln, were doing everything they could to bolster the fading enthusiasm for the war.

Sometimes the press helped, and sometimes they hurt. Such was their way. Newspapers were packed with lists of dead that went on and on in endless rolls. Not to mention rewards for the capture of deserters. It seemed like the North and South were both growing tired.

No matter, illustrators and photographers appeared to do well in the changing news environment. People wanted pictures. They wanted to see in vivid detail the events described, not just read about them in stale black ink. *Harper's Weekly* handed its first cover of 1863 over to cartoonist Thomas Nast, who sketched *Santa Claus in Camp*.[9] It depicted a jolly, bearded Saint Nicholas on the battlefield, handing out

toys to the troops. It was considered the first modern version of Santa Claus ever drawn.

Inside the weekly newspaper, Nast's Santa Claus appeared again in a heartwarming centerfold. The drawing captured the mood of the country. Worried, lonely, and withdrawn. Santa's reindeer were perched atop a snow-packed roof as he prepared to slide down a chimney. Beneath Santa was a lonely solider posted by a campfire, looking at pictures of his family. On the other side was his wife, kneeling at the foot of the bed of their sleeping children, her head looking up to the night sky with her hands clasped in prayer.

Also in the issue were sketches of Fredericksburg from Alfred Waud, the artist who had dashed off to battlefields with his familiar sketchbook in hand. A reminder that the whole country needed to pray for peace.

Still, there were signs of progress. Ground was broken on the first transcontinental railroad at the start of the year. And, starting January 1, America's slaves were finally free. And so was Alexander Gardner.

The newspapers did not cover their split. There were others things vying for their attention. After all, a war was going on. The two men never publicly addressed the discord. But sometime after Brady displayed Gardner's Antietam images, and Brady basked in the public praise, Gardner decided to leave and start his own studio.

He looted the Brady studio of its finest talent. Gardner recruited O'Sullivan, Gibson, George Barnard, and James Gardner, his own brother, to join him on the new venture, separate from Brady.

For years, Brady had poured money into his studio, buying the finest equipment and tutoring the young men who worked for him. He sent them to far-flung Civil War battlefields, spending a fortune in the process. The quest had left Brady with bad credit.

Still, Brady was a master at publicity—for himself. But that appeared to wear on his best employees. They never got credit for their best work. Brady enjoyed all of the fame. He was a name brand.

Gardner's exit appears to have been some sort of negotiated settlement. Brady allowed Gardner to take with him the negatives from 1862, including the prized Antietam images. Perhaps Brady owed Gardner money and the negatives were a way of settling old debts. No one really knew. It had to be emotional. Brady gave Gardner his first job in the United States.

Now, with Gardner gone, Brady retreated from the war. He appointed Anthony Berger, a former locksmith, to manage the shrunken Washington studio and staff. Brady turned his focus to New York, where he focused again on celebrity. Despite the war, the city's elite sat in his studio, including the Harper brothers—James, John, Joseph, and Fletcher—who were operating a publishing empire, including *Harper's Weekly*, which ran woodcuts of many Brady photos.

Just like a decade before with singer Jenny Lind, Brady's attention revolved around his Broadway neighbor P. T. Barnum. In February 1863, Barnum was putting on quite a show. Barnum had found and promoted Charles Sherwood Stratton, a two-foot-tall dwarf whom he had taught to sing and dance and impersonate other celebrities. He called him General Tom Thumb. Barnum had found another dwarf named Lavinia Warren. He soon had the idea to create an elaborate "fairy wedding," where Thumb and Warren would get married. The event happened on February 10 at Grace Church, next to Brady's studio. Barnum himself led Warren up the aisle and gave her away. A large organ blasted music from *William Tell, Oberon,* and *Tannhäuser.*

It was a break from the war. A dash of fun and celebrity to avoid thinking about the death and destruction. The *New York Times* wrote, "Those who did and those who did not attend the wedding of Gen. Thomas Thumb and Queen Lavinia Warren composed the population of this great Metropolis yesterday, and thenceforth religious and civil parties sink into comparative insignificance before this one arbitrating query of fate—Did you or did you not see Tom Thumb married?"[10]

As with all weddings, they needed a good photographer. There was none better for the job than Brady. "It would scarcely be imagined that the same enterprising gentleman who has photographed all the leading Generals and gentleman of the day, could be so oblivious of his duty to society as to permit Gen. Tom Thumb and his beautiful bride to go down to posterity on the lips of tradition merely, unrecorded by the faithful pencil of the sun," the *New York Times* wrote. "Nor has Mr. Brady . . ."

Brady invited the city to come to his gallery and see the wedding pictures. Anyone who missed it could experience it on their own—or buy pictures. The Anthony brothers had taken Brady's photos and put up for sale a gold-mounted wedding album.

A woodcut image of the married couple ran on the front cover of *Harper's Weekly.*[11] It was "photographed by Brady." Of course, Barnum

ran an ad in that issue, promising more from Tom Thumb and his wife, in addition to a living hippopotamus, a sea lion, and an "albino family."

In Washington, the Lincolns held a reception in the couple's honor. A few blocks away, Alexander Gardner was working on opening his new studio, near the Brady studio he once ran. Gardner found a large building at the corner of Seventh and D Streets. By May he was ready to go public. He announced his grand opening on May 26, 1863, in the *Washington Daily National Intelligencer.*

Gardner promoted the technological improvements of his studio, saying it was outfitted with the "newest and most improved" cameras.[12] "To avoid the fault so generally and justly complained of, the 'Light' has been constructed so as to obviate all heavy and unnatural shadows under the eyebrows and chin. And the chemical department has been brought to such perfection that the sitting for a Carte de Visite rare exceeds five seconds! Oftener not more than one or two!" The pressure was on Gardner now that he was on his own. Perhaps that's why he took to staging battlefield photographs.

Regardless, Gardner brimmed with ambition. Poet Walt Whitman sat for a photo at Gardner's new studio. Whitman said of him: "Gardner was large, strong, a man with a big head full of ideas: a splendid neck: a man you would like to know, to meet." He added that Gardner was "a real artist—had the feel of his work—the inner feel, if I may say it so: he was not . . . only a workman . . . but he was also beyond his craft—saw farther than his camera—saw more: his pictures are an evidence of his endowment."[13]

Gardner still had much to learn. Specifically about promotion. Brady, after all, was headed to Gettysburg.

———◆———

PERHAPS IT WAS a new sense of excitement spurred by Gardner's breakup. Or perhaps it was simply because he was short staffed. But after avoiding Civil War battlefields, Mathew Brady, with his eyesight growing weaker, made it to Gettysburg about a week after his former apprentice left it. Gardner would have thought that to be a week too late. It wasn't.

Berger and Woodbury got to Gettysburg long before Brady, but Brady directed them when he arrived. They took thirty-six photographs over the span of about a week. In them, Brady tried a novel

approach. He put himself in the photos. Now they weren't just branded "Photo by Brady." Now Brady was an actual part of them. His straw hat floating in and out of the view. There was no better way to brand an image. In one Brady appears with his assistants, looking out over a wide view of Little Round Top and Big Round Top. In another he's standing in a field. In yet one more, he is seated on the side steps of a house.

By arriving late, Brady was able to study and shoot the important battlefield landmarks that the public had read about in the press. As well as the personalities. Gardner didn't have time for history to settle in.

The August 22 issue of *Harper's Weekly* gave Brady the cover image. Once again. Gardner's dead-body images would make little impact at the time. "Mr. Brady, the photographer, to whose industry and energy we are indebted for many of the most reliable pictures of the war, has been to the Gettysburg battle-field, and executed a number of photographs of what he saw there," *Harper's* wrote.

Brady's great-men theory worked. He had focused on one living subject. An old Gettysburg local named John Burns. Burns's image won Brady the *Harper's* cover. The magazine wrote that Burns was "the only citizen of Gettysburg who shouldered his rifle and went out to do battle in the Union ranks against the enemies of his country. The old man made his appearance in a uniform which he had worn in the last war, but he fought as stoutly as any young man in the army. Honor to his name! Old Burns's house is there too, a memorial in its way of the fight: from its condition it looks as though it would not be very likely to remain many years as an object of curiosity."

Brady, of course, appeared in the image at Burns's house. Gardner saw this and was certainly aghast. But the hardworking photographer had more plans.

6

Surrender

— March 4, 1865 —

T HE PRESIDENT WAS in danger. Famous actor John Wilkes Booth looked down like a hunter on Abraham Lincoln as he delivered his second inaugural address on the steps of the Capitol. Out in the crowd, Alexander Gardner's lens panned across the faces of generals and politicians. It rested on Lincoln, whose unmistakable silhouette read his speech.

On a balcony above the president stood Booth, within Gardner's frame. A white marble statue towered behind him. The massive sculpture by Horatio Greenough showed a white frontiersman preventing an Indian from killing his family. The hatchet-wielding Indian was pinned in the man's arms. Nearby, a hunched woman protected her small baby from a tomahawk chop. Greenough said the statue depicted "the peril of the American wilderness, the ferocity of our Indians, the superiority of the white man."[1] He called it *The Rescue*. It was a fitting backdrop as Booth pursued his plot to kill or kidnap the president.

Bodyguards and military officers were everywhere. The newspapers said the streets were swollen with "pickpockets and roughs." Rumors had developed that "something was going on." "Trouble was anticipated from some undeveloped quarter," the *Washington Evening Star* wrote. "Rumor had it that all the roads leading to Washington had been heavily picketed for some days, and the bridges guarded with extra vigilance, as if on the watch for suspicious characters. . . . [A]n undue proportion of 'ornery looking cusses' in grizzled costume were to be seen upon the streets, indicating something portending."[2]

Booth was dressed for the occasion. He wore a long black over-coat and a spiffy top hat. He peered down from the balcony on the East Portico of the Capitol as Lincoln's country drawl tore through the wind with the famous words: "With malice toward none, with charity for all . . . " Lincoln's words did not matter to Booth. He later told a friend, "What an excellent chance I had to kill the President, if I had wished, on inauguration-day."[3] Booth had bragged to a friend he was in close reach of the president. And he was.

Gardner had taken a picture at Lincoln's first inauguration four years before. Then, a much larger crowd stood in front of the half-finished Capitol dome, which resembled a severed head from the shoulders of the House and Senate. The second inaugural was much more challenging for Gardner because of the weather. Drenching rain and mud baths combined on the streets and sidewalks. Heavy winds earlier in the day uprooted trees and scattered about litter.[4]

Gardner struggled beneath the overcast clouds and drizzling rain that hung above. At moments the sky would brighten, enabling Gardner to make three photographs. Only one showed Booth along an iron railing, peering down as the president delivered his speech. There Benjamin French, a New Hampshire politician, said he ran into Booth. That day, French believed he unknowingly rescued Lincoln from imminent danger by blocking Booth from killing the president. "He gave me such a fiendish stare as I was pushing him back, that I took particular notice of him & fixed his face in my mind, and I think I cannot be mistaken," French wrote. "My theory is that he meant to rush up behind the President & assassinate him, & in the confusion escape into the crowd again & get away."

Booth had been working with a band of conspirators in and around Washington. The men—David Herold, George Atzerodt, Lewis Powell, John Surratt, and Edmund Spangler—had also attended Lincoln's inauguration. The original plan was to kidnap Lincoln. But in the days after the inauguration, Booth was thinking about simply shooting and killing him. That plot, though, was much more ambitious. Booth not only planned to murder the president. He and his conspirators would kill the vice president and secretary of state along with him. The Union would pay for burning the South with the blood of its leaders.

The *Evening Star* said the photographs taken that day "are superb, and will preserve to the future a life-like and remarkably spirited

presentation of the scene." Gardner had photographed the president and his future murderer.

———•◦•———

A MONTH LATER, on April 3, Alexander Gardner heard the sounds of celebration—the cheers, the bands, the hurrahing, the champagne pops—and knew it was time to leave. News that Richmond had fallen to Union forces had traveled from the lips of Secretary of War Edwin Stanton to the rat-a-tat clicks of telegraph machines to the hoarse voices of newspapermen shouting, "EXTRA, EXTRA!"

In Washington the extra came at about four o'clock in the afternoon, landing like a thud before the eyes and ears of a city ready to put the struggle between North and South behind it. Washington had known the end was near. Sherman's army had laid waste to Atlanta in his March to the Sea. Grant made his move in Virginia. Now they knew even the Confederate capital was doomed. "Washington city is in such a blaze of excitement and enthusiasm as we never before witnessed here," the *Evening Star* wrote. "The thunder of cannon; the ringing of bells; the eruption of flags from every window and housetop, the shouts of enthusiastic gatherings in the streets; all echo the glorious report. RICHMOND IS OURS!!!"[5]

The muddy streets around Gardner's studio echoed with joy. One person said, "almost by magic, the streets were crowded with hosts of people, talking, laughing, hurrahing, and shouting in the fullness of their joy."[6] Women began decorating their windows; men began toasting with sips—then gulps—of whiskey.

Gardner wasn't one of them. He was hard at work. As he had done before, Gardner prepared his heavy equipment and made travel plans. His destination: Richmond. His plan: to leave a city in patriotic celebration and photograph a city in ruin. History was happening fast, with twists and turns pulsating through the telegraph lines by the hour. Gardner, who had largely stayed away from the battlefield since Gettysburg, recognized the moment and moved with his characteristic speed—but still not quickly enough to catch the president.

Lincoln, already in Petersburg, Virginia, made it to Richmond on April 4, the day after the Union troops took control of the city. He traveled on a gunboat up the James River but was slowed by dirty water clogged with dead horses, fallen trees, and sunken ships. Still, he was able to make it through the treacherous water and into the smoldering,

ruined city. He was greeted by a group of former slaves who knelt at his feet and bowed like he was a king. "Don't kneel to me," Lincoln said. "That is not right. You must kneel to God only, and thank Him for the liberty you will afterward enjoy."

Lincoln's arrival spread throughout town. He was cheered as he walked through the streets, which smelled of ash smoke, just thirty-six hours after the Confederates fled. Lincoln was trailed by William H. Crook, his bodyguard, armed with a Colt revolver. Crook remembered the visit as one of executive duty—not glory. "We looked more like prisoners than anything else," Crook noted.

Lincoln visited the streets of the vanquished enemy and walked to Jefferson Davis's gray-stuccoed mansion. Crook wrote:

> The President's suspense during the days when he knew the battle of Petersburg was imminent, his agony when the thunder of the cannon told him that men were being cut down like grass, his sight of the poor, torn bodies of the dead and dying on the field of Petersburg, his painful sympathy with the forlorn rebel prisoners, the revelation of the devastation of a noble people in ruined Richmond—these things may have been compensated for by his exultation when he first knew the long struggle was over. But I think not. These things wore new furrows in his face. Mr. Lincoln never looked sadder in his life than when he walked through the streets of Richmond.[7]

What Lincoln's face actually looked like was anyone's guess. No photographer was present to capture it. The historic moment was left to the often-revisionist hands of sketch artists. A drawing by Lambert Hollis showed Lincoln, wearing a long black coat and trademark top hat, surrounded by a crowd. He held his son Tad's hand. It was his twelfth birthday. Some men threw their caps in the air. Jubilant slaves approached as guards stood nearby. It was most likely an amalgamation of several scenes illustrated together all at once.

Gardner, in the middle of his approximately one-hundred-mile journey, missed that scene and so many others, from Lincoln visiting the South's former seat of government to his sitting in its former leader's easy chair—a supreme act that showed the rebels were done.

Artist Joseph Becker sketched Lincoln walking up the steps of Davis's mansion. A large crowd was gathered behind his back, waving their hands in the air. Young boys were posted high up in trees for a glimpse of the tall president.[8]

General Grant had ordered that no one was allowed to leave Richmond or enter it unless they were affiliated with the army. Gardner, with his unofficial title of photographer of the Army of the Potomac, was allowed in. But the situation on the James River, and the general chaotic scene of war, made travel difficult.

Gardner made it to Richmond by boat on April 6—three days after Union forces occupied it. Lincoln had already left. He was joined by John Reekie, a fellow Scotsman who worked for Gardner primarily in Virginia (and formerly for Mathew Brady).

Even though Gardner had broken from Brady more than two years before, he and his crew were still identified with him. The *Richmond Whig* was the only newspaper left operating in the city—and it was now under a Union slant. Just like the newspapers, Southern photographers were destroyed by the Union choke hold. Supplies, particularly paper and chemicals, were nearly impossible to get.

The *Whig* treated its new arrivals like welcome guests on the gossip pages, noting the movements of the *Harper's* and *Leslie's* illustrators as well as photographers. But the paper appeared to confuse Gardner with Brady when it declared with delight, "M. B. Brady, Esq., the celebrated Photographist of New York city, and Washington, is in Richmond with a full corps of artists, apparatus and material, and will photograph views of the burned district, and other points and localities to which any historical interest is attached."[9] Brady wasn't there.

If Gardner cared, it was anyone's guess. He had learned from Brady and was now branding himself. Images by his hand or at his studio were tagged with the handsome title "ALEX GARDNER, Photographer to the Army of the Potomac." Still, his wasn't a household name, like "Photo by Brady."

Gardner pointed his camera over the wrecked land of burned bridges and blasted dreams. Before fleeing, the Confederates had set fire to warehouses in Richmond's commercial district, leaving the city a charred heap of brick and twisted metal. They called it the "Burned District." It was situated just beneath the neoclassical Virginia Capitol designed by Thomas Jefferson. "When Jefferson Davis directed the evacuation of Richmond, he left instructions . . . to burn the Confederate supplies and munitions of war," Gardner wrote in a description of his photographs of the city.

Gardner later visited an old tobacco warehouse that had been transformed into a prison for Union soldiers. He noticed it now housed rebel prisoners. "This view was taken after the time was passed when

Union soldiers and men looked wearily through the bars at the monotonous flow of the James, and wondered how much longer they could endure without going mad; or peeping out into the street at the risk of being fired at by some sentry, watched the relief on its rounds, or the arrival of more prisoners to swell the already overcrowded numbers in durance," Gardner wrote. "The Union flag floats upon the building, and the tables are turned. Rebel prisoners occupy the floors, so lately filled by Northern soldiers, with permission to kick up their heels to their hearts' content."[10]

Gardner and Reekie cataloged the carnage of Richmond in an attempt to reintroduce the Southern city to Northern audiences. The place was a bit of a mystery, cut off from the rest of the world for four years, serving as a foreign capital within the United States. Despite the Burned District, much of Richmond remained intact. The pair shot Davis's hulking mansion at Clay and Twelfth Streets. St. Paul's Church at Capitol Square, where Lee and Davis once prayed. The Spotswood Hotel, a noted gathering place for Southern politicians and the only lodging place still operating. And even the tomb of founding father President James Monroe.

While Gardner spent several days photographing Richmond, Robert E. Lee was sitting in Wilmer McLean's front parlor in Appomattox Court House, a small rural outpost. Grant had finally cornered Lee, who had sent the white flag of surrender. The once mighty Army of Northern Virginia gave up. Grant and Lee signed the terms of surrender at a meeting in McLean's house. Ironically, McLean had moved there after the first Battle of Bull Run, where he also owned property. The war, they would later say, began in his front yard and ended in his front parlor.[11] "It is a singular fact that the owner of this house, Mr. McLean, was living on the first Bull Run battle-field at the time of that engagement, and afterwards removed to this place for the purpose of being secure from the visitation of an army," Gardner noted.

Good intentions notwithstanding, Gardner didn't mention that McLean, a slaveholder, had made a fortune as a sugar smuggler during the war. Gardner photographed the home with McLean's family sitting on its front steps. He got there days after the surrender. Gardner, and every other photographer, missed the climax of the war. It would have been easy to photograph. Grant and Lee sat subdued.

The event was later illustrated and embellished in a number of re-creations. A myth developed that Lee had originally surrendered

under an apple tree in Appomattox. That was also mythologized in illustrations. But it wasn't true. Gardner made note of the tree a few years later, saying, "The apple tree (about half a mile from the Court-House) under which they first met, has been entirely carried away in pieces, as mementoes, not even the roots remaining."[12]

Gardner left Virginia within a few days of the surrender. He returned to Washington without a signature photo of the end of the war he had covered since its beginning.

Mathew Brady had other plans. He made his way to Richmond more than a week after the surrender. The old master arrived late for the show, like he had done numerous times before. But luck was on his side.

On his way, Brady and his camera operators stopped at City Point, located at the confluence of the James and Appomattox Rivers. Grant himself was there.

While Gardner focused on the places of war, Brady remained firmly interested in the people. Americans, he knew, connected with the faces of great men more than the blasted landscapes of the war. Brady had photographed Grant many times before. He knew that photographs of heroic generals like Grant and Lee were best sellers. Years later, when asked if he sold photographs according to someone's notoriety of the time, Brady singled out Grant and Lee. "Of such men as Grant and Lee, at their greatest periods of rise or ruin, thousands of copies; yet all that sort of work takes rigid, yes, minute worldly method."

So Grant was a perfect subject in the days after Appomattox—and so was Brady himself. Brady's camera operators photographed Grant flanked by members of his victorious staff. Brady stepped into the frame and appeared in the picture to the left of the men—wearing a top hat. Just like Mr. Lincoln. He then left for Richmond. He wore the hat there, too.

Brady's fame towered over his rivals. When he finally arrived in Richmond, the local newspapers singled him out by name and reputation. "Mr. Brady, the New York photographist, has made negatives of numerous scenes from the burnt district, and forwarded them to Washington to be engraved," the *Richmond Whig* noted. "Mr. Brady proposes to continue his views so long as there remains any object of interest in the Rebel Capital worth photographing for the observation of the world."[13]

Brady took many of the same shots as Gardner. He wasn't shy about sharing his subjects with the press. "It will be seen that Mr. Brady, with his quick eye, has been struck upon almost every point and object of interest in Richmond and the neighborhood," the *Whig* noted.[14]

But he soon learned that Robert E. Lee had returned to Richmond, where he had a house at 707 East Franklin Street. The house was quickly surrounded by cheering crowds, but the crestfallen Lee, the *New York Times* reported, kept "himself so secluded that nobody would suppose, unless so informed, that he is still among us. Few, I believe, have ventured to intrude upon his privacy, beyond the circle of his own friends."[15]

John Reekie, Gardner's assistant who formerly worked for Brady, remained in Richmond after Gardner had left. He photographed the exterior of Lee's three-story Greek Revival town house in the days after the general returned. But that wasn't good enough for his former boss. Brady wanted Lee's picture, and he wasn't afraid to intrude.

He did so in his gentle way—and through an intermediary. Brady appealed to Robert Ould, a Confederate colonel in charge of prisoners, to get him inside the house and take Lee's picture. It was a big request. After all, as Lee's youngest son once said, there was "none of the little things in life so irksome to him as having his picture taken." Brady later said Ould helped him, as did Lee's wife, Mary. "It was supposed that after his defeat it would be preposterous to ask him to sit, but I thought that to be the time for the historical picture," Brady later said.

Ould and Mary Lee's intercession worked. Brady waited in Lee's backyard. The old general walked through the back door. "He allowed me to come to his house and photograph him on his back porch in several situations. Of course I had known him since the Mexican war when he was upon Gen. Scott's staff, and my request was not as from an intruder."

Brady got the photo shoot no one else had. Lee in defeat. The fifty-eight-year-old general donned the uniform he had worn when he surrendered to Grant just days before. He held a hat in his right hand. Brady directed a number of poses with Lee. One standing, one sitting in a chair, another flanked by his son G. W. C. Lee and Lieutenant Colonel Walter Taylor.

That day, a *New York Times* reporter said he had "met Mr. Brady, the celebrated photographer of New York, who had just been favored with an interview by the General, and had taken splendid cabinet

portraits of him and all his staff. It will doubtless add an interesting item to his already splendid gallery of notabilities. Mr. Brady says the General received him with the utmost affability and cordiality of manner."[16]

Ultimately, the photo wouldn't make an immediate splash. The illustrated newspapers wouldn't want it on their covers. Things were happening in Washington that would change everything. Brady had to leave—at once. It was not a good time to be away.

Assassination

— April 14, 1865 —

ALEXANDER GARDNER RETURNED to a Washington city even more excited than the one he had left the week before. While Richmond was a dark wreck of a town, Washington flickered in light. On the night of April 13, there was a "grand illumination" throughout the city—and the nation—meant to celebrate Lee's surrender. "The very heavens seemed to have come down, and the stars twinkled in a sort of faded way, as if the solar system was out of order and the earth had become the great luminary," the *Washington Evening Star* wrote. Nearly every house, every business, every restaurant, every government building was alit with gas lamps and lanterns. American flags were draped across the brick and stone facades like a giant blanket of Stars and Stripes.

The view from up high was best. The *Star* said, "High above all towered the Capitol, glowing as if on fire and seeming to stud the city below with gems of reflected glory as stars light upon the sea. Away to the right a halo hung over the roofs, rockets flashed to and fro in fiery lines, and the banners waved above the tumultuous throng, where shots and cheers rolled up in a dense volume from the city, and with the increase of the grand conflagration, drifted away to the darkness of the surrounding hills."

Gardner was surely impressed. It was a spectacle for a man whose job it was to play with light. Although it must have been somewhat of an odd feeling. The war was over. What was next?

Pennsylvania Avenue, where Photographers' Row stood, was "especially resplendent," the *Washington National Republican* wrote of a view from atop the Capitol dome.[1]

The *Star* cataloged the illuminations of nearly every major street and business in town. Gardner's studio didn't make it into print. Neither did Brady, who was still in Richmond. (Although one could imagine the showy display Brady would have done if he was in town.) Their lesser known competitors got the ink. The *Star* said photographer Edward Bell's studio displayed a transparency that read, "Glory to the Union and her brave defenders." E. Z. Steever's place was noted for gas jets that illuminated the letters *U.S.* above a globe with the motto "The Union forever."

Still, their studios were surrounded by the pomp and circumstance. And many of the buildings illuminated pictures of the war heroes taken by Gardner and Brady. Next to Gardner's studio on Seventh Street, the Wolfsheimer & Brothers store lighted up the words:

> *Long live our chief, the president,*
> *In glory, peace and health*
> *Nobly he brought the war to end,*
> *Crushed treason in its wealth,*
> *O God! Preserve his worthy life,*
> *Let never war or civil strife*
> *Again disturb our land.*

Civil strife would return soon enough. That night, twenty-six-year-old John Wilkes Booth was in room 228 of the National Hotel, just a few blocks away from Gardner's studio. The fireworks and street noise kept him awake. Not to mention, he couldn't bear to think of the Confederacy as a lost cause. Into the early morning of April 14, Good Friday, Booth dashed off a letter to his mother, Mary Ann Holmes Booth.[2] The debonair actor from a famous theatrical family wanted his mother to know he was okay.

Dearest Mother:

I know you expect a letter from me, and am sure you will hardly forgive me. But indeed I have nothing to write about. Everything is dull; that is, has been till last night. (The illumination.)

Everything was bright and splendid. More so in my eyes if it had been a display in a nobler cause. But so goes the world. Might makes right. I only drop you these few lines to let you know I am well, and to say I have not heard from you. Excuse brevity; am in haste. Had one from Rose. With best love to you all, I am your affectionate son ever,

John

Booth awoke on Good Friday for a busy day. The previous night's celebration still echoed in the streets. At first, everything seemed ordinary. He had breakfast at the National Hotel. He went to Booker and Stewart's barbershop to get his hair trimmed and mustache tidied. Then he stopped by Ford's Theatre to get his mail—a service provided to friendly traveling actors. Booth had last performed at Ford's on March 28 in a rendition of *The Apostate*, a five-act tragedy where he played a villainous Duke Pescara.

On April 14, drama would be replaced with comedy. The theater was set to host a performance of *Our American Cousin*, an English satire about the introduction of a rustic, backwater American meeting his British relatives to claim a family estate. As he picked up his mail, Booth learned that the president would attend the show that evening with his wife and General Grant. Now was the perfect time to execute his conspiracy, Booth thought. He knew the ins and outs of the theater and all of its nooks and crannies. And, even better, he knew the lines to the play.

Assassinations weren't easy no matter how much prior planning or thought. Very few in world history had been pulled off. He had only eight hours to prepare.

That day, Booth was all over Washington. He went to a nearby livery stable to rent a horse. He went to Mary Surratt's boardinghouse at 541 H Street to deliver a package containing field glasses. Surratt, a widow and mother of Booth's friend, a Confederate agent, agreed to take the package to her tavern located south of the city in Surrattsville, Maryland, where he would pick it up later that night along with other supplies stashed there. He went to Herndon House, a boardinghouse, to meet with fellow conspirators Lewis Powell, David Herold, and George Atzerodt. The orders were plain: Powell would kill bedridden Secretary of State William Seward at his home. Atzerodt would kill

Vice President Andrew Johnson at Kirkwood House, a hotel where he was living. Herold would help Powell and guide him out of Washington to safety. They would all strike at ten o'clock.

The conspirators spent the day gathering knives and guns and other supplies. Others in Washington went about their daily business. That afternoon, Polkinhorn and Son, printers, situated close to Gardner's gallery, went to press with the playbill for the show at Ford's Theatre—a happy detour from its regular jobs. The busy Washington printing press had printed many of Gardner's famous photos of death and destruction. In September 1863, it published Brady's *Incidents of War* catalog.[3] It also printed the *Washington Daily Intelligencer.*

Gardner himself was in his studio at Seventh and D Streets, unpacking his delicate glass negatives from Richmond. They were the culmination of four years of covering the war through pictures. At his gallery, Gardner displayed hundreds of what he called "views of the war." Also on display were the many photos he had taken of Lincoln. The president was at Gardner's studio in February—the last time he had been with any photographer. The pictures weren't perfect. Lincoln looked old and haggard. The glass-plate negative of one cracked, scarring a line over the top of Lincoln's head. Now would be a great time to have the president come in and sit for him again.

Harry Clay Ford, who operated Ford's Theatre with his two brothers, was also thinking about Lincoln. He prepared the second-floor presidential box for Lincoln and Grant's planned visit. He had a partition removed to make for more room. The outer box he had decorated with red, white, and blue American flags and a portrait of George Washington.[4] Ford also prepared an advertisement to run in the evening newspapers. The papers came off the press about two o'clock. Ford's four-line ad read:

LIEUT. GENERAL GRANT, PRESIDENT
and Mrs. Lincoln have secured the State
Box at Ford's Theater TONIGHT, to witness Miss
Laura Keene's American Cousin.[5]

Ford hoped he'd have a full house. He would.

———◆———

THE PAPERS THAT day described the great illuminations of the night before in addition to more mundane business in Washington. News from Richmond updating readers on the destruction and transition to peace—something that included a national salute of two hundred guns fired at the town's square. Grant's return to Washington and his establishment of permanent headquarters in the city. And there was an update of ailing Secretary of State William Seward's health. Seward, who had been in a carriage accident, was in somewhat improved condition. Earlier that morning, he was able to sit up for a few hours for the first time since he was injured.[6]

The newspapers were on Booth's mind. Earlier that day, he wrote a letter to the *Washington National Intelligencer* and put it in a sealed envelope. It read:

> For a long time I have devoted my energies, my time and money, to the accomplishment of a certain end. I have been disappointed. The moment has arrived when I must change my plans. Many will blame me for what I am about to do, but posterity, I am sure, will justify me. Men who love their country better than gold and life.

He signed it with the names John W. Booth, Powell, Herold, and Atzerodt. Now they were all part of this, whether they liked it or not.

⸺•⸺

PRESIDENT LINCOLN SPENT his day mostly at the White House. He had breakfast with his family, took visitors, and read the daily newspapers. While Lincoln's wife made social preparations to see the play, Lincoln focused on an important meeting with his cabinet, which included a rare appearance from General Grant. They, of course, discussed various ideas for rebuilding the South. Then Lincoln asked Grant to describe the scene of Lee's surrender at the Appomattox Court House. Grant informed Lincoln that he could not make it to Ford's Theatre later that night. Lincoln would need another guest.

Later that day, Lincoln and his wife took a carriage ride in the fresh air, perfumed with lilacs and cherry blossoms. They headed to the Navy Yard, where one young man noted they had no mounted bodyguard with them. "It was because of the absence of any guard, perhaps, that my companion and I stopped and watched them pass,"

wrote Thomas S. Hopkins, who also noticed the changes in Lincoln's physical appearance. "The lines in the President's face had deepened and lengthened. Otherwise it was little changed. It had not hardened. Rather it had softened and mellowed as does the face of one who has come through great tribulation with faith undimmed. I turned to my companion and said: 'There is no other country in the civilized world where one may see the ruler of a great people riding on the streets with no guard or escort.'"[7]

Lincoln's security was, in fact, lax. William H. Crook, who had accompanied Lincoln to Richmond the week before, was in charge of presidential security. John Parker, another bodyguard, was set to relieve Crook at four o'clock—but he showed up three hours late. According to Crook, he accompanied Lincoln late that evening on a walk to the War Department, where they briefly met with Secretary Stanton. On the walk, Crook said Lincoln told him, "Crook, do you know I believe there are men who want to take my life? And I have no doubt they will do it." Crook said he asked Lincoln why he thought that. The president, he said, responded, "Other men have been assassinated." Then he added, "I have perfect confidence in those who are around me—in every one of your men. I know no one could do it and escape alive. But if it is to be done, it is impossible to prevent it."[8]

Crook's replacement eventually arrived at the White House. Parker, a former police officer who had a history of drinking on duty, would be entrusted with the president's safety for the rest of the night.

After dinner, Lincoln put on his black Brooks Brothers frock coat embroidered with a custom lining that read, "One Country, One Destiny." He slipped on a pair of white kid gloves over his skinny fingers and a beaver-skin top hat. He grabbed opera glasses and climbed into a carriage with his wife to attend the show. Lincoln was a fan of the theater, a habit that was the brunt of criticism from the rural, Protestant nation. Perhaps a nod to the president's melancholy thoughts: he often carried in his pocket a copy of Shakespeare's *Macbeth*.[9]

John Wilkes Booth, lurking in the darkness, would soon scribble a quote from the villain of the play in his diary. "'I must fight the course.' Tis all that's left me."[10]

Booth had once been featured in *Macbeth*—an event that led to his being stylized as the "gymnastic actor" because he jumped onto the

stage from a high rock. Lincoln and his party would soon see Booth's gymnastics up close.

The carriage clip-clopped into the misty night and stopped to pick up Lincoln's replacement guests, Major Henry Rathbone and Clara Harris, a daughter of Senator Ira Harris of New York.

At eight o'clock the curtains were raised, and *Our American Cousin* began. More than one thousand people filled Ford's Theatre's seats. Lincoln and his party arrived about thirty minutes late. When he entered the crimson presidential box, the play stopped and the orchestra struck up "Hail to the Chief." The president's lanky frame sank into a walnut rocking chair. The show continued.

During an intermission, Parker left Lincoln's watch and went to the next door Star Saloon for a drink. He never returned. The president of the United States was unprotected.

John Wilkes Booth monitored the play. He knew it down to the minute. The words and rhythms. The stagehand movements. The ebb and flow of laughter. He waited for the right time to strike. The moment when there would be one person onstage, enabling him to jump down and make his escape.

Booth left his horse with Ned Spangler, a carpenter and stagehand, outside the theater before he disappeared into the brick playhouse. He entered and crept up the theater's steps. William J. Ferguson, a restaurateur seated in the first-floor audience, couldn't help but gaze up at the presidential box. Just after ten o'clock he spotted Booth. "I saw Booth pass along near the box, and then stop, and lean against the wall. He stood there for a moment," Ferguson said.[11] Ferguson turned his attention back to the stage.

Harry Hawk, the lead actor, delivered his lines as Booth opened the door to the presidential box. The theater reverberated with Hawk's voice. "Don't know the manners of good society, eh? Well, I guess I know enough to turn you inside out, old gal . . ."

Booth raised his small .44-caliber Derringer pistol as Hawk delivered the punch line: "You sockdologizing old mantrap!" Booth pulled the trigger. The audience roared with laughter to the sharp crack of a pistol. A single shot tore through the left side of Lincoln's head and into his brain. The president's bearded head lurched forward, but he remained in his rocking chair. Booth didn't have time to fire another shot. He briefly wrestled with Rathbone before taking a knife

and slashing him in the left arm. Mary Lincoln screamed as Rathbone yelled, "Stop that man!"[12] The actor climbed the banister of the box and jumped down eleven feet to the stage. He raised his bloodstained knife with a flourish only a thespian could do.

The actor, honoring the moment, was said by some to utter the same words as Marcus Brutus upon killing Julius Caesar, the ruler of the Roman Republic. "As he struck on the stage, he rose and exclaimed, 'Sic semper tyrannis!' and ran right directly across the stage to the opposite door, where the actors come in," Ferguson remembered.

Booth fled into the darkness and headed for rural Maryland. While he would never return to Washington, his famous face would soon be plastered everywhere.

In his wake, the theater's stuffy air held the shouts of commotion. Soldiers rushed in. Their shiny bayonets glistened in the gaslight. People pushed and shoved one another, looking up at the presidential box. Something terrible had happened. But what? "There was a rush towards the President's box, when cries were heard—'Stand back and give him air!' 'Has anyone stimulants?'" the Associated Press reported. "On a hasty examination it was found that the President had been shot through the head above and back of the temporal bone, and that some of his brain was oozing out."

The chaotic scene was carried out into the streets. The feeling of celebration in Washington just a day before was replaced with dread and pandemonium. The *Baltimore Sun* labeled it a "great national calamity."[13]

Carl Bersch, an artist who once worked for Mathew Brady, stood on his balcony near Ford's Theatre with his easel and sketch paper and watched the chaotic scene unfold. "A loud cry came from a window of the theater, 'President Lincoln has been shot; clear the street,' soldiers and police attended to that," Bersch wrote in a letter describing the scene. "In the course of 10 or 15 minutes, out of the north door of the theater appeared a group of men, carrying the prostrate form of an injured man on an improvised stretcher. They stopped a few moments at the curb, hastily debating where to take the injured man to give him the best attention most quickly."[14] He continued, "I recognized the lengthy form of the President by the flickering light of the torches, and one large gas lamp post on the sidewalk. The tarrying at the curb and the slow, careful manner in which he was carried across the street, gave me ample time to make an accurate sketch of that particular scene."

Lincoln was carried across the street to Peterson House, a local boarding place owned by a German tailor. The president was placed in the room of a War Department clerk named William Clark. His long body was too big for the small bed.

Bersch's painting of the scene, titled *Lincoln Borne by Loving Hands*, is the only eyewitness visual reproduction of the event. Photographers weren't yet on the scene, but reporters were.

In the streets, rumors spit from the mouths of nearly every newspaper reporter. They were starting to talk of conspiracy. Was there a plan to cripple the Union that Lincoln so hoped he could put back together? Yes.

Moments before, Lewis Powell and David Herold were outside William Seward's handsome mansion near the White House, just as Booth carried out his attack on Lincoln. The Seward home was at Lafayette Square, an area with a haunted legacy. In 1859 Philip Barton Key, the son of "Star-Spangled Banner" writer Francis Scott Key, was fatally shot in the Lafayette Square park by the husband of his mistress. The story was a sensation in prewar Washington. Images of Key and his assailant, produced by Brady's Washington gallery, run by Gardner, were printed in the pages of *Harper's Weekly*. Powell and Herold, passing through the park, would soon be destined for those pages as well.

Powell entered the home while Herold waited outside to ferry him out of town. He climbed the creaky staircase to the third story, where the secretary of state was recovering. He told Seward's servants that he had medicine from a local doctor. He was allowed inside. In reality, he had a Whitney revolver and a silver bowie knife engraved with the words *The Hunter's Companion—Real Life Defender*. Powell used the revolver to pistol-whip Seward's son Frederick. He used the knife to attack Seward. He thrust the knife down several times, at one point hitting Seward's face. Family members raced about the house amid the ruckus. Powell fled, his knife thrashing at anyone in his way. He lost his hat at the crime scene. Powell ran into the street shouting, "I'm mad, I'm mad!"[15] Not only was he mad; he was abandoned. Herold, sensing that something had gone wrong, had gotten scared and left. Powell retrieved his horse and galloped away.

His work was unfinished. While his family initially thought he was dead, Seward survived the attack. He spit blood from his mouth and said, "I am not dead, send for a doctor, close the house."

Meanwhile, across Washington, George Atzerodt abandoned his task of murdering Vice President Johnson. He got drunk instead.

Secretary of War Edwin Stanton, who had just visited Seward earlier in the evening, returned to the house upon hearing the news, despite warnings that he too could be attacked. There talk turned to rumors that the president had been assassinated at Ford's Theatre. Stanton stepped out into the danger and headed to investigate. He would find his president unconscious and dying. The long gray-bearded Stanton had a long night ahead of him. He was now in charge of a manhunt.

Good Friday turned to Saturday. At one-thirty in the morning, Stanton sent a telegram to a military general: "This evening at about 9:30 P.M., at Ford's Theatre, the President, while sitting in the private box with Mrs. Lincoln, Mrs. Harris and Major Rathburn [sic], was shot by an assassin, who suddenly entered the box and approached behind the President. The assassin then leaped upon the stage brandishing a large dagger or knife, and made his escape in the rear of the theatre. The pistol ball entered the back of the President's head and penetrated nearly through the head. The wound is mortal."[16]

About an hour later, Stanton sent another, saying the president was still alive and that his investigation "strongly indicates J. Wilkes Booth as the assassin of the President. Whether it was the same or a different person that attempted to murder Mr. Seward remains in doubt."

At three o'clock in the morning, Stanton updated the president's condition, saying, "The President still breathes, but is quite insensible, as he has been ever since he was shot. He evidently did not see the person who shot him, but was looking on the stage as he approached behind."

Stanton's telegrams were picked up by newspapers across the country, which were rushing to print the sensational details of the unfolding case. The *New York Herald* printed seven editions between Friday and Saturday.

Lincoln lay dying, surrounded by friends and family. Dr. Anderson Abbott, a black Canadian physician, jotted notes as his breath began to weaken:

Six o'clock—Pulse failing; respiration twenty-eight
Half-past six—still failing and labored breathing
Seven o'clock—symptoms of immediate dissolution
Twenty-two minutes past seven—Death[17]

At that moment, twenty-two minutes past seven, Stanton looked at his dead president and said, "Now he belongs to the ages." He dashed off another telegram to tell the nation that Lincoln was gone.

———————◆———————

NORTHERN NEWSPAPERS WERE thrown into deep elegies read by pasty-faced readers. "The monstrous crime of Friday night shocked this city with an agony unutterable," wrote the *Philadelphia Inquirer*. "Yesterday morning men walked the streets, and looked into each other's eyes, and found no words willing to leave their lips. Their hearts were surcharged with grief and a wrath inexpressible."[18]

Not everyone was sad. After all, the nation had just fought a civil war. The *Demopolis (AL) Herald* headlined:

GLORIOUS NEWS.
Lincoln and Seward Assassinated!
LEE DEFEATS GRANT[19]

Lincoln's naked body was wrapped in an American flag and removed from Peterson House and taken to the White House. The boardinghouse bedroom where he had died was left untouched. The bloodstained bed sheets were still in place. Julius Ulke, a German immigrant boarder at the house, set up a camera and took a picture of the room just hours after Lincoln was gone. The quest for Lincoln iconography had begun. "Everybody has a great desire to obtain some memento from my room so that whoever comes in has to be closely watched for fear they will steal something," wrote William Clark, who slept under the same bedsheets thrown over the dying president.[20]

Clark had packed away the president's left-behind clothes, a lock of his hair—and even a portion of his brain. On Easter Sunday, he was visited by Albert Berghaus, a sketch artist for *Frank Leslie's Illustrated Newspaper*. Clark said he aided Berghaus in "making a correct drawing of the last moments of Mr. Lincoln, as I knew the position of every one present he succeeded in executing a fine sketch. . . . He intends, from this same drawing to have some fine large steel engravings executed. He also took a sketch of nearly every article in my room which will appear in their paper."

The war secretary couldn't worry about Lincoln assassination keepsakes or history scavengers. Stanton, known for his tenacity and

organizational skills, needed to find Lincoln's killer and anyone who aided him. Stanton needed skilled help. So after Lincoln died, he sent a telegram to Colonel Lafayette Curry Baker, a noted investigator in New York who took over the Union's intelligence after Allan Pinkerton. "Come here immediately and see if you can find the murderers of the President," Stanton wrote. Baker left at once.

Washington was a fortress city once again. Ford's Theatre was sealed off like a crime scene. Mounted patrols were dispatched in every direction. The electronic telegraph, which transformed the Union's war effort, tapped warnings across the land to prevent Booth's escape. It didn't work. Booth had slipped across the Potomac.

Investigators fanned out across the Washington area. Stanton had one immediate task. He needed pictures. The nation needed to know what Booth and his fellow conspirators looked like—and police needed them to help apprehend them. As Booth's conspiracy unraveled in Washington, Stanton sent investigators searching for visual images of the most wanted man in America.

Meanwhile, Mathew Brady was helpless. He was in Richmond, preparing to photograph Robert E. Lee when Lincoln was shot. The *Richmond Whig* said the assassination was the "heaviest blow which has fallen on the people of the south." There was no way he could get to Washington in time to experience the frenzy and the ensuing chase for history. Brady left Richmond on the day Lincoln died.

Gardner was firmly ensconced in his studio. Photographers and sketch artists knew there would be heavy demand for anything related to Lincoln and the chase for his killers. The illustrated weeklies would pay top dollar for engravings, and perhaps they'd make history. Platoons of them prepared to scurry at a moment's notice.

The talk of conspiracy meant there would be a sprawling terrain to cover. Gardner, with his previous work with the Army of the Potomac and the Secret Service, was in the perfect position for the unfolding story. With Brady exiled in Virginia, he had a head start to capture the story of the century. Perhaps he would have it all to himself.

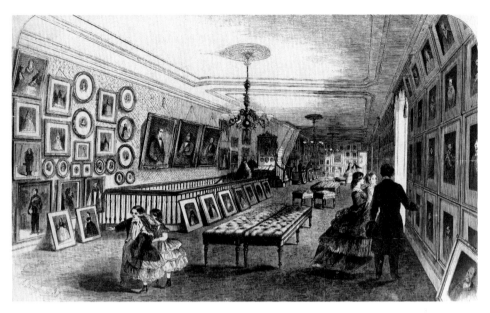

Illustration of the interior of Mathew Brady's lavish New York gallery at Broadway and Tenth Street as shown in *Frank Leslie's Illustrated Newspaper*, January 5, 1861.

Swedish opera singer Jenny Lind appeared in New York as part of a great P. T. Barnum spectacle in 1850. She posed at Mathew Brady's studio, adding to the photographer's growing fame.

All photographs in this section are from the Library of Congress, unless otherwise indicated. The images are shown in their original state, untouched and uncropped.

Mathew Brady in his Washington studio after returning from the first Battle of Bull Run, July 22, 1861.

Mathew Brady directing shots of visiting Japanese at the Willard Hotel in Washington. Sketched by *Frank Leslie's Illustrated News* artists in 1860.

HARPER'S WEEKLY.

A JOURNAL OF CIVILIZATION.

Vol. IV.—No. 202.] NEW YORK, SATURDAY, NOVEMBER 10, 1860. [Price Five Cents.

Entered according to Act of Congress, in the Year 1860, by Harper & Brothers, in the Clerk's Office of the District Court for the Southern District of New York.

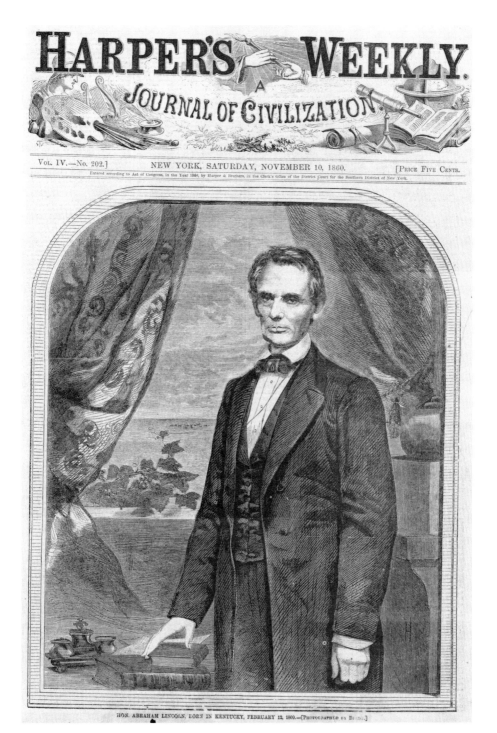

HON. ABRAHAM LINCOLN, BORN IN KENTUCKY, FEBRUARY 12, 1809.—[Photographed by Brady.]

Engraving of Brady image of Abraham Lincoln on the cover of the November 10, 1860, issue of *Harper's Weekly*. Brady, who said Lincoln told him the photo made him president, took the image during Lincoln's visit to Cooper Union in New York when most made fun of his prairie-lawyer appearance.

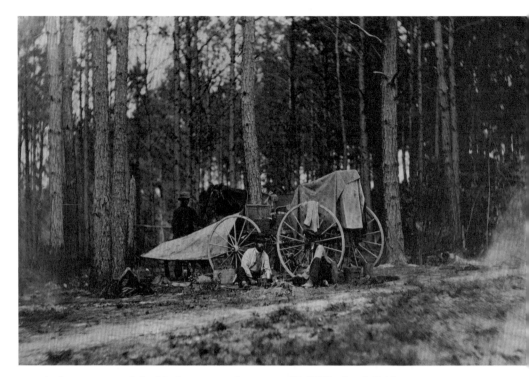

A photo wagon of the kind commonplace near Civil War battlefields.

The *New York Herald*, much like Brady, sent teams of reporters into the field. Here is their wagon photographed during the war by Gardner.

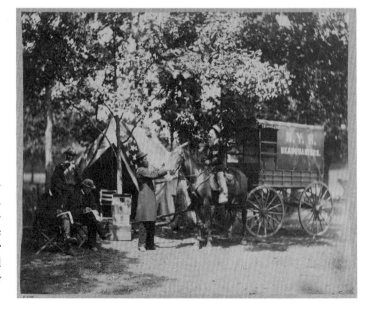

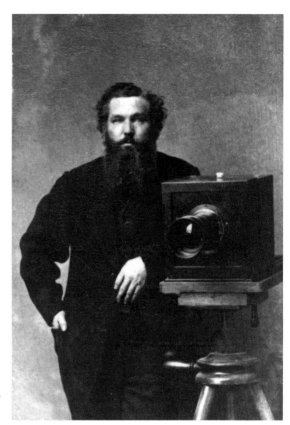

An undated photo of Alexander Gardner with his camera. *National Archives.*

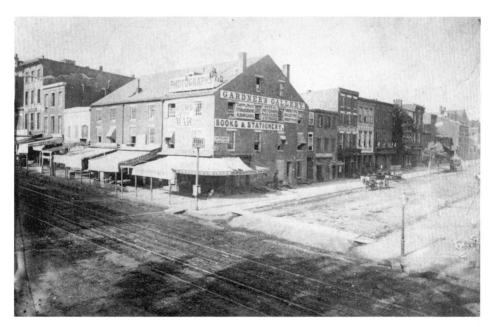

Alexander Gardner's Photographic Gallery, Seventh and D Streets, NW, Washington, DC, circa 1863, shortly after he broke away from Brady.

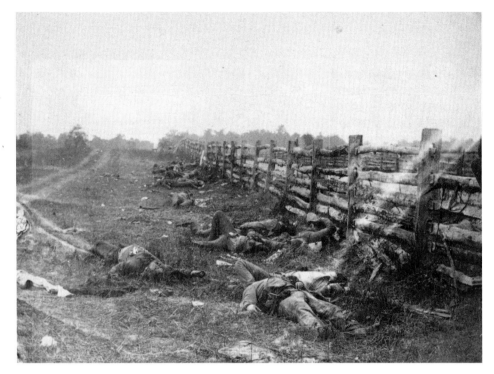

Alexander Gardner's photo of dead Confederate soldiers by a fence on the Hagerstown Road, on September 19, 1862, after the Battle of Antietam. Brady displayed the image at his New York gallery as part of a series called "The Dead of Antietam." The *New York Times* gave Brady full credit, saying he had brought home the "terrible reality" of war.

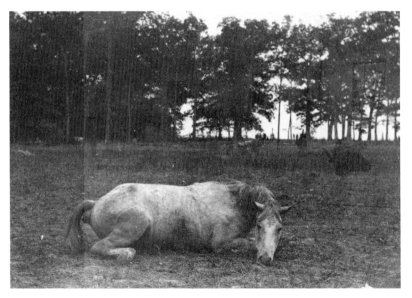

Gardner, while taking photos after the Battle of Antietam in September 1862, captured a picture of a Confederate's dead horse. Many remarked on the incredibly lifelike horse spotted in the battle's aftermath.

Lincoln, as viewed by Gardner, at General George McClellan's tent headquarters in Maryland, following the Battle of Antietam.

Lincoln photographed by Gardner in Maryland on October 3, 1862, after the Battle of Antietam. Lincoln is flanked by Allan Pinkerton *(left)* and Major General John A. McClernand *(right)*. The president wanted to be seen victorious on the front and showcased Antietam as a major victory, even though it wasn't.

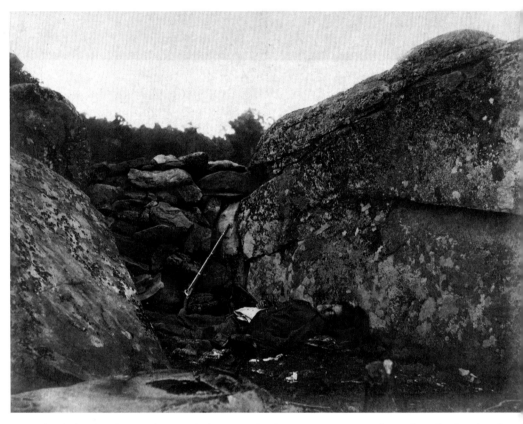

Alexander Gardner's photo titled *Home of a Rebel Sharpshooter*, taken after the Battle of Gettysburg in July 1863. Gardner moved the body and staged the photograph for optimum effect.

Lincoln's head shot photographed by Gardner in 1863. Many consider it the best, most powerful likeness of the president. It became a major influence for Daniel Chester French's statue of Lincoln at the Lincoln Memorial in Washington.

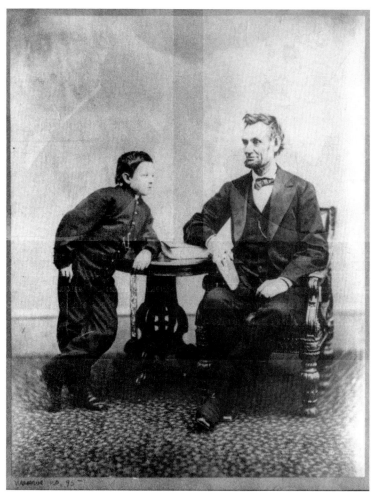

Lincoln pictured by Gardner with his young son Tad on February 5, 1865, two months before his death. The photo was in emulation of a Brady studio photo showing Lincoln and son.

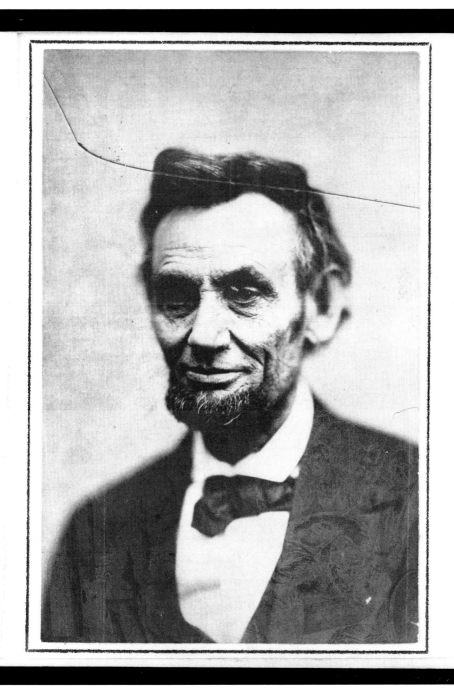

Lincoln photographed on February 5, 1865. The glass plate cracked during development, creating the line over Lincoln's head. The picture was branded by photographer Gardner as Lincoln's last before death.

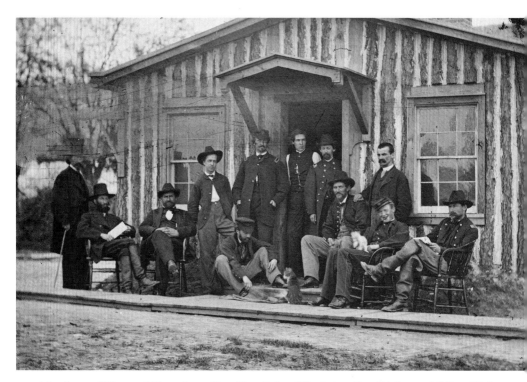

Members of General Grant's staff at City Point, Virginia, after Richmond fell to Union forces in April 1865. Mathew Brady, wearing a top hat, stands at far left.

Gardner showed up at the village of Appomattox Court House too late to photograph Lee's surrender to Grant, but he was able to capture the exterior of the house where it occurred. Pictured in April 1865 on the front steps is the family of Wilmer Mc-Lean, owner of the house.

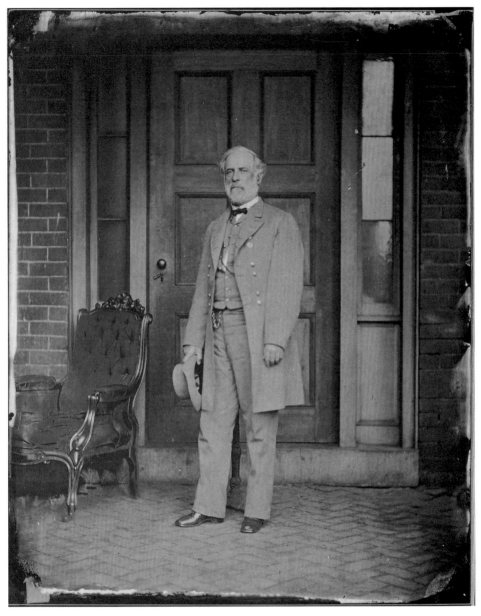

Mathew Brady portrait of General Robert E. Lee, taken on April 16, 1865, at Lee's house in Richmond after he surrendered to Union forces. Brady learned of Lincoln's death in Washington while pursuing the picture. *National Archives.*

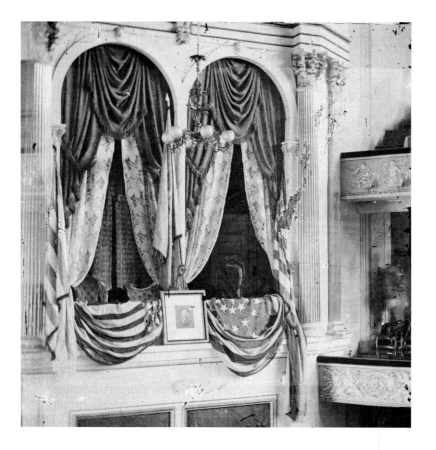

(above) Mathew Brady was still in Richmond when Lincoln was killed, but his camera operator was allowed into Ford's Theatre. Here is the presidential box where Lincoln was killed. The flags had been removed but were replaced in an effort to re-create the scene. A Union guard is pictured to the right, his blur creating a ghostly feel.

(right) Inside Ford's Theatre, Mathew Brady's assistant took photographs of important objects. Brady later released an image of the walnut chair where Lincoln sat when assassinated.

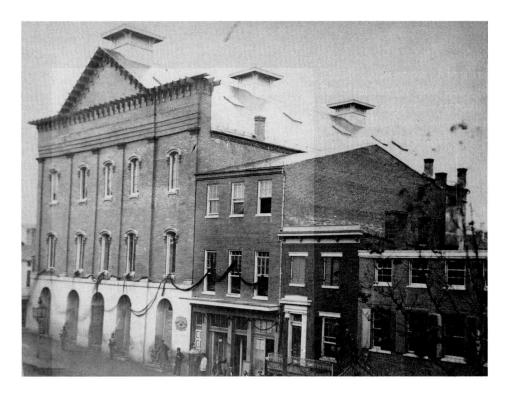

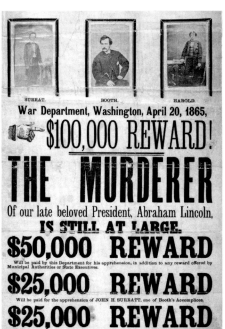

(above) Alexander Gardner raced to Ford's Theatre after Lincoln's assassination. Black lace is draped across its brick facade.

(left) "Wanted" poster printed throughout the nation following Lincoln's assassination by John Wilkes Booth. During the hunt for the conspirators, Alexander Gardner made copies of photographs for the posters. Such posters became common throughout the West in the decades to follow.

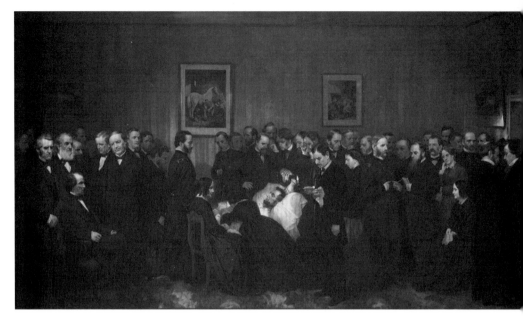

The Last Hours of Lincoln. Designed by graphic historian John B. Bachelder and painted by Alonzo Chappel based on photographs taken by Mathew Brady following Lincoln's death. The ambitious collaborative painting was released in 1868. *Chicago History Museum.*

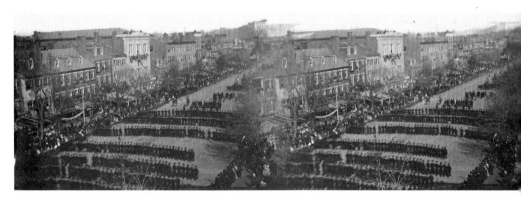

Lincoln's funeral procession on Pennsylvania Avenue, photographed by Brady's studio on April 19, 1865.

8

The Crime Scene

— April 15, 1865 —

FORD'S THEATRE WAS dressed in mourning. A day before, the theater held the hardy laughs and the heavy screams of a comedy turned tragedy when an assassin's bullet struck President Lincoln's head during a lighthearted show. Overnight, it morphed from playhouse to crime scene.

Alexander Gardner stood on the hushed corner across the street and pointed his wooden box camera at the three-story brick facade. He removed the lens cap and created an image showing the theater's five arched doorways frowned with low-slung black muslin bunting. Guards were posted at the entryways. Men loitered in front of the attached Star Saloon, where Booth and Lincoln's bodyguard both slugged whiskey the night before. Now, nearly every Washingtonian needed a drink to dull the sordid news—but they couldn't get one. The city's mayor had ordered all saloons and liquor stores closed until after Lincoln's funeral.[1]

Nearly all of Washington's theater's had gone silent. The Washington Theatre, Grover's New Theatre, and, of course, Ford's all announced performances were canceled until the "general grief" over Lincoln's death subsided.[2] Some wondered if Ford's would ever hold an audience again.

In that somber, mournful mood, Gardner knew that the nation—North and South—wanted to see the place where Lincoln was assassinated. Lincoln was the country's first president to have been killed in office. But there was also a global audience. The war had heightened

Lincoln's international stature, and his death would surely extend it. Political assassinations were rare in the annals of world history. Lincoln was now on the level of Julius Caesar, who was stabbed to death in 44 BC by a group of political conspirators. That event was immortalized in paintings showing Roman senators, wearing white loincloths, jabbing daggers into their leader's flesh. Photos, of course, didn't exist of its immediate aftermath.

Gardner's aim was to capture the people and places involved in Lincoln's death. He had to hurry. Photographers and illustrators were all over town, seeking to create images of the unfolding event. Any delay or miscalculation would prevent an artist from being first or exclusive—the ultimate judge of success.

Across America publishers raced to print their own immortal depictions of Lincoln's death—with reimagined views of the scene at Ford's Theatre. Philadelphia publisher Alfred Pharazyn worked on a fictive and brightly colored print illustration of Booth jumping onto the Ford's Theatre stage—dagger held high—as Lincoln stood in his presidential box, holding his hand to his head in agony. New York publisher Currier and Ives commissioned one with Booth standing behind Lincoln's head, holding a smoking gun. The *National Police Gazette*, an illustrated magazine known for graphic depictions of crime scenes, rushed to create a dramatic spread that would re-create several scenes of the conspiracy: Lincoln's assassination, his deathbed scene, and Lewis Powell's attack on William Seward.[3]

Gardner had his own idea on how to memorialize—and monetize—Lincoln's death, but right now his task was to show the crime scene up close. In reality, not imagination. But would the government, deep into a manhunt, let him? Of course they would. War secretary Edwin Stanton wanted Gardner to photograph the interior of the presidential box where Lincoln was shot. The pictures would be useful at trial if he ever caught the man who killed the president. A photographer for Mathew Brady, who was still in Richmond, was also allowed inside the theater.[4]

Crime-scene photography was not common in 1865. But Gardner's experience on the battlefield certainly aided him in taking pictures of complicated and grave scenery. The Germans had largely begun using photography in the courtroom. Images were used to record the faces of the recently arrested in case they escaped, bodies how they were

when they died so police could investigate murder or foul play, and reproductions of articles and objects found at crime scenes. American photographers like Gardner, caught up in war, were new to it.

On his quest, Gardner was guided by James J. Gifford, the theater's chief carpenter, who helped build the place. Gifford was a Southern sympathizer and friend of Booth's, like many of the other workers at Ford's Theatre. "He had such a winning way, that it made every person like him," Gifford said of Booth. "He was a good-natured and jovial kind of man. The people about the house, as far as I knew, all liked him."[5]

Gardner had photographed Washington's landmarks from the Post Office to the White House. Ford's Theatre was never that important. Until now. The theater stood square on Tenth Street. The site already had a gloomy history. The building stood on the spot that once housed the First Baptist Church. In 1861 John T. Ford and his brothers rented—and ultimately bought—the building and retrofitted it into a theater. The place burned to the ground within a year. The Fords rebuilt in 1863 and modeled it after the Holliday Street Theatre in Baltimore.

Shortly after reopening, the theater featured John Wilkes Booth as a star attraction in *The Lady of Lyons*. The five-act play began with Booth's voice echoing in the hall while reciting these lines: "A deep vale shut out by Alpine hills from the rude world; Near a clear lake, margined by fruits of gold and whispering myrtles, glossing softest skies as cloudless save with rare and roseate shadows, as I would have thy fate." The *Washington National Republican* wrote: "We feel warranted in saying that Ford's New Theatre will be the scene of more than usual brilliancy and beauty. . . . An excellent company, a comfortable and beautiful theatre."[6]

The theater was well known and well appointed. It was not Lincoln's favorite, but he visited it often. Enough so, the box perched just above the right-hand side of the house, facing the stage, was called "the President's box."[7] The box was one befitting a president. It had curtains of lace and satin, Turkish carpet, and velvet furniture that was brought in specially for Lincoln's visit.

Inside the theater, Gardner's camera faced the box, the place where the president was mortally wounded. He had one immediate problem. Gardner was tasked with photographing the theater just as it was when

Lincoln was shot. But in the aftermath, the decorative flags around the presidential box had already been removed. So Gardner did what he had done on the battlefield: he re-created the scene.

Gardner's adept re-creations were a departure from the true and honest labels given to his profession. The public had little idea that photographs were only slightly less imaginative than illustrations made by cartoonists. Most thought a black-and-white picture was the real thing, preserving events as they were and men and women as they actually looked. "Photography has generally been regarded as the most literal of graphic arts," the *Photographic News* opined at the time, "incapable of rendering anything but *facts* as they are, guiltless of anything like fancy, and antagonistic of imaginative art."[8]

Gifford helped him and returned the theater to how it looked on Good Friday. Or, at least, how he thought it looked. Right down to the flag tousled by John Wilkes Booth's boot on his jump to the stage. Some of the flags at the theater had already disappeared to either souvenir hunters or in the commotion of the night before. The men found replacement flags to fit their purpose. "I set a scene for a gentleman there to take a view for the Secretary of War," Gifford later testified. "At the time I left the theatre, the scene was set as it was the night of the assassination."[9]

This type of photography wasn't easy. The elements were against him, just like in Gettysburg or Antietam. Gardner needed light. The cavernous interior of a darkened theater, barely brightened by gas lamps and unreliable sunbeams filtering through small windows, was not the best place to produce a good picture. It required long exposures and a skilled hand.

From high up in the theater, Gardner made a shot facing down on the presidential box. Another straightforward shot showed the box with a guard standing off to the side. Because of the long exposure time, the guard's movement blurred his visage, creating an impression that the theater was already haunted. Gardner also shot various objects from the theater; the red-cushioned rocking chair where Lincoln sat was put on two stools. Brady's operator did the same.

Stanton arrived at the theater that day and ordered the chair to be taken to his private office. The war secretary was familiar with Gardner. In addition to allowing Gardner to tag along with the Army of the Potomac, Stanton, with his full stoic face and curly long beard, had

posed before Gardner's camera—like almost everyone else in Washington's power circles.

Stanton carefully examined the theater, from the stage to the passageways to the staircases. Photographs were produced showing the empty stage, with Lincoln's box looming above. The theater, filled with more than one thousand guests just hours before, seemed as empty as a graveyard.

Stanton then sought his own re-creation of the scene. He found actors who could deliver a private performance of *Our American Cousin*. This wasn't for show. It was for investigative purposes. The replay confirmed his suspicion. Lincoln's murder was carefully plotted by Booth to coincide with the movements and heavy laughter of the play. It wasn't a spur-of-the-moment attack.[10]

Booth and his conspirators were Stanton's focus that Saturday. He sent a letter to Charles Francis Adams, the U.S. ambassador to Great Britain and grandson of founding father John Adams. "The murderer of the President has been discovered, and evidence obtained that these horrible crimes were committed in execution of a conspiracy deliberately planned and set on foot by rebels, under pretense of avenging the South and aiding the rebel cause."

Outside the theater, Stanton's investigators had fanned in every direction, looking for Booth and anyone else connected to him. Earlier that night, investigators arrived at Mary Surratt's three-and-a-half-story boardinghouse in Washington. Surratt had delivered items for Booth to her Maryland tavern. A tipster reported that Booth was frequently seen at her house and was friendly with its inhabitants. Louis J. Weichmann, who boarded at the house and knew many of Booth's fellow conspirators, answered the door.

Weichmann was interviewed by James A. McDevitt, a detective with the Washington National Police. McDevitt was searching for Booth and Surratt's son. Weichmann became a voluntary police witness for McDevitt—and his best.[11] He would become particularly useful in identifying Booth's friends and conspirators, who were all wanted for questioning. Anyone who spotted Booth would benefit in turning him in. Stanton issued a ten-thousand-dollar reward in return for his capture.[12]

Little help was needed to identify Booth. Across America demand had grown for photos of Booth. Particularly among Southern

sympathizers or those just curious to get a glimpse of the man who killed the president. Still, there was patriotic pride. Owning a Booth photo was considered part treason. In Baltimore mobs of people forced photographers to remove photos of Booth from their studios. They said such displays were disloyal.[13]

Investigators ransacked Booth's room at the Washington National Hotel. There they found a trunk of papers and photos of the actor that could be used as an aid to identify his movements throughout Washington. Booth's photo wasn't a rarity. Many Americans kept photos of eminent actors like him. But photos of the other conspirators would be much harder to find.

———◆———

GARDNER FINISHED MAKING his pictures of Ford's Theatre—but he still had a lot to do. The photographer dashed across Washington, making photos of the symbolic places involved in Lincoln's assassination. He went to the United States Telegraph Company, the place where news of Lincoln's death tapped across electric lines to inform the nation, and photographed it. Men wearing hats huddled about on its steps in anticipation of more news. The festive flags and lanterns that adorned the front of the building the day before in celebration had been removed. Gardner also went to John C. Howard's livery stable, where Booth kept his horse as he plotted his conspiracy. And he went to the Navy Yard Bridge, where the night before Booth rode over rickety wooden planks, crossed the Anacostia River, and slipped into Maryland.[14] Guards there were shown photographs of Booth to positively identify him, although they didn't need them.

Besides Ford's, the bridge was an important location, showing the various missteps that aided Booth's murder and enabled his escape. The guards were not supposed to allow anyone to cross at night. But Booth talked himself across. Silas T. Cobb, a guard at the bridgehead, spoke with Booth sometime before eleven o'clock that night. Cobb said he asked him to identify himself. "My name is Booth," Cobb recalled the actor saying. "I asked him why he was out so late; if he did not know the rules, that persons were not allowed to pass after nine o'clock. He said it was new to him; that he had somewhere to go, and it was a dark night, and he thought he would have the moon. The moon rose that night about that time. I thought he was a proper person to pass, and

I passed him."[15] Minutes later, Cobb also allowed Booth accomplice David Herold to cross, although Herold had misidentified himself with the name of Smith.

By the time Gardner arrived at the bridge, Weichmann was with McDevitt at the house of David Herold, which stood near the Navy Yard, looking for photographs. "We searched Mr. Herold's house, and procured photographs; and Officer McDevitt also procured a photograph of Booth at that time," Weichmann said.[16]

John T. Holahan, another boarder at Mary Surratt's who traveled with Weichmann and McDevitt, found a photograph of John Surratt. Now authorities had photos of several key conspirators. The pictures would aid them on their hunt. They would need the help.

———•———

BOOTH AND HEROLD were deep into southern Maryland. After crossing the bridge, they first went to Mary Surratt's tavern and retrieved the field glasses stashed there. Then, early in the morning, they arrived at the house of Dr. Samuel Mudd, a physician who owned a tobacco farm once tended by slaves. Mudd set and splinted the actor's leg, which had been wounded on his jump onto the Ford's Theatre stage. He also gave him crutches.

Booth and Herald then headed toward the pine thickets and marshlands near the Potomac River, with a plan to cross into Virginia, a place Booth thought could give them safe refuge. Southern Maryland was strictly rural, with small farms dotting a swamp-like terrain. Summers were hot and humid, creating another challenge for Booth and his bum leg. Behind them, the countryside was swelling with detectives and Union officers. Some came out of duty to their country, others out of greed for reward money. Right then, everyone was looking for Booth and any whispered accomplice.

———•———

GARDNER RETURNED TO his studio and began preparations for his own moneymaking. A public thirst for Lincoln iconography had just begun, and his studio would play a critical role. Gardner had photographed the slain president more than anyone else. The president had an affinity for the Scottish photographer. Once, after a sitting on August 9, 1863, the president wrote to Gardner:

My Dear Sir

Allow me to return my sincere thanks for the cards and pictures which you have kindly sent me. I think they are generally very successful. The Imperial photograph in which the head leans upon the hand I regard as the best that I have yet seen.
 I am very truly
 Your Obt Sevt

A. Lincoln

That was the first time Lincoln visited Gardner's studio since he broke with Mathew Brady. The photo Lincoln so admired showed him sitting at a table. He looked dignified and young. His left hand held his head upright in deep thought. Now, all anyone could think about was Lincoln's head and the man that blasted the left side of his head with a bullet.

Tucked away in Gardner's studio, in the heart of where the Lincoln conspiracy was hatched, was the last photo he had taken of the president. It was done in February 1865. The picture showed the deep lines on Lincoln's cavernous face. And, of course, the line tracing over his head, caused by a crack in the glass-plate negative.

Soon, a Boston-based firm would commission lithographs based on the photo. And Gardner's printer, Philp & Solomons, would print and put up for sale copies of the actual picture with text reading: "From life by Gardner—Mr. Lincoln's last sitting." Within a few weeks, Gardner's photo would be advertised as "Photographs of President Lincoln. The Last Picture He Sat For."[17]

———◆———

ACROSS TOWN, LINCOLN'S body was in a room on the second floor of the White House. His autopsy was complete in the afternoon. Soon after, the blood was drained from the president's body, and he was embalmed.

Drs. Charles Brown and Harry Cattell performed the lurid procedure. Embalming, like photography and so many other things, had grown into big business during the war. Embalmers were constantly needed to prepare dead bodies and send them back home—often long distances. They advertised that bodies could "be kept in the most

perfect and natural preservation." Brown and Cattell used a European method that involved opening an artery, draining the blood, and replacing it with a chemical preservative. In fact, Brown had patented the procedure. "The Doctor claims to be able absolutely to arrest the process of dissolution," the *Chicago Tribune* reported. "He cannot restore a body to its life-like appearance before death, but he does claim to be able to preserve it in just the condition in which he receives it."

Brown and Cattell nicked Lincoln's jugular and drained it, before pumping an antiseptic solution that transformed the president into a marbleized state. Right there, Lincoln was morphing into the lionized stone-faced version of himself Americans would remember in the decades and centuries to come. "Brown informs our reporter that the body of the President will never know decay," the *Tribune* wrote. "After a time it will lose its marbleized appearance and become, to a certain extent, mummy-ized. It will not perceptibly change for several months."

Lincoln's body did change, however. The men shaved his face. They left behind the president's chin whiskers. His famous beard, now an icon in photographs being printed across the nation, was gone. The embalmers dressed Lincoln in the suit he wore to his second inauguration, massaged his frozen flesh with a slight smile, and shut his eyelids. The president was now ready for burial.

No picture was taken of Lincoln's autopsy or his embalming. Gardner, the man likely to have taken it, remained in his studio with his own unique chemicals. Not for embalming the president, but for memorializing his death. As the president's body was being prepared to be carried throughout northern cities, Gardner would be needed to re-create one more thing.

———— • ————

EASTER SUNDAY WAS devoted to Jesus Christ and Abraham Lincoln. Preachers in small churches and lofty cathedrals talked of the two martyrs—and the other great assassinations throughout history. In two short days, Lincoln, once derided, was now on a world pedestal like a plaster statue. "His glory and the love we bore him needed only martyrdom to make them sacred," said the Reverend Charles Carroll Everett.

When Caesar, the tyrant, fell, the people, who before had hated him, began almost to love him and to follow his murderers with

thoughts of vengeance. What idolizing love shall the death awaken
of him whom we thought we loved as much as possible before. Henry
the Fourth of France was assassinated, and ever after the people of
France spoke of him tenderly as the good King Henry. William the
Silent, the founder and the Father of the Dutch Republic, whose
history and character have all along seemed to have a strange and
beautiful resemblance to that of Mr. Lincoln, the same integrity, the
same modesty, the same quietness, the same immovable purpose, the
same devotion of his people.[18]

Gardner took his photo of Lincoln and began fitting it for a me-
morial card that could be sold as a keepsake. A fitting tribute for a man
being compared to emperors and kings. But those preparations were
interrupted by investigators in need of his help.

Colonel Lafayette Baker arrived from New York and assumed
control of the investigation. After conferring with Stanton, Baker im-
mediately got to work. The first thing he wanted was photographs.
"I could learn but little more than that John Wilkes Booth was the
supposed assassin and Harold [sic] was his accomplice," Baker wrote. "I
asked if any photographs of the supposed assassins, or descriptions of
their persons, had been secured or published. To my surprise, I learned
that nothing of the kind had been done; during the afternoon of Sun-
day, rumors were freely circulated throughout the city, connecting
John Surratt with the other assassins. I immediately secured pictures
of those mentioned above."

In reality, photos had been procured the day before. At Baker's re-
quest, investigators took them to Gardner's studio. Gardner was an
expert at copying existing photos for print. After all, years earlier he
gained notoriety for copying and printing counterfeit U.S. currency.
And he was adept at copying maps for Union troop movements and
espionage.

Gardner copied three separate photos of the men—Booth, Herold,
and Surratt. The pictures were arranged atop a "Wanted" poster. Booth
was in the middle, his delicate features and trim mustache leaning to-
ward the camera. Surratt's photo was to the left, showing the clean-
shaven Confederate agent wearing a frock coat. Herold was on the
right, with his right arm leaning on a table. His small stature made him
look like a little boy caught in the middle of something gone awry. The
poster included descriptions to go along with the photos. They read:

BOOTH is five feet 7 or 8 inches high, slender build, high fore-head, black hair, black eyes, and wears a heavy black moustache.

JOHN H. SURRAT [*sic*] is about 5 feet, 9 inches. Hair rather thin and dark; eyes rather light; no beard. Would weigh 145 or 150 pounds. Complexion rather pale and clear, with color in his cheeks. Wore light clothes of fine quality. Shoulders square; cheek bones rather prominent; chin narrow; ears projecting at the top; forehead rather low and square, but broad. Parts his hair on the right side; neck rather long. His lips are firmly set. A slim man.

DAVID C. HAROLD [*sic*] is five feet six inches high, hair dark, eyes dark, eyebrows rather heavy, full face, nose short, hand short and fleshy, feet small, instep high, round bodied, naturally quick and active, slightly closes his eyes when looking at a person.

The poster advertised a one-hundred-thousand-dollar reward: a fifty-thousand-dollar bounty for Booth and twenty-five-thousand-dollar bounties each for Surratt and Herold. It included a forceful message from Stanton: "All persons harboring or secreting the said persons, or either of them, or aiding or assisting their concealment or escape, will be treated as accomplices in the murder of the President and the attempted assassination of the Secretary of State, and shall be subject to trial before a Military Commission and the punishment of DEATH. Let the stain of innocent blood be removed from the land by the arrest and punishment of the murderers."[19]

The reward money enticed government officials, military soldiers, private investigators, journalists, and just about anyone else to join the hunt for Booth. It resulted in voluminous tips—most of them false. Neighbors turned on neighbors. Everything seemed suspicious. While Americans expected Lincoln's assassin to be caught within hours, it started to appear it would take days, if not forever.

Regardless of the outcome, Gardner's work had created the most famous "Wanted" poster in American history. He, like his competitors, just hoped he could be there when Booth was found—dead or alive.

The Funeral

— April 19, 1865 —

T HE STRONG SUN bathed the capital with beams of a springtime warmth—a perfect day for photographers. But one that could show only the coldness of Lincoln's unexpected death.

Five days had passed since the president's heart stopped beating, leaving Washington frozen in mourning. With the hunt for Lincoln's assassin ongoing, it was finally time to say good-bye to the sixteenth president. His body was dressed, the final silver tacks were nailed into his coffin, and the people came in droves. Up and down Pennsylvania Avenue, the city prepared for Lincoln's funeral procession to the Capitol. A procession that would pass a stretch of "Photographers' Row," eventually boarding a train in a weeks-long excursion through America back to Illinois.

In that milieu, few could imagine the death of a president as a work of art—except for Mathew Brady. Brady was late to the epic assassination of Lincoln. He arrived back in Washington from Richmond after his rival, Alexander Gardner, had already dug in to get the best shots—and long after the president gasped his last breath.

Brady's slowness to Richmond had enabled him to snag a portrait of a defeated General Robert E. Lee. And then his team of photographers lurked about, waiting to photograph anyone whose image would sell. "The arts of war triumphed first—those of peace afterwards," the *Richmond Whig* noted. "So with all the great Generals and officers taken by General Grant. No sooner are they at liberty upon parole than the lying-in-wait photographer rushes upon them, and with one

shot from his camera folds them up in his portfolio—taken again. Such is the fate of notoriety."[1]

Now, the lying-in-wait photographers were focused on Washington. Lincoln's death had quickly transformed the president into a Christlike martyr—meaning few in the North would care about Brady's image of Lee or Grant or the ruins of Richmond. Instead, Americans wanted photos of Lincoln and the man who killed him—Booth. Or anything else attached to the horrific event.

The news of Lincoln's death wasn't reported in Richmond until two days after Lincoln died. And its reporting showed just how much things had changed in the country. The *Whig* said, "That a state of war, almost fratricidal, should give rise to bitter feelings and bloody deeds in the field was to be expected, but that the assassin's knife and bullet should follow the great and best loved of the nation in their daily walks and reach them when surrounded by their friends, is an atrocity which will shock and appalls every honorable man and woman in the land."[2] That coming from a newspaper planted in the heart of the Confederacy.

Brady, a master at getting press, left Richmond when he heard the news. The *Whig* noted his departure, saying Brady and his photographic corps would "return to the North with the fruits of their tour."[3] In reality, he returned to a Washington ready to say good-bye to its president.

Everyone was looking to take advantage of Lincoln's death, from embalmers to photographers to artists to private investigators. Sure, Brady was late, but it could have been worse. Detective Allan Pinkerton was in New Orleans when Lincoln died. He didn't get the news until the morning of Lincoln's funeral. He sent a letter asking for work. "This morning's papers contain the deplorable intelligence of the assassination of President Lincoln and Secretary Seward," Pinkerton wrote to Stanton. "Under the providence of God, in February, 1861, I was enabled to save him from the fate he has now met. How I regret that I had not been near him previous to this fatal act. I might have been the means to arrest it. If I can be of any service please let me know."[4] Pinkerton thwarted an assassination attempt on Lincoln's train ride from Illinois to his first inauguration. Four years later, a train would hold his heavy coffin and carry him back along the same route.

On April 19, formal business stopped in Washington in honor of Lincoln's funeral. Even the newspapers didn't go to press. About the only work being done involved preparations for the grand ceremony or the investigation into the conspiracy surrounding Lincoln's death. For the latter, Brady was late but thought he could catch up to rival Gardner and make some excellent shots, like he had in the past.

The conspiracy was a live, unfolding event. It wasn't like showing up at a cornfield after a battle had already taken place. This photography required skill and patience and information. It required connections to government sources and energy to dash off at a moment's notice. It required being in the right place at the right time.

While Gardner was out taking pictures of the scenes surrounding Lincoln's death and the hunt for those who conspired to kill him, Brady's focus was on art. In that, he would team with Massachusetts artist-historian John B. Bachelder.

Bachelder was foremost a mapmaker and designer. His projects were carefully crafted and deliberate. Most of all, they were complicated and infused with history. Bachelder went to Gettysburg about a week after the final battle (about the same time as Brady). There he studied the terrain and interviewed surviving soldiers about the important landmarks of battle. He didn't care about pictures of the dead. His aim was to reproduce the Battle of Gettysburg through a colorful bird's-eye-view map, pinpointing troop movements, scenery, hills, and the important moments of struggle. The sprawling map showed where important officers were wounded—or where they died. It had a strange three-dimensional effect, bringing to life the bloody days in the small Pennsylvania town. It was a conquest of graphic design.

Bachelder's map earned immediate praise as a breakthrough in educational understanding of war. "Your personal explorations, and your inquiries of all the commissioned officers in command of the Union Army, and of the Confederate officers made prisoners, have furnished you means of information not possessed, I imagine, by any other person, . . . " said former secretary of state Edward Everett. "I may add that the engraving is beautifully executed and colored." Major General Winfield Scott Hancock, who was wounded at the battle, simply said, "The drawing is most beautiful, more so than I expected to find it." Former Union general George McClellan said, "I can say that it has given me a much clearer idea of the battle that I had before, and

I earnestly hope that you will find it convenient to illustrate others of our great battles in the same manner."[5]

Bachelder's focus was now on the next big thing. Not a thousands-dead battle, but a singular death. Bachelder reached Washington the day Lincoln died and immediately began work. In the hours after the assassination, Bachelder hatched an ambitious plan. He would create one large "epic representation" image of Lincoln's death scene with the president surrounded by forty-six people who visited him in his last hours. It would be a lifelike version of Jacques Louis David's *Death of Socrates* or Benjamin West's *The Death of General Wolfe*.

The idea was pure fiction, for sure. The room where Lincoln died was so small, it could hold a fraction of the forty-six souls. It was implausible that they ever crowded the room at the same time. But the goal was not accuracy; it was commemoration and understanding.

Bachelder enlisted Brady to help. The process was clear-cut. Bachelder would identify the people who visited Lincoln, consider their relationship to the president, and sketch a rough design for where they stood—and what they were doing—when Lincoln died. The selected people would then visit Brady's gallery and pose for photographs in specific positions. The pictures would then be handed to New York artist Alonzo Chappel to create a color painting that could be made into an engraving for sale. It was a perfect collaboration for Brady with a portrait artist he admired. Chappel had painted colorful portraits of Revolutionary War heroes and scenes. Later, he did the same during the Civil War, often working from photos posed by Brady and his camera operators.[6] It was the collision of art and photography that Brady aspired to and far from the collision of journalism and photography that Gardner desired.

———————

THE MUFFLED DRUMS tapped to the hoofbeats of a riderless horse. Outside Brady's studio on Pennsylvania Avenue, the sidewalks swelled with people as Lincoln's casket floated past. Heads were uncovered. Not a footstep or a voice could be heard. The casket was on a car built specially for the occasion by George R. Hall. He spent days hastily making the coffin that cost more than one thousand dollars. Over it was a canopy surmounted by a golden eagle. Evergreens and flowers were spread around the coffin. It was pulled by six white horses and followed by a procession of the government Lincoln had successfully saved.

The town was choked with people coming from small rural towns and other larger cities. Never mind that Lincoln's body would be placed on a train and travel throughout the rest of the country. Everyone wanted to see it for the first time. In Washington. The city where he lived and died. "Every house top thus early was freighted with spectators; and the trees bordering the avenue and the public grounds bore a perilously heavy burden of human beings," wrote one reporter.

Brady's operators posted on the rooftop of his studio. Photographing a moving procession wasn't easy, but the bright sun helped. The operators captured at least two pictures showing the single-file ranks of men marching behind Lincoln's body surrounded by the brick buildings decorated in black. The sides of the street contained women holding black umbrellas to shield the sun. The buildings were crowned with men and women on their rooftops and spilling out of nearly every window below.

But it was Alexander Gardner who got noticed. The procession flowed by Philp & Solomons, the company that printed Gardner's images for sale. In their window was a prominent display that attracted "much attention."[7] In one heavily draped window was Gardner's photo of Lincoln, labeled as the last photo he sat for. "It was a handsome photograph of the president and his little son," the *Washington National Republican* wrote. In the other window was another Gardner photograph: a colorized version of his portrait of Lincoln with trusted aides John Nicolay and John Hay.

The procession followed a funeral service in the East Room of the White House. Dr. Phineas D. Gurley, of the New York Avenue Presbyterian Church, presided over the services. "We admired and loved him on many account," Gurley said in eulogy. "For strong and various reasons: we admired his childlike simplicity, his freedom from guile and deceit, his staunch and sterling integrity, his kind and forgiving temper, his industry and patience, his persistent, self-sacrificing devotion to all the duties of his eminent position, from the least to the greatest; his readiness to hear and consider the cause of the poor and humble, the suffering and the oppressed."[8]

Photographers weren't allowed inside the East Room. Stanton didn't want any pictures taken of the dead president in his open coffin. So all images had to be done outside. The only memory of Lincoln lying in state would come from the fantastical sketch artists. Illustrator Thomas Nast created his own allegory for *Harper's Weekly*. He

showed Lady Liberty—otherwise known as Columbia—weeping at Lincoln's closed casket, her flowing gown and hair draped over the solid mahogany.[9]

Meanwhile, Washington was drowned in black ribbons. They were draped across nearly every building and animal and person. A streaming, waving elegy of paper.

Navy Secretary Gideon Welles was in the funeral procession that rolled down Pennsylvania Avenue. Because so many people were in it, he said Lincoln's casket reached the Capitol before he left the White House. "There were no truer mourners, where all were sad, than the poor colored people who crowded the streets, joined the procession, and exhibited their feelings and anxiety for the man whom they regarded as a benefactor and father," Welles wrote in his diary. "Women as well as men, with their little children, thronged the streets, trouble and stress depicted on their countenances and in their bearing. The vacant holiday expression had given way to real grief."[10] While Welles, a strong and early supporter of Lincoln, bore his own grief, his role with the military required his attention to other matters. Namely, the hunt for John Wilkes Booth.

False reports of Booth sightings bubbled from various corners. Engravings of Booth's picture had appeared in newspapers throughout the Northeast. In Baltimore a look-alike of Booth was arrested and held until it was proven he wasn't the assassin.

Booth's grand vanishing act played on the mind of Stanton. It was evident on the day of Lincoln's funeral. Welles said that Stanton was uneasy and "nervous and full of orders as usual."[11]

Stanton's investigation had some success to speak of. Two days before, with the trail of Booth and Herold cold, the war secretary's investigation led him to arrest several alleged conspirators. Police went to the boardinghouse of Mary Surratt late on April 17 to question anyone there and search the premises. More and more, the boardinghouse emerged as central to Booth's plot. Booth and others were known to visit the place, and Surratt's son John, nowhere to be found, was the actor's close confidant.

Surratt and her boarders were held inside the house during the interrogation. Then there was a knock at the door. Officers opened and stood face-to-face with a large man holding a pickax. It was Lewis Powell, the man who attacked the secretary of state. They didn't know that at first. Investigators thought John Surratt was Seward's attacker.

But Powell struggled to answer their questions, raising their bushy eyebrows with yet more questions. Powell unknowingly stumbled upon the police interrogation and sought to leave.

Powell told the men he had come to the house to dig a gutter. In response, the officers brought in Mary Surratt from the other room and asked her if she knew Powell. "Before God, sir, I do not know this man, and have never seen him, and I did not hire him to dig a gutter for me," Surratt answered.

Certainly, Powell fitted the description of the man who attacked Seward. He was arrested—along with Surratt and the others at the house—and later identified by a servant as the man who attacked the secretary of state.

Two days later, Lincoln's funeral procession passed by the mansion of Secretary Seward, who was still recovering from his wounds. "Seward, I am told, sat up in bed and viewed the procession and hearse of the president, and I know his emotion," Gideon Welles wrote.[12]

LINCOLN'S COFFIN WAS loaded onto a nine-car train and carried northward through the cities of America. In Washington residents remained transfixed with finding John Wilkes Booth. But the newspapers showed the beats of normal life. Advertisements announcing reward money ran alongside advertisements from residents searching for lost dogs, lost papers, lost prayer books.

The train stopped in Baltimore for a ceremony at the Merchant's Exchange Building. It went on to Harrisburg, where Lincoln's body was displayed inside the Pennsylvania Capitol. Then it was taken to Philadelphia, where Lincoln's body was shown at Independence Hall. On April 24, more than ten days after he was assassinated, Lincoln's casket was marched through New York City. The funeral procession went down Broadway, the famed cavernous street of theaters. Yet another studio of Mathew Brady's would see the funeral procession.

Brady's neighbor across the street drew scorn. While most theaters closed out of respect for Lincoln's mourning, P. T. Barnum kept his lecture hall open. "Whilst the city was humbled in prayer on one side of the street, Mr. Barnum's players were mouthing it on the other," the *New York Times* reported. "The various managers view the proceeding with disgust, and the public will look upon Mr. Barnum's greedy haste with the contempt it merits."[13]

Brady's camera operators were at work throughout the city. One of their photos rested on a large crowd on Broadway near Union Square. An open second-floor window showed a six-year-old boy and another young man looking out at the passing hearse. The six-year-old was Theodore Roosevelt. "That horrible man!" Roosevelt's wife said when authenticating the picture. "I was a little girl then and my governess took me to Grandfather Roosevelt's house on Broadway so I could watch the funeral procession. But as I looked down from the window and saw all the black drapings I became frightened and started to cry. Theodore and Elliott were both there. They didn't like my crying. They took me and locked me in a back room. I never did see Lincoln's funeral."[14]

Lincoln's body was put on display at New York's City Hall. Jeremiah Gurney was in the audience as the display was prepared. Other than Gardner, Gurney was one of Brady's fiercest and oldest competitors, dating back to the early 1850s. He was known as New York's photographer. Unlike Brady and his national celebrity ambitions, Gurney largely focused on the city's high society. Before the doors were opened and the public streamed by the casket, Brigadier General Edward D. Townsend allowed Gurney to set up his tripod and make a picture.[15] The picture showed part of Lincoln's face and chin whiskers in the open casket. Gurney had captured the only photo of Lincoln in death.

When news of the photo emerged, rival photographers were incensed. Especially Brady. And so was Mary Lincoln, the president's widow. Stanton sent a telegram to Townsend moments after he heard the news and just after Lincoln's funeral train left New York. "I see by the New York papers this evening that a photograph of the corpse . . . was allowed to be taken yesterday in New York," Stanton wrote. "I cannot sufficiently express my surprise and disapproval of such an act while the body was in your charge. You will report what officers of the funeral escort were or ought to have been on duty at the time this was done, and immediately relieve them. . . . You will also direct the provost marshal to go to the photographer, seize and destroy the plates and any pictures or engravings that may have been made, and consider yourself responsible if the offense is repeated."[16]

Townsend replied to Stanton, saying he regretted his disapproval. "It did not strike me as objectionable under the circumstances," Townsend said. He pleaded with Stanton to keep the plates. He said they would be valuable to history to show what thousands of Americans

saw and what "thousands could not see." Gurney also pleaded to keep them.

Stanton eased his approach and allowed Gurney to make one print. He took the print to Lincoln's eldest son, who thought it was in poor taste to have a picture of his father in a casket. Stanton telegraphed his officials and ordered the plates to be destroyed and any prints along with them. They were. The only surviving copy was the print in Stanton's hands. He saved it in his files.

G. T. Jenes, a rival photographer, wrote to the *Brooklyn Eagle*, outraged at the secretary's seizure. "I ask them to consider how much liberty is left to a nation when so flagrant an outrage on the rights of a citizen is passed, if not with commendation, at all events, in silence," Jenes wrote.[17]

Gurney's photo drew him the kind of attention Brady always lusted for. But it didn't bring any money. He was never allowed to sell or publish his most famous photo. Reports said that Brady himself intervened to have the photo shielded from the public. If Brady couldn't have the exclusive, no one could. An item in the *Photographic News* said Brady was motivated by a rivalry with Gurney. "Brady has always been under the especial protection of the War Department, having been given access to battle-fields, captured cities, and other places of interest, when other persons of the guild found it impossible to secure such a favour."[18]

<hr />

BACK IN WASHINGTON, Brady's focus remained on his fictionalized Lincoln-in-death scene. One by one, the famous faces of Lincoln's administration dropped by Brady's studio. Bachelder had arranged the visits and the poses. Promotional material said they all "cheerfully" gave their time. About the only person who didn't pose was Mary Lincoln. Bachelder designed the painting so her back would be to the audience, at the side of Lincoln's bed. Lincoln's son did go to Brady's studio, dropped his shoulders, and posed with his head down while holding a white handkerchief.

The finished product included forty-seven people, including the president. Across the room, Vice President Andrew Johnson was seated in a chair, watching the president die. Behind him were Gideon Welles and Major Rathbone, who was stabbed by Booth in the president's box. Off to the side was Stanton, conferring with officers on the hunt to find the killer. Doctors, assistants, and senators also crowded into the room.

Brady made the photos and sent them off to Chappel, who did the painting. It took years before it was ever displayed to the public. Bachelder titled it *The Last Hours of Lincoln*. "Perhaps no scene of like importance has received such care, in design, painting, and engraving," promotional materials said.[19]

It received praise and went on display in various parts of the country. But it didn't catch on like Bachelder or Brady would have hoped. Especially for all of their time and labor. It soon became forgotten— cluttered among the Lincoln-nostalgia noise.

It signified one thing. The thirst for paint on canvas was over. Americans wanted ink on paper.

———— ✦ ————

BY THE TIME Lincoln was killed, the photographic business was changing. The end of the Civil War meant fewer people were having their pictures taken. And the whole process was becoming cheaper. Now, not only the rich had their pictures taken. So did the poor. "There is a prevalent feeling amongst many professional photographers that the demand for portraiture is on the decline," said the *Photographic News*.[20] The journal talked about the business boom when the carte de visite was introduced. Something that was pioneered by Brady. "The rage for portraits of public characters set in, and emperors and murderers, princes and prizefighters, bishops and ballet-girls jostled each other in the miniature picture galleries; enterprising and skillful portraitists made reputations and fortunes," the journal stated. Now, there was little demand for buying small cards with pictures of generals and politicians. The battles were over. The public focused on getting on with their lives, not trading cards of famous faces.

Brady's fortune had risen greatly in the demand for cartes de visite. It also fell. He had poured his money into lavish studio spending and sending teams of photographers across battlefields with expensive cameras to document a long war.

Mounting debts forced Brady to sell a 50 percent stake in his Washington studio to photographer James Gibson on September 7, 1864, for ten thousand dollars. Gibson had left Brady to work for Gardner during the split of 1863. He returned to Brady as the Washington gallery manager and part owner.

In 1864 a credit reporting company, R. G. Dun, reported that Brady "is under heavy expenses & it is difficult to tell what he is really

worth." Brady also faced a series of lawsuits and judgments for failure to pay bills or wages to employees.

Anthony Berger, one of Brady's top operators, left his Washington studio that year and went to New York to start his own studio. Berger was Brady's finest talent since he lost Gardner. About all Brady had left in Washington was his famous name.

The May 6, 1865, issue of *Harper's Weekly* had an engraved photograph of Lincoln reading to his son on its front cover. The one taken by Berger when he was employed by Brady. It was labeled PRESIDENT LINCOLN AT HOME. And it included this citation: "Photographed by Brady." Later, after the print run, *Harper's* ran a correction, saying the image was "copied from the admirable photograph of Mr. A. Berger, 285 Fulton Street, Brooklyn."[21] Brady was facing competition from all sides—but still getting mistaken credit.

10

The Hunt for Booth

— April 26, 1865 —

THE MOST WANTED man in the world hobbled about a Virginia farm like a wounded animal. Detectives trailed behind. For days, thespian-turned-killer John Wilkes Booth and fellow fugitive David Herold had been stranded in the Maryland countryside as investigators fumbled to find them. Their escape from Washington turned into a survival story. One that would befit an adventure novel if the two men weren't loathed villains. For twelve days they had managed to evade capture, despite a hefty bounty on their heads and the eyes of the nation on their pictures.

Booth's picture—taken by Brady's studio, copied by Alexander Gardner, and thrown up on posters across the country—did not do him justice, observers said. George Alfred Townsend, a reporter covering the assassination and hunt, was an acquaintance of the famous actor. He called him one of the "best exponents of vital beauty I have ever met" and said his face was worthy of the Renaissance painters. Something missed in his picture. "By this I refer to physical beauty in the Medician sense—health, shapeliness, power in beautiful poise, and seemingly more powerful in repose than in energy," Townsend wrote.

His hands and feet were sizable, not small, and his legs were stout and muscular, but inclined to bow like his father's. From the waist up he was a perfect man; his chest being full and broad, his shoulders gently sloping, and his arms as white as alabaster, but hard as marble. Over these, upon a neck which was its proper column, rose the

cornice of a fine Doric face, spare at the jaws and not anywhere over-
ripe, but seamed with a nose of Roman model, the only relic of his
half-Jewish parentage, which gave decision to the thoughtfully stern
sweep of two direct, dark eyes, meaning to woman snare, and to man
a search warrant, while the lofty square forehead and square brows
were crowned with a weight of curling jetty hair, like a rich Corin-
thian capital. His profile was eagleish, and afar his countenance was
haughty.[1]

No wonder he had eluded capture for so long. The model of male
beauty now lived in broken sleep among the bugs and mud. He walked
on a crutch. His handsome skin coated with the dust of a man on the
run. His clothes stained with so much dirt and grime, they bore a re-
semblance to Confederate gray. His once trim mustache cut off with
scissors. His hair and face looked wild and haggard. "I can never re-
pent it, though we hated to kill," Booth scribbled in his diary. "Our
country owed all her troubles to him, and God simply made me the
instrument of his punishment. The country is not what it was. This
forced Union is not what I have loved. I care not what becomes of me.
I have no desire to outlive my country." Now Booth was unknowingly
headed for a showdown with another man who said his hand too was
an instrument of God.

Booth's southward flight to Virginia took him through the Zekiah
Swamp, the largest hardwood swamp in Maryland, packed with cop-
perheads and rattlesnakes. It was like an Old Testament nightmare.
"Even a hunted murderer would shrink from hiding there," Townsend
remarked. "Serpents and slimy lizards are the only denizens; some-
times the coon takes refuge in this desert from the hounds, and in
the soil mud a thousand odorous muskrats delve, with now and then a
tremorous otter. . . . The Shawnee, in his strong hold of despair in the
heart of Okeefeuokee, would scarcely have changed homes with Wil-
kes Booth and David Harold [sic], hiding in this inhuman country."[2]

Somehow Booth and Herold made it out alive—but they spent far
longer in Maryland than expected. The first time they attempted to
cross the Potomac River to Virginia, they got lost and ended back up
on the Maryland side of the river.

While they waited in Maryland, a Confederate mail agent named
Thomas Jones brought them ham, bread, and newspapers. The latter
of which infuriated Booth. The headlines showed he was not beloved

for killing the now-martyred president. Instead, they said he was the most hated man since Judas Iscariot. Not a flattering comparison in the Christian nation.

Meanwhile, illustrators applied their vivid imaginations to Booth's escape and exile. Francis Hacker created a scene with Booth riding on horseback through the woods with the Capitol looming in the background. A ghostly figure of Lincoln stood at a nearby tree. Its branches held tiny pictures of Lincoln's face, like blooming apples. John R. Walsh, in an illustration titled *The Assassin's Doom*, depicted a diminutive Booth walking through a surreal landscape with Lincoln's and Washington's faces carved into a steep valley. The ghosts of the past were watching—along with the living, breathing souls seeking to avenge the president's death.

The reward money brought false tips and leads. Booth was spotted in Philadelphia, Chicago, St. Louis, and everywhere in between. Some said he was seen wearing women's clothes or hidden away in secret passageways. Investigators felt obligated to follow the reports, as off base as they might have seemed. Booth was even spotted in London, where U.S. ambassador Charles Francis Adams sought an arrest warrant.[3]

Wild conspiracy theories bore black ink in American newspapers, speculating that Lincoln's death went far beyond Booth's band of conspirators. Some said it was fueled by former Confederate president Jefferson Davis, others attributed it to Vice President Andrew Johnson, and still others said it was a Catholic plot ordered by the Vatican. The various theories would spin for more than a century and a half.

It wasn't just detectives and bounty hunters who searched for Booth. Photographers like Gardner and Brady, along with reporters like Townsend, followed the twists and turns of the investigation for their own purposes. Mainly to be there when he was apprehended to take advantage of a national thirst for the story.

Booth knew he was being chased. And he knew the authorities were surrounding him. Before he crossed the river into Virginia, he wrote a stream-of-consciousness diary entry full of contempt: "After being hunted like a dog through swamps, woods, and last night being chased by gunboats till I was forced to return wet, cold, and starving, with every man's hand against me, I am here in despair Tonight I will once more try the river with the intent to cross. . . . Tonight I try to escape these bloodhounds once more."[4]

Booth and Herold eventually made it onto the northern neck of Virginia on April 24. Three Confederate soldiers helped them. The pair ambled about Caroline County, a rural tobacco farming swath south of the Rappahannock River, about midway between Washington and Richmond. Booth and Herold were taken to Locust Hill, a farm owned by Richard Garrett, about three miles south of Port Royal. The farm contained Garrett's plain two-story house surrounded by apple trees and wooded ravines. Nearby was a barn used to store and dry tobacco.[5] Booth, being a good actor, described himself as a wounded Confederate soldier in need of rest. The unsuspecting Garrett, whose son was a Confederate veteran, said Booth could stay in his barn.

Many Americans had Booth's picture in photo albums on their parlor tables alongside other famous faces. "After the assassination Northerners slid the Booth card out of their albums: some threw it away, some burned it, some crumpled it angrily," historian Dorothy Kunhardt wrote.[6] No such photo existed at Garrett's farmhouse. Otherwise, Garrett and his son would have recognized the wounded Confederate soldier sleeping at their house as John Wilkes Booth.

In Washington Colonel Lafayette C. Baker led the search for Booth and believed he had a promising lead. Forces had just arrested Dr. Samuel Mudd, the man who set Booth's broken leg. Baker read a telegram that indicated Booth had made it through the swamp beyond Mudd's farm and across the Potomac into Virginia. Baker summoned Lieutenant Edward P. Doherty. He got out a map and pointed to Port Conway, which stood directly across the Rappahannock from Port Royal, the exact point where Booth and Herold crossed before finding refuge a few miles away. "There, you may rest assured, you will find [Booth] within five miles. . . . [Y]ou will have a detail of cavalry, who will be strictly subordinate to your order. There must be no shooting, the villain must be captured at every hazard," Baker said. Baker gave Doherty the help of two of his detectives. Luther Byron Baker, his cousin, and Everton J. Conger. Baker also gave them freshly printed cartes de visite of Booth and Herold. They needed to be sure they had the right men.

Gardner, who had printed the photos of the wanted men, was following Baker's orders. But he did not go on the chase. He would be left to hope for a piece of the action after Booth was apprehended.

The assassin hunters left on a steamer named *John S. Ide* and floated south to Virginia. They marched through Caroline County,

where a tip led them to Garrett's farm. Booth and Herold were in their grasp.

That night Booth and Herold slept in Garrett's weather-beaten tobacco barn. Doherty and his men circled Garrett's house at about two o'clock in the morning. Conger posted a small guard near the barn. Old man Garrett came out of his kitchen door and asked, "What's this?" Lieutenant Luther Baker ordered him to light a candle.

Garrett followed the order and returned with the flickering light. Baker went into the house and caught Garrett by the shoulder. He held a pistol to his head. "I want to know where those two men are that were here this afternoon," Baker said. Garrett said he didn't know. "They are here and if you don't bring them out I'll blow your brains out," Luther Baker said. A nervous Garrett answered that the men had gone into the woods. Baker continued to press.

Garrett's son John entered the room, wearing a Confederate uniform. He looked at the old man and said, "Father, we had better tell them all." The younger Garrett pointed to the barn. That's where the wanted men were hiding.

The barn glowed in the moonlight. Its pocked surface projected the silhouettes of Union cavalry. They had surrounded it. A confrontation, like one on the emerging western frontier, ensued. Booth and Herold heard the familiar cadence of the cavalry and remained still.

They first attempted to slip away from the barn. "We went right up to the barn door and tried to get out," Herold would recall, "but found it was locked." Garrett had locked the men inside the barn, fearing they would steal his horses—or anything else on the property. Strangers were not trusted amid the rambling farms. Union, Confederate, or otherwise.

John Garrett was asked to unlock the barn and have Booth and Herold surrender their arms. Garrett objected. The men who killed a president would surely kill him, he thought. "They know you, and you can go in," Baker told him, before threatening to burn the whole property down.

John Garrett agreed to help. He had no choice. Baker shouted at the barn, ostensibly to Booth: "We are going to send this man, on whose premises you are, in to get your arms; and you must come out and deliver yourselves up."

Garrett turned the key and entered the dark space. Booth, still on crutches, hid in the shadows with his guns drawn. Booth's voice, which

once filled the finest theaters in America, echoed: "You have implicated me." The actor felt betrayed by a family he had just met. Garrett replied, "Gentlemen, the cavalry are after you. You are the ones. You had better give yourselves up."

The more than two-dozen-strong cavalry wanted Booth alive. There is no way he could outmatch them if he fired. But Stanton needed him for questioning. To delve deep into his conspiracy and successful plot to kill President Abraham Lincoln.

Booth couldn't hold his rage any longer. He rushed from the darkness and lunged toward Garrett. "Damn you!" Booth shouted. "You have betrayed me! If you don't get out of here I will shoot you! Get out of this barn at once!" The ex-Confederate soldier did just that. He could not talk Booth or his sidekick out of the barn. That job then fell to Baker.

Booth shouted through the wooden boards to the men outside: "Who are you? What do you want? Whom do you want?" Baker ignored his questions. "We want you to deliver up your arms and become our prisoners," he said.

Booth took a moment to consider. Baker shouted that he didn't come for a fight, then threatened to light fire to the barn. Investigators would smoke them out. "Well, then, my brave boys, prepare a stretcher for me," Booth said with an actor's bravado.

Booth and Herold then argued. Herold was ready to surrender. The tagalong hadn't actually killed the president or knifed the secretary of state. Surely, the men would set him free, he thought. He played no real role in the assassination other than standing in awe of a famous actor. He didn't grasp that America was not a forgiving nation. "There's a man inside who wants to surrender," Booth told the men. They agreed to take him if he surrendered his weapons.

After a back-and-forth, Herold was ordered to show his empty hands through the barn door. When he did so, Baker grabbed the man, handcuffed him, and gave him over to his cavalrymen. All while Herold pleaded his innocence. The plot to kill Abraham Lincoln had now unraveled inside a ramshackle country barn.

Now, it was just Booth still inside. The intensity grew. Daybreak was near—something that would enable Booth to better see the men surrounding the barn. Sergeant Boston Corbett stepped forward and offered to end it right then and there. He would enter the barn alone, he said. "I offered . . . to go into the barn and take him or fight

him—saying if he killed me his weapons would then be empty, and they could easily take him alive."

Corbett was an immigrant from England. His real name was John. Shortly after arriving in America, he was baptized as a Methodist in Boston. He took the city's name as his baptismal name in honor of the place "where he had received the blessing of the Divine Spirit."[7]

The press said he was simply a "roundhead" gone to seed. A roundhead being someone who fought against an absolute monarchy. He was a descendent of someone who fought for Oliver Cromwell—a man who led an insurrection against King Charles I and signed his death warrant.

Corbett fought for his new country. He even spent ten months in the grueling Confederate prison hell of Andersonville, where he escaped and was chased by a pack of bloodhounds. He hid and lay still. One dog rubbed against him but didn't bite. "The same power that kept the lions from tearing Daniel is the same in whom I trust," Corbett said.[8]

After the death of his wife in 1858, Corbett took a pair of scissors and cut off his own testicles. Afterward, he went to a prayer meeting and ate dinner.

The man was eccentric and prone to obsession. Especially with religion and firearms. Lincoln's death affected him greatly. "He believed himself to be divinely commissioned as an avenger of blood, and only wanted the opportunity to act as the minister of vengeance for the Almighty," one newspaper wrote.[9]

Corbett stood there as Baker and Conger agreed on their own strategy. They would light the barn on fire and force Booth to surrender. The barn's perimeter was quickly sprinkled with hay and twigs. Conger started a flame. "The blaze lit up the black recesses of the great barn till every wasp's nest and cobweb in the roof was luminous, flinging streaks of red and violet across the tumbled farm gear in the corner, plows, harrows, hoes, rakes, sugar-mills, and making every separate grain in the high bin adjacent gleam like a mote of precious gold," wrote reporter Townsend. "They tinged the beams, the upright columns, the barricades, where clover and timothy, piled high, held toward the hot incendiary their separate straws for the funeral pile. They bathed the murderer's retreat in a beautiful illumination, and while in bold outline his figure stood revealed, they rose like an impenetrable wall to guard from sight the hated enemy who lit them."[10]

Boston Corbett looked through a crevice of the burning barn and spotted Booth. Lincoln's assassin was now surrounded by uncontrolled flames set by his army. "I could see him, but he could not see me," Corbett said.

Corbett was known for the "marvelous accuracy" of his aim. He plunged his gun through a crack in the barn. Corbett said:

> Finding the fire gaining upon him, he turned to the other side of the barn, and got toward where the door was, and as he got there I saw him make a movement toward the door. I supposed he was going to fight his way out. One of the men, who was watching him, told me that he aimed the carbine at me. He was taking aim with the carbine, but at whom I could not say. My mind was upon him attentively to see that he did no harm, and when I became impressed that it was time I shot him. I took steady aim on my arm, and shot him through a large crack in the barn.

A single gunshot echoed through the barnyard. The bullet hit Booth in the neck. The famous actor, so keen on his feet, dropped to his knees. Booth remained immobile but alive. The men quickly retrieved his body from the burning barn and laid him outside to deliver aid. He was eventually moved to the front steps of the Garrett home in order to keep a distance from the inferno.

Baker was angry. He needed Booth alive. That was the order from Stanton. He didn't know which of his men fired the shot. But he would find out.

With reward money and honor on the line, they struggled to keep Booth breathing. "Kill me, kill me, kill me!" Booth said. The men said they would not. They emptied his pockets, which held a diary, money, keys, compass, and a knife. Booth bit into a rag doused with brandy. "Tell mother I died for my country," he said with labored breath. Booth died about four hours after he was shot. His last words were "Useless, useless."

There were no photographers present or photos taken of Booth's final moments. Or of that harrowing night. That itself would have been useless. It was too dark. But the news of Booth's death quickly coursed through the telegraph lines and barked from the mouths of newsboys. Gardner and Brady rushed to action.

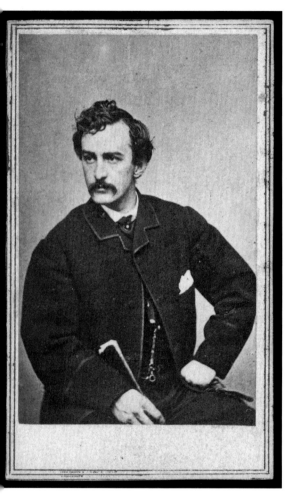

(left) Front of the John Wilkes Booth carte de visite copied by Alexander Gardner and distributed for sale after the assassination.

(right) Back of John Wilkes Booth carte de visite sold by Alexander Gardner.

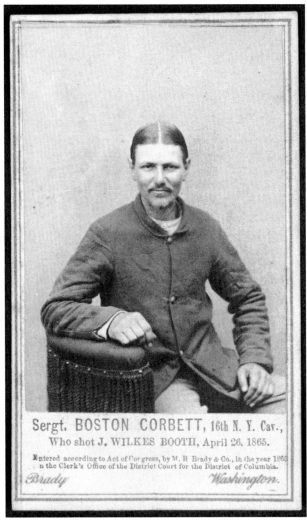

Sergt. BOSTON CORBETT, 16th N. Y. Cav.,
Who shot J. WILKES BOOTH, April 26, 1865.

Entered according to Act of Congress, by M. B Brady & Co., in the year 1865
n the Clerk's Office of the District Court for the District of Columbia.

Brady *Washington.*

Sergeant Boston Corbett, an eccentric religious fanatic, fired the shot that killed John Wilkes Booth on a Virginia farm. Corbett briefly became a hero. Brady got a photo shoot with him in April 1865 and sold his image as a carte de visite. While the photo had a wide sale, Brady didn't share any of the proceeds with Corbett.

David Herold, a cohort of Booth
photographed by Gardner.

David Herold.

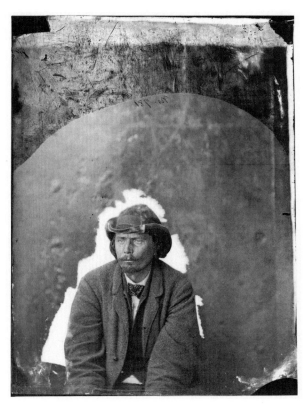

George Atzerodt, a fellow Lincoln conspirator who was ordered by Booth to kill Vice President Andrew Johnson, but instead had a drink at a hotel bar. Photographed in captivity by Gardner.

George Atzerodt.

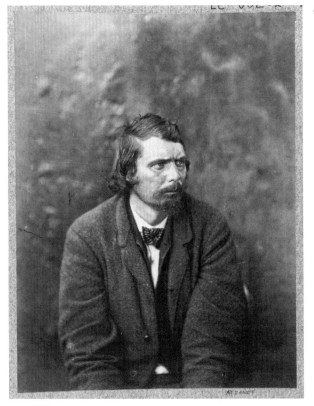

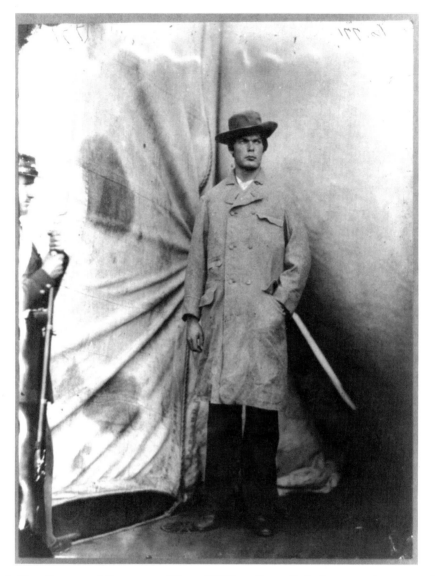

Lewis Powell stormed Secretary of State William Seward's bedroom and attempted to kill the ailing politician the night Booth struck Lincoln. Powell was photographed by Gardner in captivity while wearing the hat he wore, and dropped, at the crime scene.

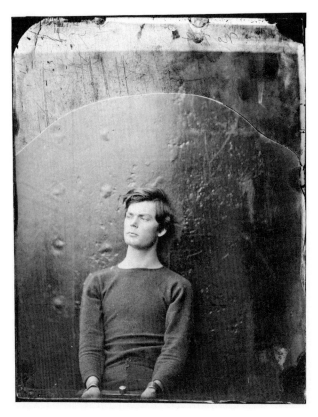

Lewis Powell photographed by Gardner in captivity. His head had been hooded nearly twenty-four hours a day.

Lewis Powell in captivity, seen wearing manacles. Photographed by Gardner.

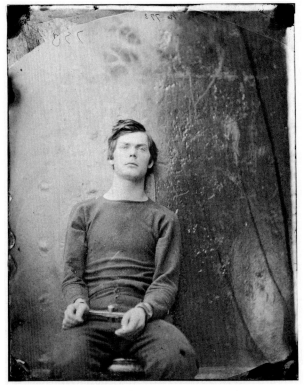

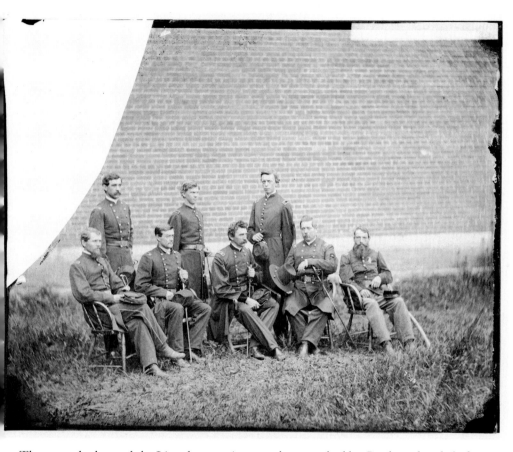

The men who hanged the Lincoln conspirators, photographed by Gardner shortly before Powell, Atzerodt, Herold, and Surratt were executed. From left: Captain R. A. Watts, Lieutenant Colonel George W. Frederick, Lieutenant Colonel William H. H. McCall, Lieutenant D. H. Geissinger, General Hartranft, Assistant Surgeon George L. Porter, Colonel L. A. Dodd, and Captain Christian Rath.

Alexander Gardner was the only photographer allowed into the Washington Arsenal to make photographs of the four condemned Lincoln conspirators, Atzerodt, Herold, Powell, and Surratt. He planned and executed a complicated multicamera shoot, creating a series of images that when put together appear to add motion, showing viewers how the hooded conspirators looked when dropped to their deaths. Pictured here is the empty scaffold, moments before the execution on July 7, 1865.

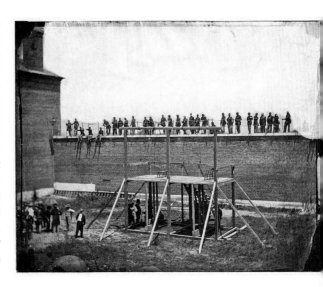

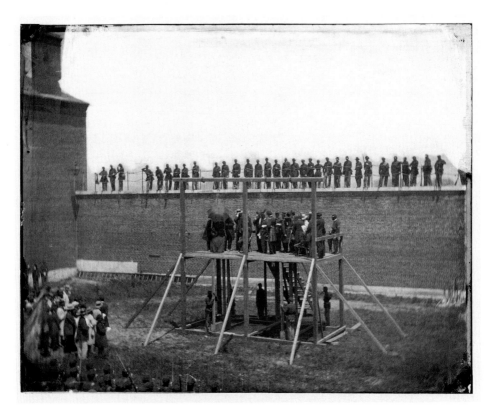

Captain Christian Rath ushers the conspirators to the scaffold and prepares them to die. All are seated except for David Herold.

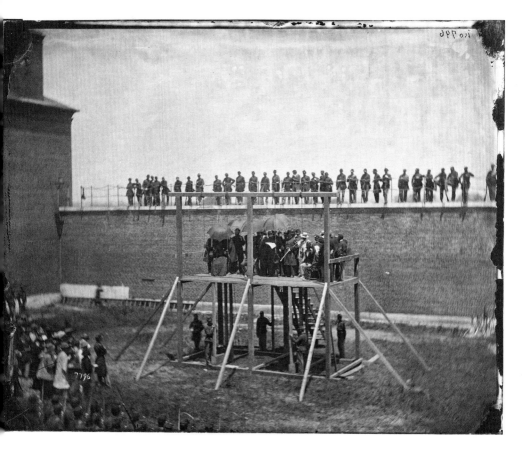

General Hartranft reads the order of execution as umbrellas shield the sun on a one-hundred-degree day. Nooses hang before them.

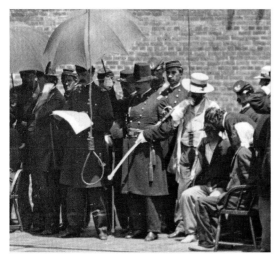

A close-up of Hartranft reading the execution order.

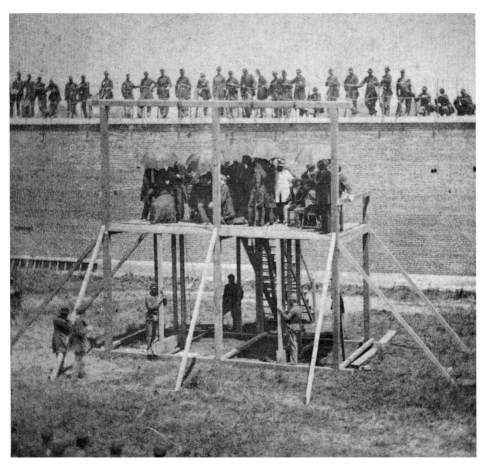

Ministers pray for the conspirators in their final moments of life. One kneels by Lewis Powell, seated second from left.

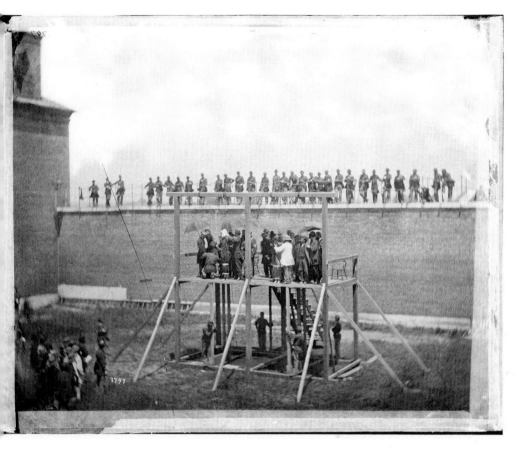

Hoods are placed on the conspirators' heads, and the ropes are adjusted around their necks.

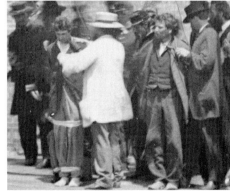

Close-up showing prisoners David Herold (*left*) and George Atzerodt (*right*) being fitted with the hangman's noose.

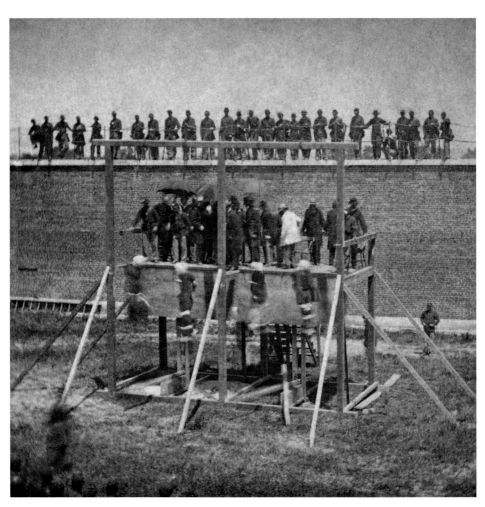

The bodies are dropped. Gardner's camera catches the conspirators just as their bodies sway in the sun. The movement creates a blur.

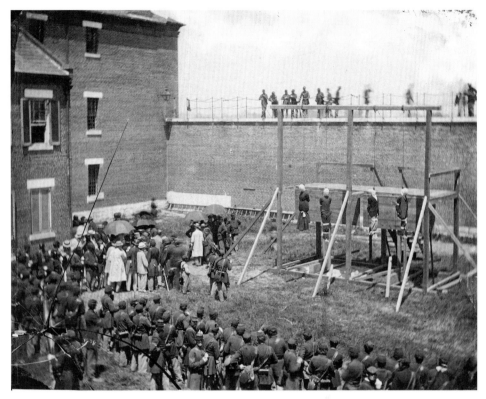

(above) The bodies remain dangling from the scaffold as the crowd departs.

(below) Close-up of the hanging.

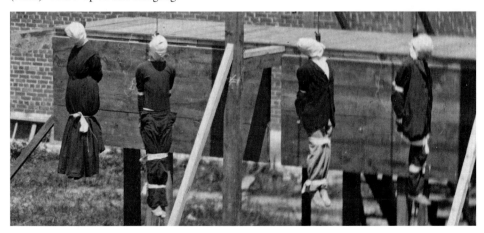

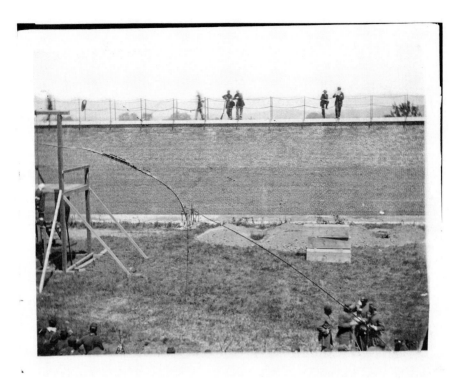

Open graves and coffins sit just beyond the scaffold as the conspirators hang.

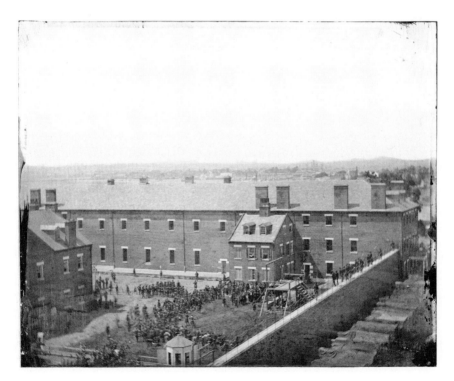

Rooftop view looking down on the hanging conspirators.

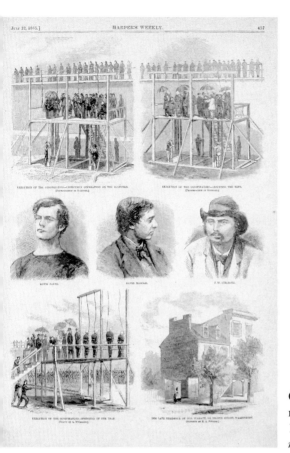

Gardner's execution photos were rushed to engravers for the July 22, 1865, issue of *Harper's Weekly*. *Internet Archive.*

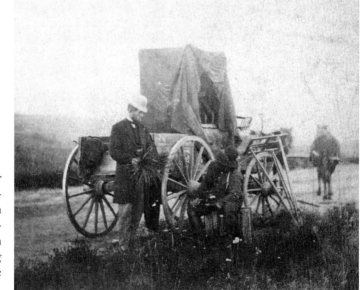

Alexander Gardner (center) and his photographic wagon in 1867. The photographer traveled west in the years following the war to capture the frontier.

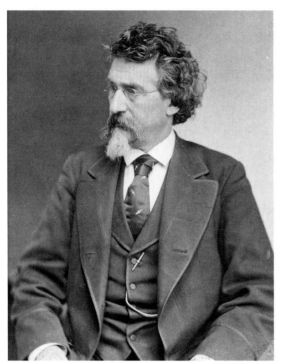

(left) Brady, beset with financial problem
following the Civil War, takes time for
portrait in 1875.

(below) Brady's photo archives and gla
plates withered in the years after the wa
The crumbling pictures in 1954 are stacke
(left) at his relative's L. C. Handy Studio
Washington. His old camera is under a clot
(right).

Illustrators re-created the scene everyone wanted to see. But it wasn't real. Francis Hacker, who created the carte de visite of Booth traveling through the forest haunted by Lincoln's ghost, created a fresh image of Booth wavering in a burning barn, surrounded by men in blue. Alfred Waud sketched a more lifelike version of Booth holding a carbine rifle.

Yet again, Gardner did his own re-creation. Colonel Lafayette Baker arrived at his studio along with his cousin Luther Baker and Conger—the two men who were there when Booth died. Gardner made a shot of the three bearded men poring over a map. Lafayette Baker points to the spot—as he had done days before—on the map where Booth could be found. Gardner titled the image *Col. L. C. Baker Planning the Capture of Booth*. He sold the image to *Harper's Weekly*, which engraved it for print. And, of course, his printer made cartes de visite of the image for sale. But it was another image of Gardner's that would be talked about and debated in the decades to come.

———— • ————

IN THE AFTERMATH of Lincoln's assassination, Brady remained focused on portraits and art. He had done so with much success, from Abraham Lincoln's first visit to his studio in 1860 to his elegant photo of Lee days after the surrender at Appomattox.

Shortly after Lincoln's assassination, both Brady and Gardner shot photos of Andrew Johnson, the new president from Tennessee who had inherited the assassination mess. *Harper's Weekly* used Gardner's version on the cover of its May 13, 1865, edition.

But Brady knew there was a new hero to shoot. Unlike Gardner, who focused on events, Brady focused on people as pictures. America would want to see—and purchase photos of—the man who killed Booth.

Boston Corbett had quickly claimed credit for killing Booth. And rightfully so. Now he was ready to take his national bow. "God Almighty directed me," Corbett said of his deed. Just as Booth had said of his.

Corbett's pistol was a regular large-size Union cavalry pistol. He was offered one thousand dollars for the gun and its five undischarged loads. He couldn't accept the money. The pistol belonged to the government.

But everyone would want to see Corbett. Brady acted quickly. He enticed Corbett into sitting for a series of portraits.

Corbett was familiar with Brady of Broadway. He once worked at a hat store on the famed street. He quit when he learned the owner had a practice of buying old hats, then cleaning and repurposing them for sale as new articles.[11]

Brady shot pictures of Corbett sitting at a chair, reading from a book, and standing up. He also shot a diminutive-looking Corbett facing a tall Edward Doherty, the commander of the Sixteenth New York Cavalry, the detachment that chased Booth and found him at the Garrett farm. Corbett appeared undaunted by Doherty's size. His forage cap was pulled down close to his eyes. Doherty's presence showed Corbett had been cleared of any blame for shooting Booth, even though he was wanted alive.

Corbett looked a bit like the madman as he was described. His hair was parted neatly down the middle in all the properness of a Methodist—but whiskers dangled from his chin in a wild glob.

Brady published the photos by the thousands. They sold well. But Corbett made no money from them. In return for posing, Brady gave Corbett a few copies of the images.[12] The image was etched into woodcuts, put into *Harper's Weekly*, and printed in newspapers. Americans now recognized the man who shot Booth.

Once again, Brady's pluck enabled him to showcase the celebrity of current events. But it was the last major victory Brady would have over rival Gardner in the chase for Lincoln's conspirators.

Booth's body had been placed onto a ship in the Navy Yard south of Washington. As Brady shot his images of Corbett, Gardner was on his way to photograph Booth in death.

11

Autopsy

— April 27, 1865 —

JOHN WILKES BOOTH'S dignified face was now nothing more than rotting flesh wrapped in a wool blanket. War Secretary Edwin Stanton knew that Booth's death would be controversial. His remains needed to be handled with the utmost care. Booth was despised in the North, but a potential martyr in the South. Stanton also needed to make sure he had the right man. The remains had to be analyzed and identified.

Booth's corpse arrived back in Washington just before two o'clock in the morning on the steamer *John S. Ide*. His body was placed on the monitor *Montauk* at Washington's Navy Yard amid a springtime fog. Authorities had long planned to keep the assassin's body there whenever he was caught.

Alexander Gardner learned of the body's arrival from a military request. His connections to the Union army paid off. He would be the only photographer allowed to take a picture of the corpse. That morning, Gardner, using his son as an assistant, lugged his heavy equipment into wagons and headed for the Navy Yard, where thousands of people stomped about, hoping to get a glimpse of Booth's body. They were accompanied by a military guard named James Wardell, a government detective assigned to watch Gardner. Security was tight. The Navy Yard didn't let the group in even after Wardell showed his badge. "The greatest curiosity is manifested to view the body of the murderer Booth, which yet remains on the gun-boat in the stream off the Navy Yard," wrote a reporter. "Thousands of persons visited

the yard today in hopes of getting a glimpse at the murderer's re-
mains, but none were allowed to enter who were not connected with
the yard. The wildest excitement has existed here all day, and regrets
are expressed that Booth was not taken alive." The *Philadelphia In-
quirer* wrote, "It seems that the authorities are not inclined to give the
wretched carcass the honor of meeting the public gaze."[1] The reporters
would not be allowed entry. If they only knew Booth's image would
be burned onto the glass negatives carried by Gardner. Or so said
the myth.

The news of Booth's death was still fresh. Not everyone was happy.
While many were angry simply because they wished Booth remained
alive to suffer a more tortuous death, others who knew him were be-
set with grief. Especially Booth's mistresses. The actor and notorious
womanizer had many who clutched his photograph in lust and despair.
One of them learned of Booth's death while riding in a streetcar. A
newspaper reported that it "caused her to weep bitterly, and drawing a
photograph likeness of the murderer from her pocket, kissed it fondly
several times."[2] Another mistress, when she heard what Booth had
done, attempted to commit suicide by taking chloroform. After she
was revived, she asked for Booth's picture, which was kept under her
pillow.[3]

They wouldn't have recognized the man in the photos. He was
no longer the beautiful man who played Romeo. His body decayed
fast. His skin coarse and tough. Shortly after arrival, Commodore J.
S. Montgomery, the man in charge of the Navy Yard, sent a message
to Navy Secretary Gideon Welles: "David E. Herold, prisoner, and
the remains of Wilkes Booth were delivered here at 1:45 this morn-
ing. The body of Booth is changing rapidly. What disposition shall be
made of it? It is now on board the iron-clad Montauk."[4]

At ten o'clock that morning, a telegraph arrived from Stanton:
"You will permit Surgeon-General Barnes and his assistant, accom-
panied by Judge Advocate-General Holt, John A. Bingham, Major
Eckert, William C. Moore, Colonel L. C. Baker, Lieutenant Baker,
Lieutenant-Colonel Conger, Charles Dawson, J. L. Smith, Mr. Gard-
ner, photographer, and an assistant, to go on board the Montauk and
see the body of John Wilkes Booth. Immediately after the surgeon-
general has made an autopsy you will have the body placed in a strong
box and delivered to the charge of Colonel Baker, the box being se-
curely sealed."

The *Montauk* was a strange-looking vessel that now served as a floating prison. Commissioned in 1862, the boat had a proud war history and was the principal ironclad in the bombardment of Fort Sumter in South Carolina. By 1865 it was selected as the best place to house the murderer of the president.

Within hours of Lincoln's death, telegrams arrived at the Navy Yard, telling authorities to be prepared to hold the assassin on the *Montauk*. "Have vessel immediately prepared, ready to receive the criminal at any hour, day or night," said one order. "He will be heavily ironed and so guarded as to prevent escape or injury to himself."[5]

Booth arrived more than a dozen days later in a makeshift body bag. No worry of escape. But several of his cohorts were also housed on ironclads in the Navy Yard. Investigators had scooped up a number of suspects and arrested anyone who had even a minor role in the event. An American president had never been assassinated before, and they wanted to make sure it never happened again. "The nation can once more breathe freely, Assassination is made a thing too ignominious and sure of punishment to ever provoke repetition in this free country," the *Washington Evening Star* wrote.[6]

Booth's autopsy was done on the *Montauk* at two o'clock in the afternoon. His body was splayed out on a carpenter's bench. An awning overhead protected it from the bright sun. He was hard to identify. "The shaving of the mustache, the out-cropping of the beard, the untidy and disordered appearance of the body had so changed the assassin's looks that his stage and street acquaintances would hardly have recognized the corpse as being that of J. Wilkes Booth."[7] A dozen days on the run left Booth's body in a terrible condition.

Charles Dawson, a clerk at the Washington National Hotel where Booth stayed, found one identifying mark. A tattoo on his wrist. "I distinctly recognize it as the body of J. Wilkes Booth—first, from the general appearance, next, from the India-ink letters, 'J.W.B.,' on his wrist, which I had very frequently noticed, and then by a scar on the neck. I also recognize the vest as that of J. Wilkes Booth," Dawson said. A dentist analyzed the body's teeth and concluded they were those of Booth. A doctor recognized a scar on Booth's neck from a tumor removal.

The death investigators picked over his body. Pieces of Booth's vertebrae were removed during the autopsy. Surgeon General Joseph K. Barnes presided over the autopsy. He later wrote to Stanton:

I have the honor to report that in compliance with your orders, as-sisted by Dr. Woodward, USA, I made at 2 PM this day, a postmor-tem examination of the body of J. Wilkes Booth, lying on board the Monitor Montauk off the Navy Yard.

The left leg and foot were encased in an appliance of splints and bandages, upon the removal of which, a fracture of the fibula (small bone of the leg) 3 inches above the ankle joint, accompanied by con-siderable ecchymosis, was discovered.

The cause of death was a gun shot wound in the neck—the ball entering just behind the sterno-cleido muscle—2 1/2 inches above the clavicle—passing through the bony bridge of fourth and fifth cervical vertebrae—severing the spinal chord [sic] and passing out through the body of the sterno-cleido of right side, 3 inches above the clavicle.

Paralysis of the entire body was immediate, and all the horrors of consciousness of suffering and death must have been present to the assassin during the two hours he lingered.

The autopsy was quick. The government wanted to get it over with. As the men stood around the body, Gardner was charged with taking its picture. Something to prove Booth was really dead. Wardell, the detective, watched him closely.

Gardner, good at keeping secrets, never spoke of what happened that day or the type of image he took. "Under no circumstances was I to allow him or his assistant out of my sight until they had taken a picture and made the print, and then I was to bring the print and the glass back to the War Department and give it only to Col. Baker or Secretary of War Stanton," Wardell said. "[Gardner] was told that only one plate was to be made and it was to have only one print made and both were to be given to me when finished."[8]

Wardell said he went with Gardner and his assistant to watch the photo be developed. "I went with him and even went into the dark room." Wardell claimed he got the print and the plate from Gardner's assistant and took it to the War Department, as ordered. "I went in to the outer office and Col. Baker was just coming out of the War Office," Wardell said. "I gave him the plate and print and he stepped to one side and pulled it from the envelope. He looked at it and then dismissed me."

The photo was never seen again. According to Wardell, Stanton later denied that a photo had ever been taken. The war secretary, as

with the Lincoln death photo, was funny about pictures of the president and his assassin. Perhaps he kept it to himself, like he did with Lincoln.

Harper's Weekly ran a sketch of the autopsy. Some inferred it was from an image taken by Gardner, but the magazine didn't attribute it to him. The sketch showed a decrepit body laid out in front of about twenty men. Booth's face is not shown up close, so the drawing had little visceral impact.[9]

The *New York Herald* did run a short item on the autopsy, saying a "photographic view of the body was taken before it was removed from the Monitor."[10] But print reporters weren't allowed on the ship.

Wardell said he looked at the photo, and it matched the photo of Booth on the "Wanted" posters, "except that the hair was longer on the sides, the mustache was shaggy and dirty and there was a growth on his chin." Wardell concluded, "The War Department was very determined to make sure that Booth was not made a hero and some rebel would give a good price for one of those pictures or the plate."

Years later, Gardner's young son Lawrence would claim to have assisted his father during the autopsy. He said the photo was never even taken. "The object of my father's visit to the Monitor was photography, and the body in question was to be the subject. Did we take a picture? No. After everything had been prepared Gen. Eckert concluded that inasmuch as there was so little likeness in the remains to the photograph in existence of Booth, perhaps it would be best not to make the picture, and the plan was abandoned for that reason."

On May 2, 1865, regional military leaders sought to further squelch any desire for images of Booth. General Lew Wallace issued a blanket order, stating, "The sale of portraits of any rebel officer or soldier, or of J. Wilkes Booth, the murderer of President Lincoln, is forbidden hereafter in this department. All commanding officers and provost-marshals are hereby ordered to take possession of such photo wherever found exposed for sale, and report the names of the parties so offending, who will be liable to arrest and imprisonment if again guilty of a violation of this order."[11] The photo ban was unpopular and an overreach. It was lifted by May 27 by General E. D. Townsend, the same officer who allowed Gurney to take a photo of Lincoln in his casket in New York.

Secrecy remained a government aspiration. Not just in destroying any autopsy photo of Booth, but also in the disposal of his body. The

government didn't want relic hunters or Southern sympathizers to dig him up. Stanton entrusted Col. Baker with the handling of the body. "The Secret Service never fulfilled its volition more secretively," the *Times* of London said.[12]

Booth's body was placed on a small rowboat with two men the night following the autopsy. When asked what happened to the body, Baker would only respond, "That is known to only one man living besides myself. It is gone. I will not tell you where. The only man who knows is sworn to silence. Never till the great trumpeter comes shall the grave of Booth be discovered."[13]

Some said the body was thrown overboard and dropped into the river. Others said it was burned. In reality, it was taken to the Washington Arsenal grounds, put into a gun box, and lowered into a hole dug beneath a prison floor.

Gardner would soon arrive at the arsenal grounds and tiptoe over the area where Booth was buried. The photographer's aim would not be on the shallow grave. Rather, it would be on the fate of Booth's fellow conspirators and four knots tied into nooses. America was still in pursuit of swift retribution.

12

The Rogues' Gallery

— April 27, 1865 —

ALEXANDER GARDNER WALKED past the blue-clad sentries and through the tall gates of Washington's Navy Yard to photograph eight men who wondered if they would die. Their minds blinked with terrible thoughts. Would a vengeful nation keep them in prison forever? Hang them? Something worse? The real torture was yet to come, through the aid of heavy iron and soft cotton—but for now, the men would be in the warm view of Gardner's glass lens.

With John Wilkes Booth dead and buried, attention turned to the conspirators who detectives alleged had helped him in his quest to kill the president and cripple the government. The newspapers already predicted many would die. The *New York Herald* opined that between twenty-one and twenty-three people "concerned in the assassination" would face the death penalty.[1]

The men singled out by the War Department to face Gardner's camera should have been the most worried. Gardner was given a list of prisoners to photograph on the *Montauk* and *Saugus*, which he did over a period of several days. One by one they were marched before him: Joao M. Celestino, Samuel Arnold, Edmund Spangler, George Atzerodt, Michael O'Laughlen, Hartman Richter, Lewis Powell, and David Herold. Some were bit players. Others were major stars of the conspiracy. The ships *Montauk* and *Saugus*, docked at the Navy Yard, had become a temporary den of rogues. The government was still figuring out what to do with them.

The death penalty was a debated topic in the United States during the years before the war. The same old arguments were levied for and against it. But the option of execution increased in public consideration at the end of the war, when a vengeful nation struggled with rectifying the horrors of battle.

The nation had become numb to death. Earlier that morning, the *Sultana*, a steamboat carrying a load of released Union prisoners, exploded just north of Memphis. An estimated eighteen hundred people died on the Mississippi River. The worst maritime disaster in American history received scant attention in newspapers, which were focused on Booth and the men housed on the *Montauk* and *Saugus*.

The United States already had thousands of Confederate prisoners—including the nation's former president, Jefferson Davis—in custody. Many called for Davis himself to be executed, while others argued it would shatter the brittle peace.

Public hangings were the common method of execution. The fervor to punish those who plotted against Lincoln—and the country, for that matter—spurred talk of returning to more tortuous practices. "Doubtless there are many at the present who would be glad to return to [the] ancient system of fire and torture, by way of demonstrating their freedom from the 'mawkish sympathy' for criminals which distinguishes the present age," one newspaper wrote.[2]

The *New York Times* said, "No high carnival of blood will follow the suppression of the Southern rebellion. No dreadful holocaust of victims, like those at the mere perusal of which the student of history shudders, in reading the records of other days and other lands, will stain American annals. Not vengeance, but justice will be the motto of American government."[3]

Justice was on Secretary Stanton's mind. He wanted the conspirators tried in a military court. It would give him extreme advantages, including speed. Justice needed to be swift. For now, though, he wanted pictures of the suspects. And that duty fell to Gardner, who had a monopoly on military photography. The day would give Gardner claim to the most famous photo shoot in American history—and produce innovations still in use a century later.

His work was done on the ships docked at the Washington Navy Yard, a few miles south of the bustle of Pennsylvania Avenue. Not a perfect backdrop, but it would do. The Navy Yard was established in

1799 as the nation's home port and shipbuilding center. It was burned by American military orders in 1814 after Washington was captured by British forces. The fire destroyed the facility, but it was necessary. The Americans didn't want its naval fleet and supplies to aid the British.

The yard had high brick walls guarded by sentries who wore blue tunics with eagle buttons. Their arms held brightly polished guns. "Inside are some few trophies of guns taken from us at York Town, and from the Mexicans in the land of Cortez," wrote British journalist William Howard Russell. "The interior enclosure is surrounded by red brick houses, and stores and magazines, picked out with white stone; and two or three green grass plots, fenced in by pillars and chains and bordered by trees, give an air of agreeable freshness to the place. Close to the river are the workshops: of course there is smoke and noise of steam and machinery."[4]

The Navy Yard was on the eastern branch of the Potomac. The stream was choked with big and large vessels. Foreign ships often docked in the yard. Sound of cannons and guns and dynamite often echoed throughout the walls. The Navy Yard was a test facility for Union weaponry.

Lincoln liked to visit the Navy Yard. He would take cruises on the Potomac, watch new inventions being tested, review the troops, or just relax and drink coffee and smoke cigars. One day he showed up to witness a rocket test. His last visit was on the day he was killed. Dr. George Todd, a surgeon aboard the *Montauk*, wrote of that day, "Yesterday about 3 P.M. the President and wife drove down to the Navy Yard and paid our ship a visit, going all over her, accompanied by us all. Both seemed very happy, and so expressed themselves, glad that this war was over, or near its end, and then drove back to the White House."[5]

In the weeks after, Gardner stepped aboard the *Montauk* and met the men who conspired to capture or kill the president. One subject was David Herold, Booth's friend who was assigned to guide Powell out of Washington but fled to join Booth in his escape. Herold did not fire a shot or jab a knife. Perhaps he was just in awe of the famous actor. But he was firmly entrenched in Booth's world and with him during his final moments. He even took up some of Booth's bad habits. In the months before the assassination, Herold began drinking.

The Navy Yard was his second home. His father was the principal clerk of the Navy Yard store for more than twenty years. Herold lived

in the shadows of the ship where he was now a prisoner.

Gardner arranged a canvas awning on the *Montauk* deck as a backdrop. Herold was marched before his camera. The prisoner had just arrived on the boat after being ferried from the Garrett farm in Virginia. It took Gardner a while to get a "satisfactory shot," but he was able to capture Herold in three different poses.[6] The lighting was warm and revealing, which enabled Gardner to infuse the pictures with mood.

He directed Herold so he could get shots straight on of his face and his side, but Herold always appeared to turn away, adopting the look of a shamed schoolboy. "He appeared sullen, and he put on a pouty look as he took his seat in the chair and glanced with dissatisfaction in the direction of the wharf, where a number of spectators were watching every movement on the vessel, many of whom were his old acquaintances," a reporter wrote.[7] Herold wore dark gray pants, a light-blue military vest, a faded blue jacket, and black slouch hat.

The twenty-two year-old Herold was not a low-life degenerate. He was from an upstanding family. He had attended three years at Georgetown College and enjoyed the pursuits of a well-off upbringing. He was fond of horses, dogs, and guns. He spent months at a time in the southern Maryland countryside hunting with his father—something that proved useful in guiding Booth to Virginia. After college, he entered the pharmacy business, but he wasn't a hard worker and it didn't last. During his plotting, Booth did not trust Herold with large tasks. He was merely support staff. Still, some described Herold as a braggart.

When he was placed aboard the *Montauk*, he asked for someone to send for his mother to get him a pair of shoes. He later told an officer, "Take a good look, a good square look, so you will know me."[8]

Gardner's camera took the long look. Herold's hair was parted on the side. His normally shaven face bore the shadowed whiskers of a man recently on the run. So did his rumpled and dirty jacket. His soft features bore the look of a mama's boy.

He was not known to be a religious man, but his face showed the clean look of an Episcopalian, which he was. He was also not known to care for politics, but he later said his "sympathies" were with the South, both "head and heart."

That head now drifted to the side as Gardner attempted to capture his face. Herold would not look at the camera. No matter how Gardner moved the camera or posed his subject, Herold appeared consumed

with other thoughts. Surely, they were about his fate.

Herold's hands were fixed on his lap. They had to be. A close look at Gardner's images show Herold was cuffed by iron manacles. The handcuffs were connected not by a chain, but by a bar, making it difficult to move.

In 1865 manacles, as they were called, were the symbol of a criminal. News reports buzzed after Jefferson Davis, the ex-Confederate president, was reported to have been manacled by his Union captors. "My God!" Davis exclaimed when he saw the manacles, carried by a blacksmith. "You don't intend to put those things on me."[9] Davis asked the guard to shoot him instead. Davis resisted until he was thrown onto his bunk and held down while the blacksmith hammered together the rivets. Only his legs were manacled, but they were quickly released.

Herold had not only his hands manacled but also his legs. The restraints had such a mental effect that asylums refused to use them on the mentally disturbed. Southerners perhaps were most familiar with them. The irons were routinely used on slaves. Sometimes they were attached to their necks.

In the aftermath of the conspiracy, the manacles became such a public fascination that the *Philadelphia Inquirer* ran an engraved sketch of them. "The wristlets are attached to an iron bar, about twelve inches in length, which prevents the wearer from joining his hands, as in the old-fashioned shackle, where the claps are connected by chain links, thus eventually preventing the culprit from unfastening or breaking them."[10]

The irons made it difficult for Herold to wipe tears from his eyes—and they made it impossible for him to clasp his hands together to pray. And prayer was about all he had. That day, it was reported he had begun to realize that "there is no hope for his escape from the awful doom that awaits him."[11]

Still, the torture would get worse. On April 22, Stanton had ordered the heads of all accused conspirators covered with canvas hoods twenty-four hours a day. They were like straitjackets for the head. Herold hadn't received his yet.

The hoods covered the entire head, including the eyes and ears. They had an opening at the mouth. The prisoners could still eat and breathe, but not much else. Later, the hoods were remade so they were padded with cotton. "It fitted the head tightly, containing cotton pads, which were placed directly over the eyes and ears, having the tendency

to push the eyeballs back in the sockets," said prisoner Sam Arnold. "One small aperture allowed about the nose through which to breathe, and one by which food could be served to the mouth, thence extending also from the crown of the head backwards to the neck. The cords were drawn as tight as the jailor in charge could pull them, causing the most excruciating pain and suffering, and then tied in such a manner around the neck that it was impossible to remove them."

Alexander Gardner was a welcome sight for the prisoners. They had to take off their hoods for their photo shoot, if only briefly.

Lewis Payne Powell was also aboard the *Montauk*. He had been arrested at Mary Surratt's house ten days before. Powell was put in front of Gardner and stripped of his hood. He had a "cool impudent stare" that he would later adopt for the courtroom.[12] "A great mystery envelopes [sic] this man," wrote the *Philadelphia Inquirer*, "a mystery which seems impenetrable."[13] What was impenetrable was his mind. His mental state was already fragile. Stanton's order for hoods mentioned him by name. "The Secretary of War requests that the prisoners on board the iron clads belonging to his department shall have for better security against conversation, a canvas bag put over the head of each and tied around the neck with a hole for proper breathing and eating, but not for seeing—and that [Powell] be secured to prevent self-destruction."[14]

When a sergeant walked in to fit Powell with his hood, Powell asked, "What is *that* for?" The sergeant responded that he was "there to obey orders, not to answer questions; as I forced the hood down I noticed a tear start and roll down his cheek."[15]

Days later, the twenty-one-year-old Powell attempted suicide by bashing his head against the wall of his cell. "The bumping attracted the attention of his jailer, who found on examination, that the prisoner had seriously injured himself. To prevent further injury, his hands were confined and a cap, stuffed full and large so as to act as a pad, was fastened upon his head," a reporter wrote.[16]

The injuries weren't apparent when he stood before Gardner, although Powell appeared on different days. The government did not show Powell as he looked locked away in the *Montauk*. When he appeared before Gardner's camera, he was dressed as he was on the night he stormed Secretary Seward's house and attempted to kill him.

Powell was a good-looking young man. His face was chiseled and strong. His shoulders were broad. His eyes were blue. His legs were long, adding to his six-foot-one frame. "He had one of those peculiar

dark southern complexions," one man observed.[17] There was no way Gardner's camera could betray him—and it didn't.

The son of a Baptist minister, Powell was born in Alabama and ended up in Live Oak, Florida, where his dad had a plantation. He was kicked by a mule and his jaw broken when he was a young boy. The incident left no evidence. Powell's square jaw gave his face a look of prominence. His father said Powell had a "kind and tender" heart and was "determined in all of his undertakings."[18] Perhaps too determined.

Powell was seventeen when the war broke out. He ran away from home and joined the Confederate army. In 1863 he fought in Gettysburg and was wounded in the wrist. He became a prisoner and was transferred to Baltimore. His good looks helped him romance a nurse, who helped him escape. He kept his Baptist teachings. He did not drink and he did not smoke.

Gardner's photos showed Powell in dark trousers and a light-colored overcoat. A sentry, holding a bayonet, stood still at his right side. The hat he had left behind at the scene at Seward's mansion topped his dark hair.

The camera did not show his good-natured smile, which was often flashed when he played his favorite game of cards. He looked serious but unafraid. He didn't look like a prisoner or an insane man. He looked like a politician on board to review the troops. Or a young businessman headed to the bank. The camera, however, did show Powell's jaw. "His bold eye, prominent under jaw and athletic figure gave all the marks of a bold desperate villain, but not one capable of planning a deed of cunning," the *Washington Evening Star* wrote.[19]

Powell was a perfect model for Gardner. At one point, guards removed Powell's manacles, allowing him to drop his hands by his side or put them in his coat pockets.

Gardner photographed him again aboard the *Saugus*. That session produced a photo set that was strikingly modern. Something that appeared not of the nineteenth century. Powell was clean-shaven, unlike most men of the day. He wore a blue long-sleeve collarless wool shirt. Gardner posed him looking straight at the camera. The light hit the right side of the face, making him look like a stage actor. His head thrown back defiantly against the cold iron wall—the same type of wall Powell used to bash his skull days before. Gardner took more pictures of Powell than any other prisoner. Surely he thought he was a good subject.

The other major conspirator to face Gardner was George Atzerodt. The German immigrant who was supposed to kill Vice President Andrew Johnson but instead chose to drink at the hotel bar. The press described him as "small and shambling."[20]

Atzerodt had the face of a riverboat gambler down on his luck. He had a muddy complexion, with brown hair and a light-colored mustache and goatee. The newspapers said he "was a vulgar looking creature" and had "unpleasant green eyes."[21] He spoke with a thick German accent, which he never lost after spending much of his time in Charles County, Maryland.

Gardner shot him looking dazed and dusty, his round shoulders hammered by his blacksmith trade. In one photo, Atzerodt appeared as if he was sitting by a campfire, deciding his next move. In another, he looked like a haggard man awaiting his next drink.

Before the war, Atzerodt owned a carriage-painting business. Then he became a smuggler for Confederate forces, a job that brought him into the world of John Surratt and then John Wilkes Booth.

His face was discernible enough for him to be recognized. The *Evening Star* said he "had the meanest face, but is thick set." A clerk remembered Atzerodt as being at the Kirkwood Hotel the night of the assassination. He described him as "suspicious looking" and wearing a gray overcoat. Authorities looked through the registry book and noticed a name written "very badly." It was Atzerodt.

That led police to Hartman Richter, Atzerodt's cousin who lived in Germantown, Maryland. A tipster spotted Atzerodt's "suspicious" look in southern Maryland and warned authorities. Richter first denied Atzerodt was at his house. That caused Richter to get arrested too— even though he had nothing to do with the conspiracy.

Now Richter was on the *Saugus* in irons. Gardner made photographs of him. Richter appeared like a man caught in the wrong place. His face stared off to the side as if he were lost. One day he was an average farmer, and now he was being treated like a man complicit in the assassination of the president of the United States.

Richter had not seen his cousin for three months until he showed up at his farm on Easter Sunday after the assassination. "When I met him in the morning he had an overcoat on his arm—it was a kind of gray overcoat," Richter testified later. Gardner shot Atzerodt wearing the gray overcoat he wore from the Kirkwood Hotel to his cousin's farm.

Richter wasn't the only prisoner brought before Gardner with only a tacit connection to the conspiracy. Joao M. Celestino was kept in the bag room of the *Montauk*. Celestino was a Portuguese sea captain who spoke poor English. His boat, which carried a large amount of gold and silver, had been confiscated by Union officials. He was suspected of being a blockade runner. In frustration, Celestino was heard to have threatened Secretary Seward's life on the day he was attacked. Celestino blamed Seward, the chief foreign diplomat, for taking his silver and gold. Someone remembered that, and Celestino was arrested as a conspirator.

Gardner's photos of Celestino show a man perplexed. Celestino, wearing a double-breasted coat, had a bushy mustache and a full head of hair. He had the hard look of a sea captain. Albeit a sea captain adrift.

Other, more involved conspirators appeared in Gardner's view. There was Samuel Arnold, who was much better kempt than Atzerodt. Arnold stood before Gardner with the innocent look of a bank clerk. He was a schoolmate of Booth's at St. Timothy's Hall in Baltimore. He reconnected with Booth when the actor was plotting to abduct Lincoln. Arnold became an integral part, but he later dropped out, long before the plan turned to assassination and was actually carried out. When he appeared before the camera, he was thirty years old. He looked stoic and calm, but his stare offered a hint that he was afraid.

So did Michael O'Laughlen, another classmate of Booth's and one of his earlier friends. The two grew up across the street from one another. O'Laughlen briefly served in the Confederate army. He later worked in the produce business. O'Laughlen also entertained Booth's idea of abducting Lincoln and hauling him off to Richmond. He even stood with Booth and others in an attempt to trap Lincoln's carriage when they thought he would attend a play on the outskirts of Washington, but Lincoln never went. He dropped out of the conspiracy.

O'Laughlen was also an engraver. He understood photography and knew Gardner's work. Now he was his subject. Gardner captured images of O'Laughlen with a pale face that permeated his black eyes.

Another man to appear was Edmund Spangler, the Ford's Theatre carpenter whom Booth entrusted to hold his horse the night of the assassination. Spangler handed that duty off to a man named "Peanut John." After Lincoln was shot, Jake Rittersbach, who also worked at Ford's, said he tried to chase after Booth, but that Spangler punched

him in the face and said, "Don't say which way he went." That got Spangler arrested and put before Gardner's camera.

Spangler was thirty-nine years old and enjoyed booze. That was obvious by his haggard face. But perhaps it was from the drugs aboard the *Montauk*. "Spangler was badly frightened when he was first placed on board, and for a time he was nearly out of his wits," the *Evening Star* wrote.[22] Dr. George Todd prescribed medication to keep him calm. The hood and manacles probably didn't help.

One description said, "He is of short, thick stature, full face, showing indications of excessive drink, dull, gray eyes, unsymmetrical head, and light hair, closely cut."[23] Gardner's photos captured it all.

After his time on the *Montauk* and *Saugus*, Gardner and his staff went back to his studio and developed the images of the alleged conspirators. He had photographed all of them but Dr. Samuel Mudd and Mary Surratt. Neither of them was aboard the ships. They were at the nearby Washington Arsenal.

The images were complex. They grabbed the criminals' likenesses from the front and side. They weren't commercial. They were purely for his work with the U.S. government. *Harper's Weekly* published one of the images on its front cover. That of Lewis Powell flanked by a sentry.

The photos were innovative. The photo shoot set the precedent for criminal photography. His camera took front and side images, showing the face can change in different angles. It was the beginning of the famous "Rogues' Gallery," which Gardner would formally establish a decade later for the Washington Metropolitan Police Department.

The photos are also considered to be the earliest of a "criminal line up."[24] A lineup Gardner would soon see again—hooded in death.

13

Trial by Picture

— May 1865 —

T HE NORTH WAS in the mood to kill. Four years of war scarred the landscape. Farms were destroyed. Small towns were bombarded and divided. Whole lives were interrupted. The simmering rage built against the Confederates and boiled over when Americans learned the horrors of Andersonville, a Southern prison where Union troops were held and tortured and starved into piles of bones.

After Lincoln's funeral train steamed across America and whistled its sad elegy of mourning, the Lincoln family considered their next life. Wife Mary Todd packed her bags in preparation to leave the White House. Son Robert Todd planned to open a law practice in Chicago. But America wasn't ready to move on. The conspirators against Lincoln were unfinished business. An often asked question was how many of their necks would be wrapped with a hangman's rope.

The angry sentiments were best captured by the nation's illustrators. The men who forged careers making fun of Lincoln's gangly body now eviscerated those responsible for putting it into the ground. *Uncle Sam's Menagerie*, a drawing distributed throughout the North by G. Querner, showed the conspirators as "Gallow's Birds." In the depiction, a man played Yankee Doodle on an organ. Perched above were conspirators Michael O'Laughlen, David Herold, George Atzerodt, Lewis Powell, Mary Elizabeth Surratt, Samuel Arnold, Edmund Spangler, and Dr. Samuel Mudd. Beneath them was the skull of John Wilkes Booth, crowned by a black crow. Uncle Sam pointed at it with

a stick. The artist implied the conspirators' flesh would soon melt away and their bones would gather dust along with Booth.

Another illustration, sold as a carte de visite, showed the conspirators hanging from a sour-apple tree. A horned devil was posted beneath them, waiting for their arrival in hell. The devil held Booth in his arm.

Rumors continued to be published about Booth's body. One said his head and heart were removed and taken to Washington's medical museum. Another said his body was dropped at sea. Some people speculated the body was at the Washington Arsenal—and it was. Now his fellow conspirators would join him there. Albeit alive. At least, at first.

After Gardner's rogue photo shoot, the prisoners were slapped with manacles, shrouded with their hoods, and taken to the arsenal. Sketch artists scrambled to witness their transfer. Their drawings were quickly made into woodcuts for the weekly illustrated journals. They showed the white-hooded conspirators being moved into the arsenal at night in the amber shadows of lantern light. The lack of sunlight meant photographers couldn't get a picture.

Posted on the east bank of the Potomac, the Washington Arsenal was a major defense point and one of the most secure sites in the city. Part of it once served as a penitentiary. It had plenty of room to house the conspirators and to host their trial. But a major benefit of it was its brick walls, which aided secrecy and safety.

Renovations were done in preparation for the event. Namely, a new upstairs courtroom to fit about three hundred people. It had tall white walls, newly made pine furniture, and barred windows. Gas fixtures were installed in case testimony labored into the night. And it often did.

Major General John Hartranft, who was awarded the Medal of Honor for rallying troops in the confusion of the first Battle of Bull Run, was put in command of the jail and its surroundings. The nation's thirst for blood and revenge was fervent. But Hartranft assured officials that it would be "impossible for any attempt to get possession of the prisoners by a mob to succeed." The *Philadelphia Inquirer* observed, "His forces are encamped just outside the outer walls, while thick cordons of sentries surround the red brick building which confines the wretched criminals, who, in chains, with mufflers over their heads, are already undergoing a living death. They are not allowed any communication with the outside world, and the guards who feed them are not allowed to converse with them upon any pretense."[1]

Washington braced for the trial of the century. An event that would rival anything in America's young history. The prosecution of the Lincoln conspirators would stand alongside the Salem witches, the British soldiers in the Boston Massacre, Aaron Burr, and John Brown. This time, America would get images to aid their imaginations of the event. Who would live and who would die?

This was no ordinary trial. America was still at war. President Andrew Johnson considered the murder of Lincoln—and any plot against him—to be an assault against the government. The seven men and one woman were active enemies of the state. He ordered them to be tried by a military commission. "That the persons implicated in the murder of the late President, Abraham Lincoln, and the attempted assassination of the Honorable William H. Seward, Secretary of State, and in an alleged conspiracy to assassinate other officers of the Federal Government at Washington City, and their aiders and abettors, are subject to the jurisdiction of, and lawfully triable before, a Military Commission," wrote Johnson's order dated May 1.

War Secretary Stanton managed the proceedings with his characteristic tight fist. He first ordered a secret trial, such was his way, but later relented after several days of testimony following pleas from reporters and photographers.[2] Reporters struck deals with the government to allow censure of any material deemed sensitive. The court agreed to provide transcripts of the proceedings to the press. But those transcripts would not contain the words of any of the conspirators. They were barred from testifying in their own defense.

Alexander Gardner's camera introduced the country to the military commission that presided over the case. Nine men acted as judge and jury of the eight conspirators. They had the power of life and death—a power that was amplified by Gardner's photo. He shot them wearing their military uniforms. Major General David Hunter, the president of the commission, set the mood. He held a sword in his left hand.

The men had been frequent guests of Gardner and rival Brady, their likenesses captured before and during the swirl of war. The commissioners were unique in politics and colorful in character. There was Major General Lewis "Lew" Wallace, whose slender and fit physique stood in the back of Gardner's photo. Wallace, with a neatly trimmed beard that trailed to his chest, was a writer from Indiana who would go on to pen *Ben-Hur: A Tale of the Christ,* a best-selling classic published

by Harper's. Standing next to him was Brigadier General Thomas Maley Harris, a West Virginia doctor who gave up his practice to join the Union army. Perched on a stool was steel-eyed Colonel Charles H. Tompkins, who was given the Medal of Honor for charging through enemy lines, taking an enlisted man's gun, and shooting dead a Confederate captain—the first Confederate death of the war. Also there was Major General August V. Kautz, a stone-faced and intense German immigrant who once published two issues of a newspaper called the *Truth Teller* in defense of Leschi, a Native American chief he believed had been wrongfully tried and executed for murder. (A century later, Leschi was exonerated by the American government.)

If the conspirators hoped for an unbiased jury, they were out of luck. Many of the commission members accompanied the honor guard that carried Lincoln's body by train back to Springfield. The president's body was dropped into the ground on May 4, and they quickly returned to Washington for the trial. Stanton, who carefully orchestrated the trial proceedings, wanted the conspirators tried and executed before Lincoln was buried. But this pace, which was lightning quick by any legal standard, was as fast as he could go.

The military commissioners sat at a large table draped with a felt green cloth. The press said they sparkled in their "brilliant full dress uniforms"—the same ones they wore before Gardner's lens.

Admission tickets, with Hunter's signature, were handed out to favored reporters and photographers for admittance. It paid to have good and cozy relations with the government they covered. Newspapers allowed in included the *Philadelphia Inquirer, Boston Transcript, Boston Advertiser, New York Times, New York Herald,* and Washington city papers as well as the Associated Press, which flashed news to member news organizations through telegraph lines. The press sat at a table near the commission members.

One reporter remarked on the discomfort of the chairs in the room, calling them "hard-bottomed."[3] But the press did get use out of the spittoons scattered about the room and filled them with their dark-brown tobacco spit. The room also included a water cooler and two upright stoves, but the latter weren't needed in the warm weeks of May and June.

The conspirators entered the courtroom to the loud thud of a heavy prison door connected to an adjacent prison. They sat at the front of the courtroom on a raised platform surrounded by a plain

railing called the prisoners' dock. Each prisoner was flanked by an armed guard. The order was set from left to right: Surratt, Herold, Powell, Atzerodt, O'Laughlen, Spangler, Mudd, and Arnold.

Witnesses sat in a small box in the center of the room on a raised platform surrounded by a railing. Brady's studio's photographs of Ford's Theatre were propped up in the courtroom and used to direct witnesses. They were "of great value to the court," the *Philadelphia Inquirer* said.[4] Meanwhile, the photographs of the conspirators copied by Gardner were in envelopes to be used for witness identification. Especially those of John Wilkes Booth.

Sketch artists sat in the courtroom and made drawings, while the reporters scribbled on paper. Mainly, they focused on sensationalized descriptions of the prisoners. They said Lewis Powell's coal-black hair fell over his eyes, intensifying the "savage desperation of his look." David Herold was said to be "dirty in face and dress." Surratt, the only woman to stand trial, was described with the expression "fat and forty"—even though she was much older, but buxom and rotund. About the only appearance to get positive remarks was that of Dr. Mudd. The *Washington Evening Star* said Mudd looked "much out of place among the low type of countenances of his fellows."[5]

The trial gave way to long, meandering testimony. It spanned several weeks. As it wore on, the conspirators were described with the more mundane characteristics of daily life.

Powell routinely attempted to look out the courtroom windows. The plantation boy surely lusted for an escape to the sun from his darkened cell. Surratt, known for wearing a veil, was said to be indifferent to the testimony and cared only "to hide her face." At times she cooled herself with a palm-leaf fan. Herold appeared lighthearted and ready to laugh at any incident intended to draw a smile. Atzerodt appeared uneasy. The prisoner who paid most attention was Samuel Arnold, who looked forward with intensity and watched the testimony closely.[6]

Reporters left the recording of the testimony up to the government hands. They printed and released daily transcripts, although information deemed "sensitive" was left out. Several papers devoted entire front pages to the raw text of testimony. A rarity at the time, and a first for the press. Newsprint and ink were expensive. The *Philadelphia Inquirer* ran woodcuts of the conspirators made from Gardner's "mug shots" of them.

Outside the brick walls of the trial, additional arrests were still be-
ing made.[7] Just as the trial began, news of Jefferson Davis's capture
briefly supplanted the trial in Northern newspapers. Benjamin Brown
French, Washington's commissioner of public buildings, walked out of
his home on May 14 and was greeted with a two-inch headline in the
Daily Morning Chronicle that blared: CAPTURE OF JEFF DAVIS.
"Thank God we have got the arch traitor at last," French wrote in his
diary.[8]

The newspapers quickly ran with gossip that Davis was captured
by Union forces in Georgia while wearing women's clothes, namely, a
hoop skirt, petticoat, and bonnet. Stanton heard the news and quickly
leaked it to the press. The idea of the former Confederate president
wearing women's garments was the perfect symbol for Northern il-
lustrators and cartoonists. And they weren't bashful, depicting a
fallen and effeminate rebel leader. The *Uncle Sam's Menagerie* draw-
ing, with the conspirators labeled as Gallow's Birds, also showed Da-
vis wearing a bonnet. The Slee Brothers of Poughkeepsie, New York,
used combination printing to superimpose Davis's head on a female
body in a petticoat. Eliza Andrews, a Georgia woman, lamented in
her diary, "I hate the Yankees more and more, every time I look at
one of their horrid newspapers. . . . [T]he pictures in *Harper's Weekly*
and Frank Leslie's tell more lies than Satan himself was ever the fa-
ther of. I get in such a rage . . . that I sometimes take off my slipper
and beat the senseless paper with it. No words can express the wrath
of a Southerner on beholding pictures of President Davis in woman's
dress."[9]

P. T. Barnum offered to pay the government so he could display the
clothes. When Stanton received them, though, it wasn't as described.
Hoping to evade capture, Davis had worn a unisex raincoat that proba-
bly belonged to his wife.[10] Stanton tucked the clothes away, along with
other items he shielded from the public, like Gardner's autopsy photo
of Booth and Gurney's death photo of Lincoln.

In this frenzy, Gardner didn't join in on the Davis show. But he was
once again enlisted by the federal government for his photographic
copy skills.

Many Americans viewed Davis as ultimately responsible for Lin-
coln's death. They speculated he worked through an elaborate net-
work of Confederate agents in Canada to facilitate Booth and the

conspirators' attack on Lincoln. Lower levels of the Confederate Secret Service had considered plans similar to Booth's to abduct Lincoln.[11]

On May 2, President Johnson issued a proclamation, stating that the murder of Lincoln was aided by Jefferson Davis, the former Confederate president; Jacob Thompson, a leader of the Confederate Secret Service; Clement C. Clay, a Confederate senator from Alabama; Nathaniel Beverley Tucker, a journalist and economic agent of the Confederate government; George N. Sanders, who in Canada was allegedly involved in plots to assassinate heads of state; and William C. Cleary, who aided efforts in Montreal, a harbor of Confederate guerrilla-warfare plans, to wreak havoc on the Union.

With Booth dead and his main conspirators captured, Colonel L. C. Baker worked on his most-wanted Confederates list.

> Colonel L. C. Baker has had photographs of Davis, Tucker, Clay, Sanders, Cleary, and Thompson, with full descriptions of their stature, hair, eyes, &c., prepared on large handbills, stating the price set on the heads of each one, and their crime, of being accessories to the assassination. These handbills, similar to the rewards offered for horse thieves, will be posted through Canada and Europe, so that these criminals, should they be allowed to escape via Halifax, will be tracked wherever they go and marked forever. There is no sequestered spot for them. No rest for them in the world.

Aside from Davis being caught, most of the others evaded capture.

———•———

MEANWHILE, THE TRIAL of the conspirators lumbered forward. Things came to a temporary halt on May 23 in honor of the Grand Review, a military procession honoring the Union army and its victory. As troops thudded down Pennsylvania Avenue, where Lincoln's casket had drifted by a month before, Mathew Brady captured pictures of the grand march. It was supposed to be the ceremonial end of the Civil War, but the flags flapping in the breeze at half-mast signified the real war wouldn't end until the fate of the eight Lincoln conspirators was decided.

As the trial wound to an end, the cartes de visite pioneered by Brady and Gardner became a major point of contention. Particularly a

point prosecutors made to gauge potential Confederate sympathies of the suspects—especially those of Mary Surratt.

Brady and Gardner made the faces of generals known to households across the North and South. Their images were sold in bookstores and print shops in big cities and small towns. The small pieces of heavy paper transformed once unrecognizable men into celebrities. Union officials strongly believed anyone who possessed a trove of images of Confederate generals was disloyal.

R. C. Morgan, a War Department official who seized items at Surratt's house the night she was arrested, testified he had found cartes de visite of Confederate leaders there—two of Confederate general P. G. T. Beauregard, one of Confederate president Davis, one of Confederate vice president Alexander H. Stephens, a card with the arms of the State of Virginia, and two Confederate flags emblazoned with the description "Thus will it ever be with tyrants; Virginia the mighty; Sic Semper Tyrannis."[12] Similar to the words allegedly uttered by Booth after Lincoln's murder. Later, Lieutenant John W. Dempsey, who also searched the house, said he looked at the back of a framed lithograph on the mantel titled *Morning, Noon, and Night* and found a picture of John Wilkes Booth.

Captain William Wermerskirch was there that night. He was questioned by Mary Surratt's lawyer about the importance of the pictures, inferring the defendant's possession of them meant very little to her guilt or innocence. "Have you ever seen the photographs of Booth in the hands of persons supposed to be perfectly loyal?" Aiken asked. Wermerskirch replied, "I have seen photographs of him in the hands of persons perfectly loyal, but only in the hands of those who took an interest in having him arrested."[13]

Twenty-two-year-old Anna Surratt, who was arrested and separated from her mother the night the pictures were found, testified in Mary Surratt's defense. Anna Surratt was intelligent and neatly dressed.[14] Her testimony broke up the mundaneness in the courtroom. Her emotions were fragile. Her family had been torn apart. Her mother was on trial and potentially facing death, and her Confederate agent–brother John Surratt, Booth's friend, was hiding in Canada after learning of the assassination.

A prosecutor asked Anna if she knew Booth's picture was hidden behind the frame. She said yes. She had put it there. Anna Surratt said she had gone with Honora Fitzpatrick, a young woman boarding at her

mother's house, to a photo studio. "I went one day with Miss Honora Fitzpatrick to a daguer-rean gallery to get her picture (she had had it taken previously), and we saw some of Mr. Booth's there; and having met him be-fore, and being acquainted with him, we got two of the pictures and took them home," Surratt testified. "When my brother saw them, he told me to tear them up and throw them in the fire; and that, if I did not, he would take them from me; and I hid them."[15]

Surratt was asked if she owned any other photographs of rebel leaders. "Yes sir," she said. "Davis, Stephens, Beauregard, Stonewall Jackson, and perhaps a few others." Surratt said she got them from her late father. "My father gave them to me before his death; and I prized them on his account, if on nobody else's," she said.

But did she have any pictures of Union generals? Yes, she said. "General McClellan, General Grant, and General Joe Hooker," Surratt said. Although the Surratt house had a picture of President Jefferson Davis, it didn't have one of President Abraham Lincoln.

While testifying, Anna Surratt scanned the audience, looking closely at each face. She wasn't concerned with pictures. She was looking for her mother. "Where is she?" Anna Surratt asked.[16] She was given no answer. Finally, as her testimony concluded, Surratt began crying. She was almost forced out of the room as she again asked, "Where is mamma?" "She had looked in vain for her mother's form," the *New York Times* wrote. A crowd in the room stood in front of Mary Surratt to block her from her daughter's view. "Mrs. Surratt was for the first time since the commencement of the trial bowed down with grief, and she wept like a child as her daughter's form passed out of the court-room, and tears of sympathy came in abundance from the female portion of the audience," the *Times* continued.

Both Anna Surratt and Mary Surratt would have many more tears to wipe. The case headed for a close in June, as Washington embraced a humid summer bringing sweat to everyone's brow. It would be a long summer for the Surratts.

John Bingham gave the closing summation for the federal government. They prosecuted all of the conspirators together and even John Surratt in absentia. "That Mary E. Surratt is as guilty as her son of having thus conspired, combined and confed-ated to do this murder, in aid of this rebellion, is clear," Bingham said. "First, her house was the headquarters of Booth, John H. Surratt, Atzerodt, Powell and Herold. She is inquired for by Atzerodt; she is inquired for by Powell, and

she is visited by Booth, and holds private conversations with him. His picture, together with that of the chief conspirator, Jefferson Davis, is found in her house."

The military commission began considering the arguments and the evidence on June 29. Washington braced for the decision, but life seemed to move forward after months of grief. One sign was that Grover's New Theatre on Pennsylvania Avenue was showing a comedy: *Our American Cousin*, the play Lincoln watched when he died.

Washington didn't know how quickly the judgment would come. The commission worked fast. It took just a majority vote of the nine men to convict. Six votes of the nine were needed to inflict the death penalty. Despite hundreds of witnesses and more than a month of testimony, the commission made their decision in about a day. It was submitted in secret to President Andrew Johnson for approval.

Alexander Gardner knew the decision was coming. And he knew he would finally have his chance. The cartes de visite that dominated the Civil War—and were much talked about during the trial, bolstering the government's case—were not his specialty. That was for his rival Brady.

Gardner wanted to do something new and different. He wanted to capture a live event in all of its complexity, like he was unable to do on the battlefield. If the commission mandated the death penalty, he would have his chance. As the conspirators sat in their cells and wondered about their fate amid sleepless nights, Gardner's cameras were ready.

14

The Gallows

— July 6, 1865 —

WASHINGTON'S OLD ARSENAL Prison echoed with the sound of impending death. A strange percussion of hammers and saws rip-roared through the brick-walled military complex—and it continued with purpose.

Samuel Arnold stood in his dirty cell that afternoon and took note of the "mysterious sounds" coming from the prison's courtyard.[1] He worried the noise signaled his fate. Maybe they were building his coffin? Arnold, who had backed out of John Wilkes Booth's plot to murder the president three weeks before the attack but had stood trial for his association and involvement in an abduction plan, was awaiting the military commission's verdict and sentence. Isolated from the world, he counted the number of bricks in his cell to distract his mind from the clatter. One, two, three . . . The act calmed him into thinking that carpenters were simply making repairs to the building. But in the back of his mind were the military commission and their secret deliberations of the trial of the Lincoln conspirators.

The commission had quickly rendered its decision, but kept nearly everyone in suspense for five days. The sounds Arnold heard while he counted bricks were spurred by Major General Winfield Scott Hancock. He had walked through the arsenal gates with four death warrants. "In accordance with the directions of the President of the United States, the foregoing sentences, in the cases of David E. Herold, G. A. Atzerodt, Lewis Powell, and Mary E. Surratt, will be duly executed at the Military Prison near the Washington Arsenal between the hours

of 10 o'clock AM and two o'clock PM July 7, 1865," wrote Hancock to the prison's commander, John Hartranft. The sentence ordered that the four be "hung by the neck" until dead.[2]

While Arnold's name wasn't on the death warrant, it wasn't good news for him. The military commission had sentenced him to be imprisoned "at hard labor for life." The same sentence was given to Dr. Samuel Mudd and Michael O'Laughlen, while Edmund Spangler got the sentence of hard labor for six years.[3]

Hartranft entrusted Captain Christian Rath to be the "executioner." Rath was an old military friend of Hartranft, and the two often bonded over their love of fine animals.[4] Rath retrieved blueprints for building a gallows and then put his men to work. At first he had trouble. The arsenal carpenter nearly fainted when he heard the order. He had never built a gallows. But soon, within the arsenal walls, a giant death apparatus took shape in the form of a twenty-foot-tall wooden scaffold to hang four of the eight Lincoln assassination conspirators. It was much grander than anything constructed on the battlefield. Rath's men hammered together a staircase leading to a ten-foot-high platform big enough to hold about twenty people and drop at least four of them to their deaths through hinged trap doors—all at once. The builders had to swing their tools fast. The order gave them less than forty-eight hours. As usual, Secretary Stanton wanted things to move with speed.

The stage was being set for a giant spectacle. The scaffold would serve the utilitarian purpose of breaking the necks of the condemned, but also as an unintentional backdrop for Alexander Gardner, who was on his way to inspect the scene.

At the White House, President Andrew Johnson coughed and wheezed from an illness as he worried about the coming days and their impact on his divided country. The *New York Times* reported that his health on July 5 "was somewhat improved," but that he still kept to "his chamber and refuses to receive visitors." In fact, Johnson had received visitors. Earlier that day, he signed the military commission's guilty verdicts and death warrants and sent them with a messenger to General Hancock, the man in charge of the operation. The act threatened the nation's brittle peace. Troops were marshaled to prepare for protests or riots in a city built at the crossroads of North and South.

As the government prepared for the executions, unknowing newspaper editors focused on gossipy items about the city's political and

military elite. Frederick Seward, the secretary of state's son, who had been stabbed by conspirator Lewis Powell in the plot to cripple the U.S. government, was still recovering from his wounds. General Henry Halleck, who had watched Lincoln die and was a pallbearer at his funeral, was preparing to summer in New York before heading to San Francisco to take charge of the Department of the Pacific. And President Johnson, of course, was reportedly quarantined while recovering from a sickness.

Alexander Gardner knew what the newspapermen did not. The Scotsman, whose ingenuity had transformed battlefield photography into art, had walked through the arsenal's gates on July 5 and examined the prison courtyard to scout locations.

During the covert visit, his owlish eyes drifted from one corner to the next. They gazed at the twenty-five-foot-tall courtyard wall crowned with lookout guards, looked at the grassy patch of land etched by the scaffold's shadow, and finally rested on a second-story window in an old shoe factory overlooking the half-built gallows. This view, he knew, offered the perfect place to capture the execution.

Gardner had just returned from spending the July 4 holiday in Gettysburg, where officials laid the cornerstone for a new monument dedicated to the troops who had died there two years earlier. He sold his pictures to *Harper's Weekly*. "The present perfection of the art of photography enables an illustrated paper like ours to depict persons and events with the utmost precision," the illustrated journal wrote. "Among our photographic friends and allies none have been more constant and serviceable than Mr. Alexander Gardner, of Washington. It is to his skill that we owe the interesting and accurate views we print to-day of the ceremonies at Gettysburg on the Fourth of July."

The actual Battle of Gettysburg had produced one of his most memorable series of photographs. It's where he had moved a dead body to take an optimum shot. The photos he took there were so powerful that *Harper's Weekly* reran one of them for the Gettysburg commemoration.[5] But Gardner was frustrated that technology and environmental challenges allowed him to depict only the event's aftermath.

Now authorities were preparing for a choreographed execution in full view of his lens. Something he could shoot in a sequence. He hoped he could use it to expand the new medium while showing the world that America had avenged the murder of its president. Although the government simply wanted evidence that it happened.

Gardner planned a daring task. He wouldn't just take pictures of the condemned after they were executed. Rather, he would orchestrate a two-camera shoot aimed at capturing the scenes like a live-action play: as the conspirators walked to the gallows, as the ropes were looped around their heads, as the execution order was read, as they dropped to their deaths. If all went well, and he was able to make the pictures amid the elements, America would experience the event as it happened, bringing them to the foot of the gallows.

Gardner had spent years building relationships within the government. Throughout the war, he bonded with fellow Scotsman Allan Pinkerton, the Union's former chief intelligence officer, and helped him spy on the Confederates. Pinkerton returned the favor by helping Gardner gain exclusive access to the most pivotal battles of the Civil War. And he was a fellow Freemason with General Hancock, a relationship that helped get him through the arsenal's prison doors before just about everyone else. Gardner's pass to the arsenal was dated July 5—a full two days prior to the execution. He was informed of the impending executions before the public or the conspirators, whom he had photographed several months before aboard the *Montauk* and *Saugus*.

Gardner was the only photographer given a pass. There would be dozens of newspaper reporters, sketch artists, but only one photographer. Not even Brady would be allowed entry. Only fifty passes would be available to outsiders to witness the hangings in person.

After surveying the gallows, Gardner returned to his studio. There, amid the life-size imperial portraits of Lincoln that he had revolutionized years earlier, he worked deep into the summer night on his next conquest. The end of the war had threatened to crush the public's desire for pictures of battlefields, but Lincoln's death and the hunt for those responsible had buoyed Gardner's business. His contract with the federal government didn't hurt. He wanted it to continue.

As Gardner and his staff prepared to preserve and bring this surprising coda to Lincoln's death into every farmhouse in the country, Washington remained in the dark. A sense of doom had settled over the city's muddy, tobacco-stained streets. The trial of the conspirators had been over since June 29, but their guilt or innocence still had not been made public by the military tribunal that heard the evidence. Days passed as Confederate sympathizers lurked all around. In stuffy parlors and dimly lighted brothels, many wondered and worried if the result would stoke the burning embers of rebellion. The reminders of

war were everywhere. Mathew Brady's photos of a burned-out Richmond, with its blasted buildings and broken bridges, had gone on display, reminding rebels of what had been done to their former capital. And Brady's hard-fought portrait of Robert E. Lee, with the general sitting in a rocking chair framed against a panel door that looked like a cross, was selling by the thousands, giving Southerners the image of a hero to carry in their pockets. A few blocks away, the Ford brothers struggled to reopen their theater after a plan to transform it into a "Lincoln monument temple" failed.[6]

Newspapers bubbled with unconfirmed rumors of guilty verdicts—news that put the divided nation—and city—on edge. Some Washingtonians sought refuge from the uncertainty by reading of a tawdry criminal case. Jury selection had just been completed for the trial of Miss Mary Harris, a nineteen-year-old beauty from Chicago who had boarded a train for Washington after reading an engagement announcement about her fiancé's intent to marry a socialite in the city. Harris, wearing a blue veil and black cloak, hid in a closet at the Treasury Building, where her lover worked as a clerk, before jumping out and fatally shooting him.

The sun had baked the capital for more than a week—and it showed no sign of easing. On July 4, temperatures approached the high nineties and ended Independence Day celebrations. The city fell into a scorched malaise as the humidity soaked shirts and dresses alike. In Georgetown the "streets were nearly deserted after breakfast." Across the rest of the city, people fled for the country. "The dawn of another Independence Day was ushered in yesterday by the usual firing of guns by men, and rattling of firecrackers and toy artillery by the children," the *Evening Star* reported. "It did not last long, however, for the young folks and large proportion of their elders, had arranged for an exodus from the dust and heat of the city to the shady groves in the surrounding country there to enjoy the day. Soon after sunrise, vehicles of every description, freighted with young and merry lads and lasses, with baskets and boxes closely packed with the requisites to make a picnic agreeable at dinner time were seen moving to the northern suburbs."[7] Washington's military leaders hoped the heat wave and exodus would squelch any uprising from Confederate sympathizers upset by the executions.

WASHINGTON BRACED FOR the news. On Thursday, July 6, the *New York World* and other newspapers announced that Johnson had seen the findings of the military tribunal and would soon make them public. Newspapermen crisscrossed town, hunting the story.

At the prison, Generals Hancock and Hartranft entered the cells of the defendants with sealed envelopes containing their fate. Hartranft read the sentences to each prisoner and handed them written copies. Lewis Powell greeted the news with nonchalance. Like death was a "forgone conclusion." Powell was a preacher's son, but he was estranged from his family. He requested to see a Baptist clergyman. George Atzerodt became "violently agitated" when he learned the news and then became catatonic. A Lutheran minister came to his cell. Mary Surratt, who many believed was unfairly convicted, was visited last. David Herold listened to the reading of the death warrant with "boyish indifference." His emotions, though, soon buckled with the gravity of the situation. Five of his sisters soon came to see him. They wept as they left their brother a basket of cakes and delicacies.[8] Surratt burst into tears after the death sentence was read and pleaded for four days' additional time and then asked to see several Catholic priests along with her daughter, Anna. Hancock, sympathetic to Surratt, sent for her at once.

Outside the prison walls, newsboys rushed into the streets that afternoon crying, "Extra!" as the *Evening Star* declared in big black type that four of the conspirators would soon die. "EXTRA. THE CONSPIRACY . . . Mrs. Surratt, Powell, Herold, and Atzerodt to be Hung!! The Sentences to be Executed Tomorrow!! Mudd, Arnold, and O'Laughlin [*sic*] to be Imprisoned for Life!" The news traveled throughout the city by word of mouth. Men on horses carried it even farther.

All day, the news was shouted and discussed in the city's houses and hotels. Most approved of the decision but questioned the hasty execution. The bodies would drop in less than twenty-four hours. "The general sentiment seemed to justify the findings of the Commission, but the short period of time allowed the prisoners between the announcement of the sentence and their execution did not generally appear to meet the public approval," one reporter wrote on July 6. "This, however, is in accordance with the practice of courts-martial, sentences in such cases being executed almost immediately after the findings are officially published. It was intended that the announcement should

have been made this morning in the papers throughout the country by the Associated Press, the decision the president having been made yesterday, but owing to some misunderstanding it was not announced till today." The *New York Herald* said, "The reasons for such apparent haste are undoubtedly to satisfy the public desire for execution to follow swiftly on the heels of judgment, and to also escape the thousands of useless intercessions and importunities that would be made for pardons or commutations of sentence were the executions postponed for sixty or even thirty days."[9]

Washington residents were surprised that Surratt got a death sentence. Men whispered to one another that it wouldn't be carried out. There was no way the United States would kill a woman, they thought. "The feeling springs from a universal repugnance to hanging a woman, no matter for what offense," the *New York Herald* wrote.[10]

John W. Clampitt and Frederick A. Aiken, the two lawyers who defended Mary Surratt, picked up the extra edition and learned their client was set to be the first woman executed by the U.S. government. Hoping to get a reprieve, Clampitt and Aiken headed to a Washington civil court and interrupted the trial of Mary Harris, which was already in progress. They argued and won a writ of habeus corpus, but they were unsure if it would do any good, since Surratt had been found guilty in a military court. The two lawyers hunkered down and researched their possible legal maneuvers.

Anna Surratt couldn't bear the thought of watching her mother hang. Stricken by grief, she headed to the White House, determined to keep her mother alive. She bolted through the executive mansion's front doors and to the foot of the staircase leading to the president's office. A guard stopped her and steered her to the East Room, where she demanded to see the president. The president wasn't taking visitors, she was told. With only a few hours before sunrise, Surratt left.

East on Pennsylvania Avenue, General Hancock was at the Metropolitan Hotel. The aging structure, stitched together by combining a row of Federal-style townhouses, had a glimmer of its past history, once having housed the inaugural balls of Presidents James Madison and James Monroe. Some fifty years later, it served as Hancock's house and base of operations during Washington's darkest times.

These days, Hancock was a wanted man. He had a limited number of passes for people to attend the executions, and they were the hottest tickets in town. Knowing that Hancock was moving around

the city, newspapermen posted lookouts up and down the various avenues, hoping to get a glimpse of his carriage so they could pounce for an audience. "At the Metropolitan Hotel . . . a great crowd assembled, in hopes of meeting him and procuring passes to the execution," a reporter wrote. "His letter-box was filled with letters and cards that projected like a fan, and for a time the entrances to the hotel were completely blockaded." The passes were limited to members of the press, a few necessary witnesses, and army officers. "Gen. Hancock's headquarters were besieged for passes," wrote the *Washington Evening Star*. "The rule of limitation, however, was strictly adhered to, and none permitted to attend the execution for the mere gratification of curiosity." The *New York Herald* wrote that the newspapermen were "under obligation to General Hancock for his kindness and disposition to facilitate their labors."[11]

Reporters surrounded the Washington Arsenal gates. They cared little for the interplay between Gardner and Brady—and that Gardner would be the only photographer with a pass. The working press hadn't yet realized the power of the picture—the ability to describe a scene with zero words but raw emotion in shades of black and white. Many newsmen assumed the event would be witnessed by the select few pressmen, not recognizing that Gardner planned to show it to the world. The *Philadelphia Inquirer* editorialized, "The criminals are undeserving a public death, and the false sympathy which might be gotten up in such a case among the multitude, to say nothing of the 'mock heroic' character which would surround them in the eyes of their Rebel friends, is avoided, and they will pass away and be remembered only as culprits who were destined to die as the vilest and lowest villain who murders his victim in an alley or on the highway." Their deaths would be public if Gardner had his way.

That night, executioner Christian Rath was at the Old Arsenal Prison knotting together ropes to make four nooses. The great scaffold stood in the distance. It was now done, waiting for its day in the sun. Rath grew tired and put less effort into the final noose. He tied the nooses onto the crossbeam of the gallows and then took a length of rope for a test. Rath needed to do a trial run. "I took a length of it out behind the prison, filled a bag with shot, and climbed out on the limb of a tree," Rath said. "A crowd stood around, watching me, interested in the experiment. I threw the bag from the limb, first securing it to the rope. It brought up with a jerk, the limb broke off short, and I was precipitated

to the ground with great force. But the rope held. I was bruised a little, but I didn't care, as my experiment had proved a success."[12]

While Rath practiced execution, his subjects prepared for their last night on earth. No relatives visited Powell. He slept well for about three hours and then spent the rest of the night talking to his minister. George Atzerodt was visited by his brother and elderly mother—the latter scene was reported to have brought the prison officers to tears. Herold was visited by more sisters and was able to get some sleep. Mary Surratt didn't sleep at all. She stayed up all night crying with her daughter and suffering pains and cramps caused by her nerves.[13] A physician gave her wine and valerian.

The sketch artists created their own scenes from the news. Powell in his lonely cell. Herold surrounded by weeping sisters. Surratt shrieking with grief before her priest.

Powell expressed deep regret Surratt was sentenced to die. He felt responsible for her entanglement in the whole affair because he showed up at her house when it was being searched.

General Hancock went to sleep that night unsure of how many conspirators would hang. He thought the president might grant Surratt another chance at freedom. The *New York Times* reported, "It is believed that Mrs. Surratt's sentence will be commuted to imprisonment for life. Such appears to be the general desire so far as can be determined this evening."[14] Hancock ordered cavalry officers to be ready to ride from the prison to the White House at a moment's notice if President Johnson changed his mind. He wasn't taking any chances.

Neither was Gardner. The photographer's mind raced with the possibilities but also the problems. He surely fretted about all of the obstacles. Particularly the things he couldn't control that could ruin a picture. The movement of the weather. The movement of the crowd. The movement of the bodies. The movement of time. Gardner and his team would have only an hour to take his wet-plate negatives coated with chemicals and develop them. Sixty minutes in what promised to be unrelenting heat and humidity.

As revelers celebrated the coming executions on the street outside of Gardner's studio, the photographer prepared his mobile development station for the morning and stocked it with supplies. One o'clock would come too soon.

It's unclear if Gardner expressed any apprehension of his assignment. Inside his studio were the mug shots he had taken of the Lincoln

conspirators in April. Perhaps it was a good omen for Mary Surratt. She was the only one who escaped his lens and didn't sit for a picture. Still, Gardner knew the men who were about to die. He captured their faces in life, and now their hooded heads would soon be snapped in death.

15

The Execution

— July 7, 1865 —

THE TINY SHADOWS of guards crowned the tall prison wall like toy soldiers neatly lined on a parlor table. Alexander Gardner crouched in a nearby building and pointed his lens at the men and then focused it on the wooden scaffold below. Assistant Lawrence Gardner stood next to him and did the same. They were like trained assassins— but with heavy cameras on their tripods instead of guns. Four years of battlefield practice came down to this moment.

It was shortly after eleven o'clock in the morning. The sun fired through the clear sky as thermometers approached one hundred de- grees. Birds caroled. Steamboats puffed down the Potomac. Sketch artists made drawings. Old men told old stories—until the familiar summertime beat was interrupted by a loud thud. Trapdoors dropped open. A rattle reverberated through the brick walls of the United States Arsenal. This was no ordinary day in Washington.

Reporters heard the rumbling sound and jerked their heads toward the arsenal's prison yard. They were relieved by the sight. It was a false alarm. The prison guards were just testing their death traps by knock- ing out wooden beams made specially for the scaffold. There were two drops, held up with the beams, connected to the back of the platform. They flapped with creaky hinges. One drop stuck on the first try, so a carpenter was called to make it work. On a second try, it "worked per- fectly." But William Coxshall, the war veteran charged to operate it, said, "We weren't confident it would all happen as it should." He won- dered, would it work when it held live bodies? It needed to. Captain

Christian Rath didn't want to go through this again. Plus, it was a custom in some parts to let a prisoner live if he or she survived the first attempt at execution.

Rath wondered if Mary Surratt would make it to the scaffold. His order was to hang four Lincoln conspirators by two o'clock in the afternoon. But Surratt's lawyers were making a last-ditch effort to save her life as she sat in a prison cell crying. Her daughter, Anna, had gone to the White House once again earlier in the morning, but to no avail. Now she was ensconced with her mother in her cell, saying good-bye and hoping it wouldn't be the last time she saw her alive.

Everyone was on edge. Reporters scrambled for news and questioned exactly when the event would happen—and how many would hang. Just about any sound caught their attention. From the shrieks of the condemned to the twists of prison key locks to the knocks of boots on the hard floor. That is to say, they were sensitive to noise.

By noon, the crowd of witnesses had increased at the penitentiary yard. Then the click of a hammer was heard coming from the second-story window of the shoe workshop where Gardner was perched. "The eyes of all were turned in that direction," a reporter wrote. "Presently a window was raised, and forthwith was seen protruding the familiar snout of the camera, showing that the inevitable photographer was on hand. Gardner's good-humored face presently was seen over the camera, as he took 'a sight' at the gallows, to see that it was focused properly."

Yet another false alarm. The arsenal complex resumed its busy buzz. "The work is being tested in view of us while we are writing—all is confusion and bustle—the precious moments are flying, and we must also fly to our task again," a reporter for the *Washington National Republican* wrote. The reporter justified his presence at such a macabre affair. "However repulsive it may be to others," he wrote, "the Reporter for the public press has to be present, and becomes almost ubiquitous on such occasions, rushing wildly about seeking for items, catching at every little straw and waif that is floating down the stream of history."[1]

Gardner's purpose was much different. He wasn't looking for little bits and pieces. He was looking for the big pictures. He wanted to tell the story as a whole with his long lens. For history. It wouldn't be easy.

The seconds ticked forward. Words were carefully formed.[2] Time was precious both for the conspirators who were about to die and for

the photographer who wanted to capture it. His assistants stood at the ready to rush his delicate chemical-laden plates to his portable darkroom. Everything needed to be perfect, or the moment would be lost forever.

As he waited, Gardner's camera panned across the landscape. Off in the distant view, crowds clamored at the arsenal gates, where throngs of troops were posted with steel muskets and bayonets that glistened in the sun.[3] The crowd swelled. The people—lawyers, doctors, blacksmiths, ministers, drunks—came to Washington the night before, as soon as they heard the news of the impending executions. Trains dropped off loads of travelers from the North. Country roads were slammed with pedestrians. Boats from Alexandria clogged the Potomac shoreline.

City hotels were filled. Travelers even took rooms at the National Hotel, where Booth once lived. Inside Hammack's Restaurant at Pennsylvania Avenue and Fifteenth Street, army and navy officers dined on French cooking amid execution thrill seekers. At the Capitol Saloon, at barrooms across town, men slugged whiskey and gossiped about Mary Surratt's fate. "Everyone had his pet theory, but it concerned Mrs. Surratt alone—the fate of the others seemed certain," the *New York Times* said. All of the men, of course, had planned to see Surratt's face in person. "Everybody who had a cousin or a grandfather thought of course *they* could get in," a reporter wrote, "but they found out they couldn't unless they had that little bit of paper called a pass."[4]

Few, if any, of them did. One poor veteran, with a thick Irish accent, exclaimed, "Arrah and be jabbers, if there was a battle going on there they wouldn't keep us out o' there."[5] Rich men offered hundreds of dollars for the few tickets available. The efforts to obtain the limited number of tickets weren't successful. "The public generally were therefore obliged to wait until the newspapers should furnish the accounts of the solemn scene," the *New York Herald* wrote.[6]

There was no worry of their storming the gates. Three thousand guards were on hand, although few of them would witness the execution. Most roamed the arsenal grounds. The arsenal, positioned square in the heart of an Irish immigrant neighborhood, was a large storehouse of cannon balls, mortar shells, and gunpowder. It was the nation's largest arsenal, protecting a city that once was the conquest prize of the now vanquished South. The complex, which included the prison where the Lincoln conspirators were housed, was like a little

city. It had handsome buildings, trim lawns, ancient trees, and sloping banks. Hundreds of people showed up for work there every morning to make the weapons of war. Sometimes it was like a sweatshop. The year before, on June 17, 1864, an outdoor explosion rocked the complex. Flares were shot into a nearby building, causing a fire. Young women who worked inside jumped out of windows in a panic. Their dresses helped spread the fire. By the end, all that was left was "the wire of their hooped skirts."[7] Twenty-one people, mostly young Irish immigrant girls, were killed. The cause was red star fireworks laid out to dry that had accidentally ignited. The culprit was the heat.

Heat was now Gardner's obstacle as the clock ticked toward one o'clock. It threatened his chemicals and his plates. And so did the flies. They were everywhere. Especially out in the courtyard, where off-duty soldiers laid on their backs in green grass and relaxed in the shade. Horses were posted nearby amid "the innumerable pests of flies that are besetting them as if to drive them mad."[8] Such was life on that sliver of a swamp.

Double guards lined the road from Fourth-and-a-Half Street at city hall south to the arsenal. "Washington streets are used to troops, but somehow or other the little bodies of pickets stationed all around have a portentous appearance this morning," a reporter wrote.

That morning, like usual, one hundred soldiers showed up at the arsenal, ready to work on anything that needed to be done. Rath greeted them. Today, he said, he needed volunteers. He wouldn't—he couldn't—command them "to take part in the gruesome work" ahead. "I was simply overrun with volunteers," Rath said. "Seemingly they regarded it as an honor to serve in any capacity in avenging the death of Lincoln."[9]

Rath looked them over with a close eye. He chose two husky fellows to knock the posts from the platform under the drop and then instructed them on signals. He chose four others to place the nooses around their necks and three others to lead the condemned to the gallows. Rath, still unsure of Surratt's fate, said he personally selected Lieutenant Colonel William Henry Harrison McCall to lead Surratt. "I didn't want any ordinary soldier to lay his hands on her," Rath said. Rath promised to give them each a drink when it was over. They would need it.

Rath and McCall surveyed the prison courtyard. Gardner passed through and got them to pose for a picture along with several others.

General John F. Hartranft, the prison commander, was seated in the middle. He looked like a man on a mission. His bushy mustache protruded down like a bloodhound's ears. Stanton wanted the finest men used for the execution, and Hartranft thought he had them. To his right was McCall, who sat stoically, with a brave face. On the end was Rath. He sat sunken in his chair and looked off into the distance. "Had I known what I would have to do there, I would never have taken the office," Rath said later. He had developed personal connections with the prisoners. It was hard to see them die.

The camera did not capture General Winfield Scott Hancock. Some wondered if he was away handling Mary Surratt's potential reprieve. That was the only reason he would be this late, they thought. Hancock did not think Surratt should die.

Reporters scurried about the yard and scribbled on pads and notebooks. Prone to half-truths and untruths, the reporters transformed the prison yard into a sounding box of rumors. They said Powell had made a confession absolving Surratt of her accused involvement, that Surratt's writ of habeus corpus had been granted, that General Hancock had refused to execute it and had been arrested and then freed by President Johnson.[10]

While the reporters gossiped, the relic hunters couldn't be kept away, even with the strong presence of a military guard. One man took wood chips from the gallows. Another snatched about an inch of rope used for the nooses.[11]

Hancock arrived in the penitentiary hallways sometime after twelve o'clock. He walked with a hurry and inspected the yard. The death warrant said the conspirators should be killed by two o'clock. His lateness delayed the execution. Time was running out. Hancock said a few hushed words to Hartranft, who nodded. Hancock then spoke in a louder voice. "Get ready, General," he said. "I want to have everything put in readiness as soon as possible."

Hancock was as fast as he was tactical. A West Point graduate who served in the Mexican-American War, he became a hero at Gettysburg, where he was given the nickname "Thunderbolt of the Army of the Potomac." In pictures, his hair swept to the back of his trim head. He was a Democrat, but party affiliation was superseded by the fact that he was a military man. Orders were his duty. "Never was a hero called in the bright and open day to see such a deed done," an eyewitness remembered. "Hancock was. He obeyed the call, and saw

that the hangmen were protected; that the assassination was not inter-rupted. How his spirit rebelled at the task that was written on his broad face."[12]

The scaffold dominated the south courtyard. Gardner kept it in his focus. It was placed between the shoe factory, where he was perched, and the prison's east wall. Within about ten steps of the gallows was a pile of red dirt freshly dug from the ground. The prisoners would see their graves when climbing the thirteen unlucky steps of the scaffold before being dropped five feet to their deaths.

Gardner kept his cameras ready. At twelve forty, four wooden arm-chairs were brought out and placed on top of the scaffold.[13] They were carefully positioned on top of the trapdoors. The whole scene looked like a stage being set for a play. The sudden sound of weeping and cry-ing wafted through the yard. Inside the gloomy prison, the conspira-tors had been separated from their families and left in the care of their spiritual advisers. David Herold's sisters screamed. Anna Surratt was yanked from her mother's cell in hysteria. Gardner made his first pic-ture, reporters milled about in conversation, guards posted atop the wide prison wall stood in wait, and some sat and dangled their legs over the ledge.

One thing Gardner's view didn't show was the heat. "The sun in the meanwhile shone down on the whole ghastly scene as fierce in its unclouded splendor as ever shone on the hot sands of Syria," a witness wrote.[14]

Gardner's eye was fixed on the iron prison door, where he waited to see his subjects. It opened and closed with a loud slam. Hancock walked out with newspaper reporters in tow. He told an orderly to mount his horse and wait at the arsenal's outer gate on Four-and-a-Half Street. "Should you see a mounted soldier riding this way, then ride here and tell me," Hancock told him. The reporters asked Han-cock if Surratt would get a reprieve. "I expect nothing," Hancock re-plied. "That woman, however, shall not lose a chance at life, if I can help it. That's why I sent that orderly to the gate."[15]

Hancock surveyed the prison yard one final time. Everything looked ready. The general headed back inside. The reporters took their place at the scaffold.

The penitentiary held more than two hundred people and was pinned at the north end of the arsenal complex. Throughout its his-tory, its most notorious inmates were involved in less sensational

crimes than Surratt, Herold, Powell, and Atzerodt. Harry H. White burned the Treasury Department. Edward Hall was a counterfeiter. John B. Henderson was a forger. Edward Mooney was a mail robber. Joseph Allemander was a silver thief.[16]

Out in the yard beneath Gardner's camera, the two-hundred-person crowd of spectators and reporters asked one another, "Will there be a reprieve?" "Will Mrs. Surratt be executed?"[17] Just after one o'clock, they got their answer when someone murmured, "Here they are." The prison door swung open, and out walked Mary Surratt. She was held upright by two guards. There was no doubt the Maryland widow was destined for the gallows ahead. She wore a black twill dress. An alpaca bonnet topped her head and shrouded her face with a thin veil. The bright sun bore through the veil, and reporters could see her face. "Her upper lip, as sometimes seen in the newly dead, curled upward from the now incomplete teeth, which added greatly to the ghastliness of her expression," one *New York Herald* reporter wrote.[18] The newspapermen colored their descriptions through their political view of the case.

Two priests, Father Jacob Walter and Father Bernardin F. Wiget, held an umbrella over Surratt's head. Moments before, in the quiet of the penitentiary, they had prayed her last rites. Father Walter firmly believed Surratt was innocent. The day before, when an orderly gave Walter a pass for entry to the arsenal, the priest said he had followed the trial and there "was not enough evidence to hang a cat." "Besides," he said, "you cannot make me believe that a Catholic woman would go to communion on Holy Thursday and be guilty of murder on Good Friday."[19] Her lips moved rapidly in prayer. Her wrists and ankles were ironed. Father Walter clutched a crucifix as Surratt gazed up at the death apparatus. She nearly fainted.

Behind Surratt was George Atzerodt. He looked like a haggard drunk, wasted by yet another sleepless night. He wore the same pepper-colored baggy suit that he had worn at trial. Carpet slippers protected his feet for his final steps as his oversize pants lopped at his ankles. No wonder he walked with a shamble. A Lutheran minister accompanied him.

David Herold came next. Dressed in a black coat, black hat, and white collarless shirt, he trembled violently. He was a mere boy. "The young man was frightened to death," said William Coxshall, one of the veterans chosen to drop the trapdoor of the gallows. "He trembled

and shook and seemed on the verge of fainting." Then he rallied and attempted to engage those around him in conversation.

The one prisoner who was not afraid was Lewis Powell. He was the only one who ate breakfast earlier in the morning—and he ate it heartily. When he followed Herold, his blue eyes sparkled as he marched to the gallows. They said he had the bravery of a lion and the unconcerned look of a spectator. In fact, one observer said he walked like a "king to be crowned." "Powell was bareheaded, but he reached out and took a straw sailor hat off the head of an officer," Coxshall said. The hat was too small for Powell's large head, adding a bit of comic relief to the otherwise dour proceeding. It was gallows humor, if such a thing existed.

The condemned were followed by a procession of officers on parade. They climbed the steps of the scaffold and were greeted by Christian Rath, their hangman. He directed them to their seats. "I wanted to give Mrs. Surratt any honor I could," Rath said. "So I seated her on the right, Powell next, then Herold, and the German fourth." Powell, it was said, sat down "with as much 'sang froid' as though he was sitting down to dinner."

As Surratt took her seat, one witness looked over, hoping to see the orderly Hancock had sent to the arsenal gate. "There was no sign," the witness said. "I looked at Hancock; his eyes were turned the same way; his usually florid face was the color of ashes. I could see hands open and close nervously. He looked at his watch and his chain oscillated at the touch of his nervous fingers, usually as calm as is the hand of a heavy lymphatic man; for Hancock was both."[20]

The ropes hanging above the upper scaffold beam moved with a summer wind, a welcome relief to the sweating audience. Though not a good sign for Gardner, who needed stillness, not movement. This was one scene he couldn't control. Live news couldn't be directed by a photographer. He coated a plate with chemicals, held his lungs in check, and placed it in his camera. He made his first picture of the arrival on the scaffold and hoped the wind didn't ruin it.

The scene came to life through Gardner's lens. Surratt was shielded from the sun by a black umbrella. Hartranft commanded the scaffold from the center. Beneath his feet, the twenty-two-year-old Coxshall wrapped his fingers around the wooden beam holding up the platform for Surratt and Powell. The heat was starting to get to him. A closer look showed the ravages of war. A finger on Coxshall's left hand was missing, having been blown off during the Battle of Petersburg.

The seconds ticked past as the hot sun passed through the camera and burned the image onto Gardner's plate. He handed it off to an assistant and prepared another. The acrid smell of chemicals permeated Gardner's perch.

The heat grew more intense. Umbrellas popped open across the scaffold. Hartranft read the order of execution. He spoke clearly and methodically in a low voice. "The following named persons were tried, and after mature consideration of the evidence adduced in their cases were found and sentenced as hereafter stated, as follows."

Gardner's lens held the scaffold in full view as Hartranft read from white parchment. General Hancock, holding his sword, stood to his left. A few steps away was David Herold, whose name was read first. He sat facing the audience, squarely in Gardner's frame. His cap drawn down to his eyes. A minister whispered in his ear. Herold's lips appeared to move in prayer. "And the commission does therefore sentence him the said David E. Herold, to be hanged by the neck until he be dead, at such time and place as the President of the United States shall direct, two thirds of the members of the commission concurring therein." The same words were said for Atzerodt, Powell, and Surratt.

On the left side of Gardner's frame, Surratt's black dress puffed out from beneath her umbrella. She was flanked by priests. Father Walter held his crucifix over her like it was an exorcism.

Powell was shielded from Gardner's view by an upper wooden beam. As Hartranft continued reading the sentences, observers said Powell stared up at the gallows as if to inspect its construction. Across the scaffold, a side view of Atzerodt was captured. Someone had tied a white handkerchief around his head to shield him from the sun and trap his sweat. The Union soldiers performed such niceties to the people they were ordered to kill. Even though they would be dead within minutes, they made sure the heat wasn't too much to bear.

Hartranft finished reading the death warrants. Now it was time to pray. A wind gust blew off Powell's new straw hat. Powell motioned that he no longer needed it. Now in Gardner's view, Dr. Abram Dunn Gillette, the pastor of Washington's First Baptist Church, knelt at Powell's side. Gillette spoke for Powell and said Seward's attacker

publicly and sincerely thanks, General Hartranft, all the officers and soldiers who had charge of him, and all persons who have ministered

to his wants, for their unwavering kindness to him in this trying hour. Not an unkind word nor an ill feeling act has been made toward him. Almighty God, our Heavenly Father, we pray thee to permit us to commit this soul into thy hands, not for any claim we have to make it in ourselves, but depending as we do upon the merits of our Lord Jesus Christ, grant, O Heavenly Father, we beseech thee that his spirit may be accorded an easy passage out of the world, and, if consistent with thy purposes of mercy, and thou delightest in mercy, receive him. This we humbly ask, through Jesus Christ, our Lord and our Redeemer. Amen.

The clergy for the other two men, Herold and Atzerodt, also spoke. But Father Walter did not say a word for Surratt. He couldn't. The priest, who publicly pronounced Surratt's innocence, had been placed under a gag order by War Secretary Stanton. Instead, Walter held his crucifix to Surratt's lips. Gardner could see it from his camera lens. Walter prayed as Surratt kissed the cross bolted with an effigy of Jesus Christ. A sympathetic witness in the crowd watched in sorrow and then remembered Hancock's orderly. "I looked gatewards again," he said. "No sign!"

The final moments had arrived. The Lincoln conspirators took their last breaths of Washington's heavy, humid air. Gardner prepared another plate for his camera. Christian Rath had made hoods from a canvas tent. He didn't want to see their bulging eyes or protruding tongues in death. He also cut strips to bind the arms and legs of the conspirators when placed on the scaffold. Now was time to tie them up.

Atzerodt came first, as officers tied his arms behind his back. Then came the rest. Gardner remained posted in the second-story window of the shoe workshop. The shadows loomed over the treeless prison yard. His frame showed the action. The nooses, tied by Rath the night before, were now wrapped around the heads of Herold, Atzerodt, and Powell. Powell was already wearing his canvas hood. His noose was tightened. Herold looked down at his feet as Atzerodt glared off to the side. Guards adjusted the ropes.

Surratt took the most time to prepare for death, as the men struggled with her puffy skirt. Gardner's lens showed at least three men surrounding the feeble woman. The noose, which Rath tied with fewer knots because he didn't think she would die, was eventually placed around her neck and rubbed against her pale skin.

Beneath her, Coxshall struggled to stand upright and clutched the wooden beam. "I was overcome with the heat, the waiting and keeping hold on the post," Coxshall said. "I was very nauseated and vomited." Gardner's view showed Coxshall drooped over the beam, his head downward like a scolded dog. Above the scaffold, the guards along the prison wall stood in silence. They knew the time was near. A reporter took time to note that they "presented quite a picturesque appearance in their elevated position."[21]

The conspirators were told to walk forward to the edge of the scaffold. Coxshall snapped into place. Atzerodt swayed with fear. Herold was still. Powell stood "erect and firm as a gladiator." Rath tightened Powell's noose. "I want you to die quick," he told the prisoner. Powell responded, "You know best, Captain." To the last minute, they said, Powell maintained his "stolid, indifferent, hang-dog manner."

Hancock looked at his watch. Still no one at the gate. It was time. "All is ready, Captain," General Hancock said to Rath. "Proceed."

Rath looked at Surratt. "Her, too?" he asked Hancock. "Yes. She cannot be saved," Hancock said.

Rath knew the four people who were about to die. He pitched quoits with Powell in the penitentiary yard. He once accompanied Mary Surratt's daughter to her home. He kept David Herold's pointer dog at the prison. "I never regarded the prisoners as murderers," Rath later said. "Most of them, I believe, were inspired by sincere love of the Confederacy, and the belief that removing Lincoln they were acting in the good of their country."[22] But that country was dead. They were now facing the final phase of justice in the new United States of America.

Gardner made his picture. He knew the conspirators too. He photographed them in their irons and posed them on the *Montauk* and *Saugus*, preserving their likenesses for the nation. He looked deep in their eyes and studied their faces. His photos not only captured their physical features, but also bore deep into their emotions. Now, more than two months later, their lives had ticked down to a matter of seconds before his lens.

He didn't have time to be sad. His camera needed to be ready if he wanted to capture the bodies as they dropped. Rath and his men had developed signals for when it would happen.

Surratt was pushed out onto the outer scaffold. Her knees buckled. She said, "Please don't let me fall."

Rath climbed down and stood in front of the gallows. Rath said he clapped twice. On the third clap Coxshall and his counterparts swung at the beams with all their might. The traps worked. All four conspirators dropped down all at once. Their bodies bobbed up and down like corks in the ocean. Surratt's body drifted with a swinging motion, but she appeared to die instantly. Herold struggled. Water fell from his body. Atzerodt remained still.

Gardner was able to make a picture as the bodies dropped. He hoped the movement didn't ruin it.

Meanwhile, Coxshall could bring himself to look only at the bodies that fell from his side of the scaffold. "Mrs. Surratt shot down and died instantly," he said. "[Powell], a strong brute, died hard. It was enough to see these two, he affirmed, without looking at the others." In fact, Powell did die hard. His knot had slipped to the back of his neck, causing his body to writhe. "The veins in his great wrists were like whip-cords, expanded to twice their natural dimensions, and the huge neck grew almost black with the dark blood that rushed in a flood to the circling rope," wrote reporter George Townsend. "A long while he swayed and twisted and struggled, till at last nature ceased her rebellion and life went out unwillingly."

The audience stood still for several minutes. They were silent. The bodies, their heads wrapped in cloth, hung before them in midair like meat at a butcher shop. "There they hung, bundles of carcass and old clothes, four in a row, and past all conspiracy or ambition, the river rolling by without a sound, and men watching them with a shiver, while the heat of the day seemed suddenly abated, as if by the sudden opening of a tomb," Townsend wrote.[23]

Gardner had plenty of time to make a clear, still photo of them. The bodies hung in the courtyard for about twenty minutes.

The crowd, largely made up of newspaper reporters, started to buzz again. The whole affair lasted less than a half hour. Now it was time for them to tell the world what had happened. They raced from the courtyard so they could telegraph their dispatches.

Then a soldier climbed a ladder to the scaffold and cut the rope holding Atzerodt's body. The body fell with a heavy thump. The soldier was reprimanded, and the rest of the bodies were lowered and cut down in a more dignified manner. Rath himself took charge of Surratt's body, saying he didn't want anyone to desecrate her. Doctors pronounced the four conspirators dead. Even though her noose contained

fewer knots than the others, Surratt appeared to have had the easiest and cleanest death.

The bodies were placed in pine gun boxes and carted to the nearby open graves, which were featured in another Gardner photo. Shortly after two o'clock, the dry Washington clay dirt was pushed over the holes in the ground. The conspirators were now gone from Gardner's view. In the prison courtyard, relic hunters picked at the scaffold to chip off a remembrance.

The afternoon edition of the *Washington Evening Star* hit the streets with the headline THE GREAT EXECUTION. The four o'clock extra edition from the *National Republican* devoted three columns to the gory details of the day's events. Elsewhere across the country, the news flashed through telegraph lines as America learned its government had executed a woman for the first time. Washington was thronged with thousands of people who didn't get to see the event. They grabbed the newspapers as fast as they were printed. Some celebrated, but not everyone was happy.

Coxshall said after he left with a group of soldiers, "a fight was narrowly averted on our return by some other soldiers calling us 'hangmen.'" Coxshall added, "We were soldiers and such things were a part of a soldier's duty during the fearful days that surrounded the assassination of President Abraham Lincoln."

Elsewhere in Washington, the relic hunters continued their ways. At Ford's Theatre, which again planned to reopen, a wooden bench where Peanut John sat while holding Booth's horse was cut to pieces and carted off by relic hunters. Most of the people, however, gathered outside of Surratt's boardinghouse, the epicenter of Booth's plot to kill the president. A dim night shined inside. The heartbroken Anna Surratt appeared at about eight o'clock that night and entered the house. She fainted several times in grief. More than five hundred Washingtonians watched from across the street. "From early in the evening until a late hour at night, hundreds of persons, young and old, male and female, visited the vicinity of Mrs. Surratt's residence, stopping upon the opposite side of the street, glancing over with anxious and inquiring eyes upon the house in which the conspirators met, commencing upon the fate of the doomed woman."[24]

At Gardner's studio on Seventh Street, he carefully arranged his glass negatives from the day. When fitted together in order, they captured something that had never been done before during a live news

event. The sequence showed the conspirators being taken to the gallows, placed on the scaffold, and dropped to their deaths. As the eye glances across the sequence, the conspirators appear to move. Almost like they are alive.

Gardner's photos were published in *Harper's Weekly*. The magazine ran a full-page engraving of Gardner's photo showing the hooded conspirators hanging from the gallows. Another photo showed the adjusting of the rope and the clergymen in prayer scenes. The scenes ran alongside Gardner's mug shots of Powell, Herold, and Atzerodt.

The photographer also sold the execution scenes as cartes de visite. There was one problem. No one wanted them. They wanted to forget the sad coda of the Civil War and the murder of their president. Gardner was ahead of his time.

Gardner had revolutionized battlefield photography. Now he had revolutionized live news. His photos preserved the event in all of its complexity—something the newspapers could not. Now, if someone wanted to witness the execution, like so many wished to do in July 1865, they could. Gardner preserved it forever.

The revolution of Gardner's execution series went unnoticed at the time, much like many breakthroughs. As in the past, Gardner did not get the credit. At least, not during his natural life.

16

Broken

— Summer 1865 —

DESPITE HIS FALLING fortune, Mathew Brady checked into a luxury hotel. The Civil War was over. The hunt for John Wilkes Booth had ended, as had the lives of the conspirators who had helped him. The nation was experiencing one big hangover. Nothing could rival the drama of the past four years, much less the past four months. For Brady, it was much more personal. His weak eyes had witnessed it all, and now they needed a rest.

Brady took up residence for the summer with his wife, Julia, at the Union Hotel in Saratoga Springs, New York—a resort town near the upstate area where he had grown up. It was a welcome respite after a season that brought the fall of Richmond and the death of Abraham Lincoln. He was part of America's leisure class, and he was in good company. Saratoga was a playground for the rich, known for its warm springs filled with mineral waters that soothed the ailments of the sick.

At the Union Hotel, which could house fifteen hundred people, visitors hoisted glasses of champagne, puffed on fine cigars, and feasted on meats hunted in the surrounding Adirondack wilderness served on silver plates. In the hotel dining room, guests lifted forkfuls of beef, veal, lamb, and turtle to their mouths as uniformed waiters tended to their desires.

The men and women bustled through hallways brought to life with frescoed walls. They spent the summer floating in hot-air balloons or betting on the ponies at the racetrack or playing billiards in the game rooms or courting their mistresses. The town was packed with business

magnates. The banks kept large cash reserves to quell their nonstop transactions. The Union was the center of this universe, where Brady stamped across neatly trimmed laws, drank mineral waters, and hobnobbed with the rich and famous. During Brady's stay, General Grant, the hero of the war, stopped in for a celebratory dinner.

The Union housed the great men of industry: the straight-faced A. T. Stewart, who built the first department store in New York near Brady's Broadway studio; the ailing E. S. Sanford, president of the American Telegraph Company, who rested with a broken leg; and the long-sideburned Henry Raymond, the cofounder of the *New York Times*. They were Brady's friends. He was part of their crowd. "It is wonderful how well one remembers the face of a prominent man after he has photographed him," Brady remembered. "The camera brings out every feature, and the faces are, as it were, photographed upon your brain to remain there as long as reason holds."

War was good for business. It pumped the great fortunes with more greenbacks. Telegraph companies, gun companies, and railroad companies all benefited. So would all the industries that would help rebuild the war-torn country as it expanded out west.

Mathew Brady's name was synonymous with photography, but he wasn't a shrewd businessman. Soldiers had flocked to photography studios in record numbers. Cartes de visite of politicians and generals became a certifiable fad. He had sent teams of reporters to the battlefields, towing expensive equipment to document the war. But the war experiment weighed on his finances, and by the war's end it threatened to break him. He said the endeavor cost him one hundred thousand dollars.

His most talented photographers had gone out on their own, but Brady was still a living legend. "When the history of American photography comes to be written," *Harper's Weekly* wrote, "Brady more than any other man, will be entitled to rank as its father."

Photography was still a new business, and it changed rapidly with technological advances. It was also still a small business, dominated by local camera operators in small studios in nearly every town in America.

None was as famous as Brady. His name had no equal. Still, he faced the travails of a small businessman, and his lavish spending made things worse. He lived like the famous men he photographed. By 1865 Brady had faced a string of lawsuits for not paying his bills on time. He

owed money to a host of suppliers and former employees, but managed to keep his studio open.

In the scenic Saratoga Springs, Brady and his fellow captains of industry wondered what was next. What new innovation was around the corner? America was on the cusp of the great industrial age, which would be fueled by the rising middle class. But for now, Brady seemed tired.

Brady would once again face battle with his former rivals. Trouble was ahead. But the photographer still smiled with the "light of an Irish sun."

As BRADY VACATIONED, Alexander Gardner stayed at work in Washington's dust and heat. After photographing the execution of the Lincoln conspirators, he was tasked with capturing yet another hanging.

In the late summer, Henry Wirz, a Swiss physician, stood trial for running the Confederacy's prisoner-of-war camp in Georgia called Camp Sumter, labeled by its inmates as Andersonville. After Sherman marched through the South, Union forces entered the prison and discovered a living hell. Soldiers were forced to live in marshlands wetted by their own feces and urine and blood. They were starved and left to bake in the hot Georgia sun. Many died of scurvy, hunger, or infectious diseases that spread through the camp faster than the rats squealing at their feet or the swarms of flies buzzing at their heads. One survivor said of entering Andersonville, "As we entered the place, a spectacle met our eyes that almost froze our blood with horror, and made our hearts fail within us. Before us were forms that had once been active and erect;—stalwart men, now nothing but mere walking skeletons, covered with filth and vermin. Many of our men, in the heat and intensity of their feeling, exclaimed with earnestness. 'Can this be hell?' 'God protect us!' and all thought that He alone could bring them out alive from so terrible a place."[1]

After the camp was liberated in May, Chaplain J. J. Geer made images of emaciated survivors, whose bony skeletal frames protruded through their pale, translucent skin. They were labeled the "living dead."[2]

Wirz was convicted by a war tribunal and sentenced to death. Boston Corbett, a former inmate who escaped and later killed John Wilkes Booth, testified against him. Gardner was again the only photographer

permitted to frame the event in his lens. The execution was on November 10, 1865, in the yard of the Old Capitol Prison. Authorities used a small weather-worn scaffold for the gallows. It had been used in a number of other executions over the years.

Gardner arrived early and made a number of exposures, including one of his friends—the newspapermen. "The press-gang present, seated on some dilapidated steps were taken in characteristic outfit of shocking bad hats, pencils and notebooks, and the rush of the group to see the negative was immediately followed by a scatteration and rush in the direction of the scaffold, as the prisoner was brought out somewhat sooner than had been anticipated by the crowd."[3]

Gardner made a series of photos, just like he did when the Lincoln conspirators dropped to their deaths. The backdrop was much smaller and certainly less theatrical than the custom-made scaffold built on the Washington Arsenal grounds. Still, the photos showed the heart-pounding scene like a dramatic play. Within his view, men climbed trees and clutched branches to witness the event. The Capitol dome loomed in the background. Soldiers surrounded the scaffold with their bayonets spiked upward.

Gardner captured the death warrant being read and the ropes being adjusted around Wirz's body. Wirz's face was flushed from slamming shots of whiskey in his cell. When they tied his legs together, he said, "I go before my God—Almighty God—who will judge between us. I am innocent and I will die like a man."

Gardner's camera conveyed the tension. The crowd peered closer as a guard sprang the trapdoor, dropping Wirz to his death with a loud thud. "When it was known in the street that Wirz was hung, the soldiers sent up a loud ringing cheer, just such as I have heard scores of times on the battle-field after a successful charge," the *New York Times* wrote. "The sufferings at Andersonville were too great to cause the soldiers to do otherwise than rejoice at such a death of such a man."[4] Wirz writhed in agony for a bit and then went still.

The body was cut down as relic hunters stripped the scaffold of splinters in chunks big enough to use as firewood. It was taken for an autopsy, which was photographed by Gardner. Wirz's body straddled a table as he was surrounded by a group of men. His lifeless head was positioned toward the camera. That picture was not publicized at the time. Much like the autopsy photo of Booth, it was tucked away in the War Department files. But unlike that of Booth, it was later discovered

and made public. Wirz's body was carted off to the Washington Arsenal and buried at the arsenal yard near the Lincoln conspirators.

Harper's Weekly ran several images taken by Gardner of Wirz's execution. It would be a simple footnote in history. Far from what happened to the Lincoln conspirators. But it showed one thing: Gardner had mastered the art of live photography.

The months after the war were not easy for Gardner. In September a fire broke out in Gardner's Washington studio. All of his chemicals and supplies were destroyed. "The ceiling of Mr. Gardner's fine gallery of pictures was injured by the water, but his pictures were all saved; and in removing them only one glass was broken," the *Washington Daily National Intelligencer* wrote. "All of the negatives of Mr. Gardner's splendid collection of photographs of the war and battle scenes were also saved; although a few were slightly injured; but it is gratifying to know that he has lost nothing of his splendid collection that he cannot replace."

The pictures survived the blaze. Gardner's studio reopened within a few weeks. But he and rival Brady soon began to worry about those pictures—the thousands of images burned onto glass, documenting the nation's most epic struggle. Particularly about their worth. It seemed like no one wanted them—or, at least, no one wanted to pay for them. Not even the government.

WHILE BRADY STAYED ensconced at his New York and Washington studios—continuing to move throughout high society—Gardner focused on selling his pictures from the war. He had a novel idea: to put his images together with vivid captions and sell them as a sort of coffee-table book.

The result was a two-volume leather-bound set containing one hundred pictures. It was printed by Washington's Philp & Solomons and titled *Gardner's Photographic Sketch Book of the War.* The complicated process of reprinting so many pictures necessitated a hefty price tag of $150.[5]

Alfred R. Waud, an illustrator whose sketches routinely appeared in *Harper's Weekly*, did the cover. "As mementoes of the fearful struggle through which the country has just passed, it is confidently hoped that the following pages will possess an enduring interest," Gardner's introduction wrote. "Localities that would scarcely have been known, and probably never remembered, save in their immediate vicinity, have

become celebrated, and will ever be held sacred as memorable fields, where thousands of brave men yielded up their lives a willing sacrifice for the cause they had espoused." He added, "Verbal representations of such places, or scenes, may or may not have the merit of accuracy; but photographic presentments of them will be accepted by posterity with an undoubting faith."

That "undoubting faith" didn't mention anything about Gardner's staging of photos or captions that embellished details. Still, the volumes were one of the first examples of marrying photos with words. Journalism with pictures—where the images drove the story, not the text. There was a partisan bent, however. Gardner often referred to Union movements as "we." Of course, what else could be expected from the official "Photographer of the Army of the Potomac"?

Many of the photos Gardner included are ones that had been attributed to Brady—including the photos of Lincoln at the aftermath of Antietam with General McClellan. Gardner selected images that didn't just show soldiers or famous generals and politicians. His pictures showed a wagon park, a medical supply boat, the Christian Commission, the telegraph constructions corps.

One picture showed the *New York Herald*'s traveling headquarters. "To the army correspondents the country owes more than it can fully appreciate, until the historian in the future shall attempt to give the true narration of these revolutionary events," Gardner wrote.

Another showed the rough-and-tumble nature of everyday camp life. A picture showed a group of men gathered around two chickens, ready for a cockfight, and included these words:

> Cock fighting, however, was quite unusual, and seldom permitted, except when some of the contrabands incited their captured Shanghais, or more ignoble fowls, to combat. Such displays were always ludicrous, and were generally exhibited for the amusement of the mess for whom the feathered bipeds were intended. Horses and mules perished by hundred from ill-usage, but with this exception it would be exceedingly difficult to cite an instance of cruelty to animals in the army. Fowls, dogs, kittens, and even wild animals, were made pets of, and were cared for most tenderly. Sometimes a regiment would adopt a dog, and woe to the individual who ventured to maltreat it. Several of the Western regiments carried pet bears with them, and one regiment was accompanied by a tame eagle in all its campaigns.

It was that level of detail alongside the pictures that told the story of the war unlike anything else. The one hundred photographs did what thousand-page volumes could not: show the Civil War as it was in simple human terms. It did not tell the minute-by-minute movements of battle, which few Americans could ever relate to or imagine. And it did not feature laudatory portraits of generals and presidents. It told the story of real people with long beards facing unthinkable circumstances. Gardner had a kinship with them. He was one of them. His photographic wagon rambled across the same creeks and bridges as they did. He had seen the horrors of war—and his camera preserved it for history's eye.

The book was a financial bust. About two hundred copies were printed. Most of them did not sell. Gardner was liberal with the credit he gave to his corps of photographers. Timothy O'Sullivan was credited as the photographer on forty-three images—nearly half of the book. One man not mentioned was Mathew Brady.

ON FEBRUARY 17, 1869, Mathew Brady struck first. Massachusetts senator Henry Wilson submitted a petition to the U.S. Congress that bore Brady's signature. It urged the federal government to purchase Brady's extensive photo library. The petition said Brady's collection was "too precious to remain in the hands of any private citizen." According to the petition, "They are absolutely faithful and the Portraits, according to an eminent authority, are superior in real instruction to half a dozen written biographies." It proposed his entire collection of negatives "to be placed on permanent exhibition at the National Capitol, where the pictures and negatives may be secure from injury or loss by fire; and at the same time, accessible to the historical student, the artist, and the public." The petition claimed that at the start of the war, Brady, "at great expense," organized "an efficient corps of Artists for the production of photographic views illustrating prominent incidents of the War."

Four days later, one of those corps of artists submitted his own petition. Kansas senator Samuel C. Pomeroy wrote on behalf of Alexander Gardner. In Pomeroy's petition, Gardner was given credit for conceiving the idea of a photographic history of the war. Not Brady. "Without wishing to disparage the labors of others, he believes and is so advised that there is no such collection extant, as indeed might

be inferred from the fact that he is the *only* artist who had free access
to the Army and its Headquarters at all times as well when in active
movement as in camp," the petition said.

The value of Gardner's work, according to the petition, was price-
less. Congress thought otherwise. Brady and Gardner's medium was
still new. They didn't have the power to cajole senators like the great
newspaper titans. Congress did not purchase Gardner's collection—or
Brady's.

AFTER THE WAR, Gardner had wanderlust. While he and Brady
were close in age—both were in their midforties by the late 1860s—
Gardner pushed forward with a free spirit. He headed to the untamed
western frontier. Brady stayed at home.

The West was a photographer's dream. A visual paradise packed
with vast spaces, large animals, and snowcapped mountains. Of course,
not all was peaceful. Americans increasingly collided with wild Indians
on their pursuit to connect the continent's shores. Much of that came
through the hammering of railroad tracks on Native-claimed land.

The Indians, resisting the push toward the Pacific Ocean and Cali-
fornia gold, seemed to be a common enemy and helped unify a divided
nation struggling to be put back together. Their resistance created
great tension on the plains, as Indian fighters tried desperately to stop
the white men and their railroads.

Gardner became the chief photographer of the Union Pacific Rail-
road, Eastern Branch. He documented the company's westward push
and life on the road, mostly in Kansas. His pictures showed dusty ram-
shackle towns, prairie girls, burial places, and log cabins.

In 1868 Gardner was commissioned by the federal government to
photograph the Indian country in Wyoming. He left on the Kansas
Pacific Railroad to attend the signing of the Treaty of Fort Laramie
in the Wyoming Territory, where the United States made agreements
with a number of Indian nations. The government made sure he was
treated right. They gave him a gallon of whiskey for the journey.[6] He
traveled with General William Tecumseh Sherman for a stretch.

Gardner's photos had the same unique human view that had col-
ored his war photos. His lens captured tepee encampments and Indi-
ans holding tomahawks or pointing bows and arrows. It also showed
the collision of East and West. Military commissioners, wearing

European-style uniforms and suits, stood next to Indians in head-dresses and braids. One memorable photo showed a young blanket-wrapped Lakota girl, named Fawn, standing in the center, flanked by white federal officials, including Sherman. The men towered over her short body. She looked like a young girl walking through a scary forest.

Another photo showed the chief of the Oglala, known as Old Man Afraid of His Horse, smoking a long-stem pipe. The photos also showed the bizarre and barren landscape of the West: Chimney Rock, Mushroom Rock.

Gardner returned to Washington with the earliest surviving photographic record of the Indians of the northern plains.[7]

A few years later, Sioux chief Red Cloud came to Washington along with a delegation of Indians. He was courted by Brady and Gardner and took photos at both of their studios. When delegations of Indians came to the city, both of the photographers were particular about their photos. They often posed the Indian chiefs wearing ceremonial outfits, with weapons in their hands and feathers in their hair. The Americans in the East didn't want the photos any other way.

———— • ————

BY 1872 MATHEW Brady's financial woes had grown downright grim. Lawsuits piled up from print shops, composing firms, investors, and photographers. He was declared bankrupt in federal court in 1873. Nearly a hundred people made claims against him.

Lawsuits had dogged Brady for years. Photographer James Gibson said in one suit that Alexander Gardner and Timothy O'Sullivan had liens against Brady for "certain portions of the apparatus and property of great value belonging to [Brady's] gallery."[8] Gibson, who was quite litigious, also sued Gardner.

Brady's debts totaled more than twenty-five thousand dollars. His net worth was valued at about twelve hundred.[9] Some would later attribute Brady's bankruptcy to the destruction of Boss William Tweed and his Tammany Hall machine, a group that allegedly protected Brady from his creditors.[10]

Brady lost the valuable contents of his famed Broadway studio—along with the studio itself. He also lost the Washington studio, but was able to return and operate from a portion of it under the control of investor Andrew Burgess. Because of Brady's weak finances, his

photographic archive had begun to get parceled out and sold in differ-ent batches. It was no longer whole.

In 1873 the *Washington Evening Star* wrote, "Mr. M. B. Brady, fa-mous all over the world as a photographer, and who has for some years had a branch gallery in Washington, proposes now to make his head-quarters here, and concentrate all his energies in making a great na-tional photographic establishment at the seat of government. This is a recognition of the rapidly growing metropolitan character of Wash-ington."[11] Brady and his wife moved into the National Hotel, where Booth hatched his plot to kill Lincoln the decade before.

The photographer had started to drink heavily. War Secretary William Belknap reported on September 28, 1874, that he was "ac-costed" by Brady in the lobby of the Fifth Avenue Hotel in Manhattan. The two had a dispute over the status of his negatives, but Brady en-listed Belknap's support in convincing the U.S. Congress to buy a set of his negatives.

Brady said in a letter that he had spent his fortune on the nega-tives and in the process had "impoverished myself and broken up my business and although not commissioned by the Government to do the work I did," he was encouraged by everyone "from the President down."[12]

Congress authorized a payment of twenty-five thousand dollars for a series of photographs. The money was a financial shot in the arm for Brady, but it didn't come close to covering the cost it took him to cover the war.

———— • ————

MEANWHILE, ALEXANDER GARDNER had nurtured a series of real es-tate investments and kept his studio on a firm financial foundation. He continued to develop government contracts to fund his photographic endeavors. In 1873 Gardner worked with the Washington Metropol-itan Police Department to copy nearly one thousand daguerreotypes in the police files and make them uniform in size. His technique after the Lincoln assassination of photographing the conspirators led him to create a rogues' gallery of mug shots—a breakthrough in crime fight-ing where images increasingly helped detectives identify suspects.[13]

Gardner grew tired of photography. The travel and the chase surely wore him out. So Gardner sold many of his negatives to a

photographer named Moses P. Rice, who copyrighted and claimed many of them as his own.

After 1875 Gardner was out of the photography business. Instead, he focused on real estate, insurance, and philanthropy. Gardner had been a Freemason since he was young. During one ritual he even appeared in a photograph dressed as an Indian wearing a buckskin outfit. Later in life, he intensified his interest in American Freemasonry and achieved the rank of Knight Templar, the secret society's highest rank. On November 22, 1882, Gardner was elected president of the Masonic Mutual Relief Association. The organization had a high social purpose: to care for the widows and orphans of deceased Freemasons.

The next month, Gardner became ill. Over two weeks, Gardner's health declined. Few gave him any hope, but Gardner often said, "I hold the fort." "Mr. Alexander Gardner . . . is lying at his residence on Virginia Avenue, Southwest, very low with diabetes and other complications. But little hope is entertained of his recovery. Mr. Gardner is a well-known and much-respected citizen, and his illness will be sincerely regretted by a large circle of friends," the *Washington Post* wrote.[14]

On December 10, 1882, Gardner's twinkling eyes, which had witnessed the most dramatic moments of the nineteenth century, closed forever. The man whose lens captured the dead bodies of soldiers and the hanging heads of conspirators was now dead himself. He was sixty-one.

A *Washington Post* obituary wrote of Gardner's national reputation as a photographer, saying, "His pictures of the campaigns in Virginia are preserved as the only worthy representations of any of the scenes of the war taken on the spot." The *Philadelphia Photographer* cast Gardner in legendary tones, asking, "Who, in Photography, Has Not Heard of Alexander Gardner? He was one of our veterans—one of photography's staunchest friends."[15]

Joseph M. Wilson, a Freemason of the Lafayette Lodge, delivered a long eulogy of Gardner that was printed in a booklet. Wilson said Gardner was "endowed with more than ordinary natural gifts." "His chief desire was to convince the understanding, arouse the conscience, and affect the heart," Wilson asserted. "To secure these ends, his well balanced and logical mind was eminently fitted. His personal influence commanded respect; his genuine honesty inspired confidence, and his

practical efficiency enlisted co-operation and insured success. With a manly sturdiness of conviction, he presented an almost unvarying equability of temper, and with perfect candor an equally perfect courtesy."

Wilson discussed Gardner's photographic work, saying he rose from amateur to master. His love of chemistry showed his scientific spirit. "In his profession he was an experimentalist, and never hesitated to spend time and money to secure any device which might enable him to reach the best results and there-by elevate the taste of the public in behalf of photography, which he ever held to be one of the fine arts, ranking with painting and sculpture."[16]

Wilson talked of Gardner's affinity for General George McClellan. He did not mention that affinity for Lincoln, the photographer's most famous subject.

Gardner was buried at Washington's Glenwood Cemetery on December 12, 1882. A large crowd was at his open grave. Wilson described the scene in the human terms Gardner often captured with his camera. "We gathered around him as he rested in his coffin, and gazed upon his high forehead, his finely cut features, his flowing beard [in] almost patriarchal fullness, he seemed to be sleeping."

———◆———

MATHEW BRADY SPENT his later years attending a lot of funerals—such was the affliction of living a long life. There's no record that Brady attended Gardner's funeral, but it's possible he stood in the audience as his old rival was lowered into the ground.

Late in life when reminiscing about sending his photographers to the battlefield, Brady said, "They are nearly all dead, I think."[17] In 1878 Brady served as pallbearer for Frederick Aiken, the lawyer who defended Mary Surratt. In 1884 he attended the funeral of Edward T. Anthony, of the E. & H. T. Anthony & Company that furnished many of the supplies for Brady's studio. The death that hit Brady the hardest was that of his wife, Julia, who died in 1887 of acute rheumatism. The *Washington Critic* noted that "the wife of the veteran artist" had been ill for a long time.[18]

Brady's photography pursuits were largely in the hands of Julia's nephew Levin Handy, who had trained under Brady since he was a young boy. Brady's attitude among some was that of a crabby old man. Once, when visiting New York, a reporter wrote, "In person, Mr.

Brady looks like a French marshal of the empire, though his belligerency has never taken any form other than that appropriate to the best amateur boxer of the day."[19] The photographer's hair had turned white, but he kept the "Napoleonic" mustache that had sprouted from his face since he first entered photography nearly fifty years before.[20]

Brady's studio struggled to keep its celebrity sheen, even though it had been moved and shuffled throughout Washington. Brady remained a master showman in the media. During his final years of life, he granted long interviews where he reminisced about his famous friends and turbulent times.

The *Philadelphia Times* in 1893 printed a long interview with Brady featuring reproductions of many of his famous images: Lincoln, Grant, Clay. In the article, journalist Henry George Jr. called Brady's Washington studio the "most celebrated photographic portrait gallery in the United States." Brady was seventy years old. He was clearly at the end of his career—his interviews always looked backward, not forward. Still, on the wall of his studio was a photo of Thomas Edison, the inventor whose workshop was transforming America. Edison was a "smooth-faced boy" when he visited Brady's studio in 1878. He brought with him his phonograph invention. "While waiting for Mr. Brady to get his apparatus ready, [Edison] was attracted by some sounds coming through a wall or ceiling," George wrote. "The sounds brought with them some kind of inventive inspiration which caused Edison to at once hurry an assistant away to take steps to get a patent for transmitting sound through substances."[21] Edison would later experiment with pictures.

At the end of his life, Mathew Brady was broke. His family relationships were strained. For a time, he lived with nephew Levin Handy. Another nephew, Theodore Handy, was arrested for threatening Brady for not treating him as well as other relatives.[22]

Journalist George Townsend met Brady at a Washington hotel and observed that "[Brady] allowed the glory of the civil war to take away the savings and investments of the most successful career in American photography; his Central Park lots fed his operators in Virginia, Tennessee and Louisiana, who were getting the battle-scenes. It is for this reason, perhaps, that he is at work now over the Pennsylvania Railroad ticket office."[23]

In 1893 Brady returned to Ford's Theatre to photograph its interior, just as he had done nearly thirty years before in the aftermath of

the Lincoln assassination. The shuttered playhouse was used as a government building. The upper floors collapsed and killed twenty-two clerks. About one hundred others were injured. Brady testified before a coroner's jury.[24]

Ford's Theatre was once again the site of a tragedy. Brady soon faced his own. The following year, Brady walked across the corner of New York Avenue and Fourteenth Street and was knocked down and run over by a horse-drawn carriage. It was eight o'clock at night. The carriage, carrying four men, clip-clopped away, leaving Brady on the street. A detective witnessed the hit-and-run and attempted to catch the fleeing carriage—to no avail. Brady was taken to his nephew's house and treated for a broken ankle. The handicap kept him from his business, further weakening his finances.

By the end of the year, the *San Francisco Call* ran a short item, saying, "M. B. Brady, the famous photographer, who was once the petted favorite of fortune, is crippled in body, with failing eyesight, and harassed almost to the point of madness by the stings of poverty."[25]

Brady left his nephew's care and moved back to New York in 1895. He lived in a small room within a few blocks of his old gallery. Gone were the days of luxury. For a time, Brady received financial support from a Catholic priest. Brady of Broadway was now a charity case.

Sculptor James Edward Kelly, a friend of Brady's, visited with the photographer in the fall of 1895. Brady hobbled about on crutches. Kelly said it "was a shock to see him looking wan and careworn; but at the sight of me his face lit up with his characteristic winning smile." Later, Kelly said, Brady paged through a volume of *Harper's Weekly* from the Civil War era. Brady told him, "To think of it! Those men were my companions and friends, and by them I was respected; but now I am nothing but a damned old . . . "[26] He stopped and didn't finish the sentence. Instead, he cried.

Mathew Brady died on January 15, 1896. Despite his poverty, his death didn't go unnoticed. Newspapers around the country ran the news. The *Washington Evening Star* said Brady's name "was a household word all over the nation." "The illustrated journals during the war added to his celebrity by reproducing many of his pictures of battlefields and his portraits of prominent generals in both armies," the *Evening Star* wrote. The newspaper added, "In person and manner Mr. Brady was a most congenial gentleman. His friends were legion, and

he preferred for years to give them his time and company rather than confine himself to the demands of his calling."[27]

The newspapers told of the darker side, too. One talked of his drinking problem, while another focused on his financial woes. All of them agreed on his place in history. Brady had photographed every president from John Quincy Adams to Grover Cleveland—and the chaos in between. He witnessed the Civil War and knew the men who shaped America. He almost lived to see the next century, which would be built on the photographic media he helped advance.

Mathew Brady was buried in Washington next to his wife, Julia. There was no money for a headstone. His funeral lacked the memorials lauded on his former rival Alexander Gardner, who died the decade before. But his name was already etched onto the stone of history.

The arc of his life went from poor immigrant to celebrated artist to wealthy businessman to destitute icon. The charming entrepreneur lived a full life and then saw it slip away. In the end, Brady's own story embodied a phrase he used in advertisements to lure soldiers into his studio before they went to battle: "You cannot tell how soon it may be too late."

Motion Pictures

— 1875 —

SAN FRANCISCO PHOTOGRAPHER Eadweard Muybridge stood before a Napa County jury and dodged the hangman's noose. It was easy to get away with murder in 1875. Especially on the wild frontier. Life in California was rough—less civilized than any theater of battle, perhaps, other than Sherman's March to the Sea. One Northern California store owner once remarked: "My store was in a tent. I was surrounded by rough miners and Indians. There was no law, except the law of force. Men shot other men for little or nothing."[1] Muybridge shot another man over *something*. Major Harry Larkyns had had an affair with his wife.

Muybridge, who came to California from England and took notable landscape pictures of Yosemite and Alaska, was already a bit crazy. He was incensed over the affair and suspected that Larkyns, a drama critic, was the father of his wife's child. On October 17, 1874, Muybridge took a ferry across the San Francisco Bay and then a train up into Napa County. He tracked Larkyns down in Calistoga, where there were silver and gold mines. He confronted him and shot him dead.

Muybridge pleaded insanity. As evidence for his mental malaise, his lawyers turned to his profession. They said Muybridge once risked his life and "perched himself on the edge of Half Dome in the Yosemite Valley to take a photograph."[2]

The jury, despite instructions from the judge, acquitted Muybridge and said he was justified in killing the man who seduced his

wife. Larkyns deserved it, they said. They said if their verdict was not in accordance with the law of the books, it was within the law of "human nature."[3]

The trial and acquittal were a sensation and made headlines on both coasts. Afterward, Muybridge went about his life. First, he spent time exiled in South America. Then he returned to San Francisco. Muybridge was already in his forties. He had an intense face, with a long, flowing beard worthy of a god painted by Michelangelo. He wore long velvet coats and felt sombreros. A reporter once remarked that Muybridge "bears the traces of genius in his face and general get-up."

Painters were his role models, like Mathew Brady before him. And, like the Renaissance artists of centuries before, Muybridge had a rich and important benefactor, Leland Stanford, a railroad tycoon and former California governor. Muybridge had been working on a project for Stanford.

Stanford owned thousands of acres in Palo Alto, California, and fashioned himself a country gentleman. He was obsessed with an age-old question: whether all hooves of a horse are off the ground during a trot or gallop. Authorities on the subject long said such a thing was impossible for a horse—and impossible to prove. Stanford turned to photographer Muybridge, considered the best on the West Coast, to answer the question.

Photographic technology had evolved in the years after the Civil War. But not by great leaps. Exposure time had been greatly reduced, yet motion was difficult to capture and still produced a blur.

Stanford funded Muybridge's photo experiments. They culminated with a breakthrough in 1878. Muybridge lined up twelve cameras alongside a racetrack. The cameras were connected to electric wires that were equally spread across the track at a total distance of twenty-one feet. He placed a white background of planks to enhance the lighting. When the wheels of the vehicle—pulled by the horse— hit the wires, it triggered the camera shutters one by one. Instantaneous photos were made as the horsed galloped through.

The experiment answered Stanford's question. Yes, all four hooves of a running horse left the ground at once. "Putting those twelve presentations together, every motion of the animal—his head, ears, feet and body, the driver and his whip, and the spokes in the wheels—are all recorded with truthful fidelity," the *San Francisco Post* wrote.[4]

The *San Francisco Bulletin* called the event a "wonderful triumph in photography." But at first, the press focused on how the pictures would advance horse racing. "Mr. Muybridge has made a valuable contribution to science by his patient experiments, and many valuable facts can be learned by trainers of horses from a careful study of these singular pictures," one newspaper wrote.[5]

Soon, Muybridge was using the process to photograph men walking and running—he even photographed the flight of birds, along with beasts and reptiles at the zoo. The pictures appeared alive, if only for a second or two.

The business opportunities of the breakthrough were largely ignored at first. Stanford, a lover of education, kept funding Muybridge's research. But he treated it largely as a hobby from his moneymaking pursuits.

That didn't last long. Muybridge gave a lecture demonstrating his zoopraxiscope, a device that projected sequential images, creating the illusion of movement. Thomas Edison witnessed the lecture and soon honed his Kinetoscope. Edison himself patented a sprocket device that could make the short films of the day longer. "There has never been a great invention that a dispute did not arise as to who first thought of it and made it practicable," the *Reno Evening Gazette* wrote. "Steam, railroads, steamships, photography, the dynamo, electric light, printing with movable types, and many more have all from two to half a dozen claimants to be their inventors."[6]

Louis and Auguste Lumière took a French inventor's cinematograph and built on Edison's work. The men made short films and displayed them at the Paris Exposition of 1900. Thus began the world's love affair with film. Motion pictures. Movies.

Edison admitted that the motion-picture idea itself came from Muybridge's horses in motion. But Muybridge's horses, shot in sequence, also came from somewhere: Alexander Gardner's execution sequence of the Lincoln's conspirators.

The by-product of a news event was conspirators dropping to their deaths—in sequence. The by-product of a science experiment was horses in motion. Their connection is clear: a series of still photographs taken in quick succession that produced the sense of movement. Muybridge built on what Gardner had done with a live news event.

Gardner didn't have a benefactor like Leland Stanford. There was no unlimited stash of cash to keep him afloat and fund his pursuits. He

had to do the conspirator series on his own at the tail end of the Civil War.

The astonishing success of Gardner's work at the Washington Arsenal is not much appreciated today. It is largely eclipsed by the enormity of the event he had documented. Gardner stood at an age just before the great industrial advancements where Americans wired their homes with electricity and telephones. Gardner could not stage the execution like Muybridge could stage a running horse. Rather, it was an unfolding news event filled with drama and populated by real people.

The images created by Gardner, starting in the Civil War and born from competition with Mathew Brady, brought human faces to battlefield scenes. Then, with the execution series, Gardner brought the scenes to life. Historians and students can now experience the event as if they were there. From the moments of anticipation to the reading of the death warrant to the last prayers to the death drop. Each photo tells a story. The hangman's anguish, the soldier's duty, the prisoner's dread.

Gardner, a former newspaper editor from Scotland, wed pictures with news. The moment created everything that came after: movies, newsreels, twenty-four-hour broadcast news. From the bombing of Pearl Harbor in 1941 and the assassination of President John F. Kennedy in 1963 to astronauts landing on the moon in 1969, the *Challenger* space-shuttle disaster in 1986, the collapse of the World Trade Center in 2001, and events that have not yet happened . . .

Every time someone picks up a mobile phone or points a camera at a live news event, they are connected to July 7, 1865. The strings of history unknowingly bring them back to the people who conspired to shoot Lincoln, whether through glass lenses or metal guns. We don't get to see the president's lumbering walk, but we do get to see the execution of those who conspired to kill him. On one hot summer day, the modern news media was born.

NOTES

PROLOGUE. SHOOTING LINCOLN

1. *Washington Evening Star*, February 7, 1865.
2. *Washington Evening Star*, February 6, 1865.
3. Ward Hill Lamon, *Recollections of Abraham Lincoln, 1847–1865*, 274–275.
4. Ibid.
5. *Washington Daily National Intelligencer*, January 22, 1865.
6. Thomas J. Carrier, *Washington, DC: A Historical Walking Tour*, 44.
7. Kerry S. Walters, *Outbreak in Washington, D.C.: The 1857 Mystery of the National Hotel Disease*.
8. *Columbus (GA) Enquirer*, May 5, 1857.
9. Don Nardo, *Mathew Brady: The Camera Is the Eye of History*, 58.
10. *Photographic Times*, October 30, 1891.
11. Francis Bicknell Carpenter, *The Inner Life of Abraham Lincoln: Six Months at the White House*, 12.
12. *Washington Morning Chronicle*, April–May 1865.
13. Linda Merrill, "Abraham Lincoln, February 5, 1865," http://picturing america.neh.gov.
14. Lamon, *Recollections of Abraham Lincoln*, 114.

CHAPTER 1. THE GREAT EXHIBITION

1. George Alfred Townsend, "Still Taking Pictures," *New York World*, April 12, 1891 (hereafter referred to as "Townsend interview").
2. James D. Horan, *Mathew Brady: Historian with a Camera*, 16.
3. Robert Wilson, *Mathew Brady: Portraits of a Nation*.
4. Ibid., 32.
5. Townsend interview.
6. Roger Watson and Helen Rappaport, *Capturing the Light: The Birth of Photography, a True Story of Genius and Rivalry*, 233.
7. *Baltimore Sun*, August 6, 1851, 1.
8. J. Tallis et al., *Tallis's History and Description of the Crystal Palace and the Exhibition of the World's Industry in 1851*.
9. Ibid., 9.
10. R. J. Mundhenk and L. M. Fletcher, *Victorian Prose: An Anthology*, 268.
11. Hamish Fraser and Callum G. Brown, *Britain Since 1707*, 209; Liza Picard, "The Great Exhibition," https://www.bl.uk/victorian-britain /articles/the-great-exhibition.

12. Zadock Thompson, *Journal of a Trip to London, Paris, and the Great Exhibition, in 1851*, vi.
13. Franklin Parker, *George Peabody: A Biography*, 49.
14. *Times* (London), May 14, 1851, 10.
15. *New York Tribune*, July 14, 1851, 4.
16. *New York Times*, October 2, 1851.
17. *Times* (London), May 1, 1851, supp. ed., 8; *New York Tribune*, December 21, 1850.
18. *Philadelphia Inquirer*, May 15, 1892.
19. *Harrisburg Telegraph*, October 31, 1887.
20. R. Wilson, *Mathew Brady*, 37.
21. Joseph M. Wilson, *A Eulogy on the Life and Character of Alexander Gardner*, 8.
22. Ibid.

CHAPTER 2. THE MAKING OF A PRESIDENT

1. *New York Evening Post*, April 29, 1860.
2. David Herbert Donald, *Lincoln*, 237.
3. George Haven Putnam, *Abraham Lincoln: The People's Leader in the Struggle for National Existence*, 45–46.
4. Melvin L. Hayes, *Mr. Lincoln Runs for President*, 27–28.
5. Emanuel Hertz, *Lincoln Talks*, 158–159.
6. Debbie Henderson, *The Top Hat: An Illustrated History*.
7. *New York Times*, February, 27, 1960.
8. Putnam, *Abraham Lincoln*, 17.
9. Interview in 1887 with journalist Frank G. Carpenter, reprinted in numerous papers, accessed in *Harrisburg Telegraph*, October 31, 1887 (hereafter referred to as "Carpenter interview").
10. *New York World*, April 12, 1891.
11. Carpenter interview.
12. *New York Herald*, September 16, 1850.
13. *New York Times*, October 6, 1860.
14. *New Orleans Times-Picayune*, April 18, 1858.
15. *American Phrenological Journal* (May 1858).
16. Rufus Rockwell Wilson, ed., *Intimate Memories of Lincoln*; George Haven Putnam, "Outlook of New York," February 8, 1922, 259.
17. Carpenter interview.
18. R. Wilson, *Mathew Brady*, 67.

CHAPTER 3. THE BATTLEFIELD

1. R. Wilson, *Mathew Brady*, 110.
2. Carpenter interview.
3. *Anthony's Photographic Bulletin*, no. 2.
4. Beaumont Newhall, *The History of Photography: From 1839 to the Present Day*, 67.
5. Townsend interview.

6. Brayton Harris, *War News—Blue & Gray in Black & White: Newspapers in the Civil War*, 68; Carpenter interview.
7. Harris, *War News*, 68.
8. Louis Morris Starr, *Bohemian Brigade: Civil War Newsmen in Action*, 43.
9. *Washington Evening Star*, July 16, 1861.
10. George Edward Lowen, *History of the 71st Regiment, N.G., N.Y., American Guard*, 175.
11. *Humphrey's Journal*, August 15, 1861.
12. *New York Times*, August 17, 1861.
13. Townsend interview.
14. *American Journal of Photography*, August 1, 1861.
15. Townsend interview; *Topeka (KS) Daily Capital*, June 2, 1912.
16. R. Wilson, *Mathew Brady*, 82.
17. D. Mark Katz, *Witness to an Era: The Life and Photographs of Alexander Gardner—the Civil War, Lincoln, and the West*, 16.
18. Ibid.
19. Ibid., 26.

CHAPTER 4. A HEARSE AT YOUR DOOR

1. Katz, *Witness to an Era*.
2. *New York Times*, September 16, 1862.
3. Ibid.
4. Alexander Gardner, *Gardner's Photographic Sketch Book of the War*.
5. John Cannan, *The Antietam Campaign: August–September 1862*, 54.
6. David S. Hartwig, *To Antietam Creek: The Maryland Campaign of September 1862*, 645.
7. *Baltimore Sun*, September 22, 1862.
8. Lance J. Herdegen, *The Men Stood Like Iron: How the Iron Brigade Won Its Name*, 153.
9. Gardner, *Gardner's Photographic Sketch Book*.
10. Vernell Doyle and Tim Doyle, *Sharpsburg*, 95.
11. *Pittston (PA) Gazette*, September 25, 1862.
12. *Cleveland Daily Leader*, October 1, 1862.
13. *Baltimore Sun*, September 22, 1862.
14. *Times* (London), October 7, 1862.
15. *New York Times*, October 20, 1862.
16. *New York Times*, September 20, 1862.
17. Katz, *Witness to an Era*, 56.
18. Herdegen, *Men Stood Like Iron*, 186–187.
19. *Baltimore Sun*, September 22, 1862
20. Katz, *Witness to an Era*, 54.
21. *Baltimore Sun*, September 15, 1912.
22. Ibid.
23. William A. Frassanito, *Antietam: The Photographic Legacy of America's Bloodiest Day*, 124.
24. Alpheus Starkey Williams, *From the Cannon's Mouth*, 130.

25. Oliver Wendell Holmes, *The Writings of Oliver Wendell Holmes*, 42.
26. *Baltimore Sun*, September 23, 1862.
27. *New York Times*, October 4, 1862.
28. Gardner, *Gardner's Photographic Sketch Book.*
29. *New York Times*, October 3, 1862.
30. *New York Times*, October 6, 1860.
31. Horan, *Mathew Brady*, 29.
32. *New York Herald*, October 5, 1860.
33. "Photographs of War Scenes," *Humphrey's Journal*, October 15, 1862.
34. *Humphrey's Journal*, September 1, 1861.
35. *Atlantic Monthly*, July 1863, 11–12.
36. *Humphrey's Journal*, January 1, 1862.

CHAPTER 5. THE BREAKUP

1. Gardner, *Gardner's Photographic Sketch Book.*
2. Edward J. Stackpole and Wilbur S. Nye, *The Battle of Gettysburg: A Guided Tour*, 108.
3. Michael Dreese, *The Hospital on Seminary Ridge at the Battle of Gettysburg*, 125.
4. Alan A. Siegel, *Beneath the Starry Flag: New Jersey's Civil War Experience*, 118.
5. *Raleigh Register*, August 1, 1863.
6. Gardner, *Gardner's Photographic Sketch Book.*
7. Ibid.
8. Katz, *Witness to an Era*, 71.
9. *Harper's Weekly*, January 3, 1863.
10. *New York Times*, February 11, 1963.
11. *Harper's Weekly*, February 21, 1863.
12. *Washington National Intelligencer*, May 26, 1863.
13. Richard Lowry, *The Photographer and the President*, 369.

CHAPTER 6. SURRENDER

1. James Bradley, *The Imperial Cruise: A Secret History of Empire and War.*
2. *Washington Evening Star*, March 4, 1865.
3. Benn Pitman, comp., *The Assassination of President Lincoln and the Trial of the Conspirators*, 45.
4. *Washington Evening Star*, March 4, 1865.
5. *Washington Evening Star*, April 3, 1865.
6. Thomas Goodrich, *The Darkest Dawn: Lincoln, Booth, and the Great American Tragedy*, 10.
7. Margarita Spalding Gerry, ed., *Through Five Administrations: Reminiscences of Colonel William H. Crook*, 59.
8. *Frank Leslie's Illustrated Newspaper*, April 29, 1865.
9. *Richmond Whig*, April 7, 1865.
10. Gardner, *Gardner's Photographic Sketch Book.*

11. Gary R. Edgerton, *Ken Burns's America: Packaging the Past for Television*, 23.
12. Gardner, *Gardner's Photographic Sketch Book*.
13. *Richmond Whig*, April 15, 1865.
14. *Richmond Whig*, April 25, 1865.
15. *New York Times*, April 23, 1865.
16. *New York Times*, April 30, 1865.

CHAPTER 7. ASSASSINATION

1. *Washington National Republican*, April 14, 1865.
2. John Wilkes Booth, *Right or Wrong, God Judge Me: The Writings of John Wilkes Booth*, 144.
3. Ulysses S. Grant, *The Papers of Ulysses S. Grant: November 16, 1864–February 20, 1865*, 477.
4. Ben Perley Poore, ed., *The Conspiracy Trial for the Murder of the President, and the Attempt to Overthrow the Government by the Assassination of Its Principal Officers*, 1:223 (accessed via the Surratt House Museum).
5. *Washington Evening Star*, April 14, 1865.
6. Ibid.
7. R. R. Wilson, *Intimate Memories of Lincoln*, 487.
8. Gerry, *Through Five Administrations*, 66.
9. William Herndon, *Life of Lincoln*, 257.
10. Michael W. Kauffman, *American Brutus: John Wilkes Booth and the Lincoln Conspiracies*, 293.
11. Poore, *Conspiracy Trial*, 1:187.
12. Martha Hodes, *Mourning Lincoln*, 2.
13. *Baltimore Sun*, April 15, 1865.
14. *Washington Star*, April 16, 1932.
15. Gene Smith, *American Gothic: The Story of America's Legendary Theatrical Family—Junius, Edwin, and John Wilkes Booth*, 160.
16. *New York Herald*, April 15, 1865.
17. John Gilmary Shea, *The Lincoln Memorial: A Record of the Life, Assassination, and Obsequies of the Martyred President*, 71.
18. *Philadelphia Inquirer*, April 17, 1865.
19. *Demopolis (AL) Herald*, April 19, 1865.
20. William Clark, "Willie Clark to Ida Clark," http://rememberinglincoln.fords.org/node/707.

CHAPTER 8. THE CRIME SCENE

1. *Washington National Republican*, April 17, 1865.
2. *Washington National Republican*, April 18, 1865.
3. *National Police Gazette*, April 22, 1865.
4. *Philadelphia Inquirer*, May 11, 1865.
5. Poore, *Conspiracy Trial*, 1:462.
6. *Washington National Republican*, November 5, 1863.

7. David Brainerd Williamson, *Illustrated Life, Services, Martyrdom, and Funeral of Abraham Lincoln*, 214.
8. *Photographic News*, March 31, 1865.
9. Poore, *Conspiracy Trial*, 1:533.
10. James L. Swanson, *Manhunt: The 12-Day Chase for Lincoln's Killer*, 159.
11. Edward Steers, *Blood on the Moon: The Assassination of Abraham Lincoln*, 174.
12. *Washington Evening Star*, April 15, 1865.
13. *Washington Daily Intelligencer*, April 17, 1865.
14. Katz, *Witness to an Era*, 149.
15. Poore, *Conspiracy Trial*, 1:278.
16. Ibid., 377.
17. Katz, *Witness to an Era*, 119.
18. Charles Carroll Everett, *A Sermon in Commemoration of the Death of Abraham Lincoln*, 7.
19. Library of Congress, Rare Book and Special Collections Division.

CHAPTER 9. THE FUNERAL

1. *Richmond Whig*, April 28, 1865.
2. *Richmond Whig*, April 17, 1865.
3. *Richmond Whig*, April 27, 1865.
4. Swanson, *Manhunt*, 215.
5. John B. Bachelder, *Bachelder's Illustrated Tourist's Guide of the United States*, 83–84.
6. R. Wilson, *Mathew Brady*, 197.
7. *Washington National Republican*, April 20, 1865.
8. Shea, *Lincoln Memorial*, 124.
9. *Harper's Weekly*, April 29, 1865.
10. Gideon Welles, *A Connecticut Yankee in Lincoln's Cabinet*, 176.
11. Ibid.
12. Gideon Welles, *The Civil War Diary of Gideon Welles, Lincoln's Secretary of the Navy*, 632.
13. *New York Times*, April 21, 1865.
14. *New York Times*, May 21, 2014.
15. *Life*, September 15, 1952.
16. Ibid.
17. *Brooklyn Eagle*, May 4, 1865.
18. *Photographic News* (May 19, 1865).
19. Bachelder, *Bachelder's Illustrated Tourist's Guide*, 79.
20. *Photographic News*, July 14, 1865.
21. *Harper's Weekly*, May 13, 1865.

CHAPTER 10. THE HUNT FOR BOOTH

1. George Alfred Townsend, *The Life, Crime, and Capture of John Wilkes Booth*, 55.
2. Ibid.

3. Kauffman, *American Brutus*, 261.
4. Terry Alford, *Fortune's Fools: The Life of John Wilkes Booth*, 287.
5. *Brooklyn Daily Eagle*, November 27, 1881.
6. Dorothy Kunhardt, *Twenty Days*, 107.
7. *Cincinnati Enquirer*, December 5, 1908.
8. *New Orleans Times-Picayune*, September 19, 1865.
9. *Cincinnati Enquirer*, December 5, 1908.
10. Townsend, *Life, Crime, and Capture of Booth*, 36.
11. *Philadelphia Inquirer*, May 5, 1865.
12. Ernest B. Furgurson, "The Man Who Shot the Man Who Shot Lincoln."

CHAPTER 11. AUTOPSY

1. *Philadelphia Inquirer*, April 28, 1865.
2. Ibid.
3. *Washington Evening Star*, April 15, 1865.
4. Osborn Hamiline Oldroyd, *The Assassination of Abraham Lincoln: Flight, Pursuit, Capture, and Punishment of the Conspirators*, 79.
5. U.S. Navy, *Navy-Yard, Washington: History from Organization*, 145.
6. *Washington Evening Star*, April 27, 1865.
7. *Washington National Republican*, April 28, 1865.
8. Katz, *Witness to an Era*, 162.
9. *Harper's Weekly*, May 13, 1865.
10. *New York Herald*, April 28, 1865.
11. Katz, *Witness to an Era*, 171.
12. *Times* (London), May 15, 1865.
13. Ibid.

CHAPTER 12. THE ROGUES' GALLERY

1. *Detroit Free Press*, May 5, 1865.
2. *Daily Milwaukee News*, July 13, 1865.
3. *New York Times*, May 7, 1865.
4. William Howard Russell, *My Diary North and South*, 52.
5. Timothy S. Good, *We Saw Lincoln Shot: One Hundred Eyewitness Accounts*, 71.
6. *Washington Evening Star*, July 7, 1865.
7. Ibid.
8. Ibid.
9. *Washington National Republican*, June 5, 1865.
10. *Philadelphia Inquirer*, May 19, 1865.
11. *Philadelphia Inquirer*, April 28, 1865.
12. *Washington Evening Star*, May 15, 1865.
13. *Philadelphia Inquirer*, July 7, 1865.
14. Betty J. Ownsbey, *Alias "Paine": Lewis Thornton Powell, the Mystery Man of the Lincoln Conspiracy*, 85.
15. Ibid.

16. Ibid.
17. John Chandler Griffin, *Abraham Lincoln's Execution*, 172.
18. *Philadelphia Inquirer*, November 4, 1865.
19. *Washington Evening Star*, May 15, 1865.
20. *Norfolk (VA) Post*, July 10, 1865.
21. *Washington Evening Star*, July 7, 1865.
22. Ibid.
23. *Cleveland Daily Leader*, July 10, 1865.
24. Katz, *Witness to an Era*, 164.

CHAPTER 13. TRIAL BY PICTURE

1. *Philadelphia Inquirer*, May 13, 1865.
2. *Harper's Weekly*, June 3, 1865.
3. *Washington Evening Star*, May 15, 1865.
4. *Philadelphia Inquirer*, May 11, 1865.
5. *Washington Evening Star*, May 15, 1865.
6. *Philadelphia Inquirer*, May 19, 1865.
7. *Philadelphia Inquirer*, May 10, 1865.
8. James L. Swanson, "Was Jefferson Davis Captured in a Dress?"
9. Ibid.
10. Ibid.
11. Donald, *Lincoln*, 587.
12. Poore, *Conspiracy Trial*, 2:12.
13. Ibid., 35.
14. *New York Times*, May 31, 1865.
15. Poore, *Conspiracy Trial*, 2:500.
16. *New York Times*, May 31, 1865.

CHAPTER 14. THE GALLOWS

1. Edward Steers Jr. and Harold Holzer, eds., *The Lincoln Assassination Conspirators*, 49.
2. *Washington National Republican*, July 6, 1865.
3. Ibid.
4. John A. Gray, "The Fate of the Lincoln Conspirators."
5. *Harper's Weekly*, July 22, 1865.
6. *Philadelphia Inquirer*, July 4, 1865.
7. *Washington Evening Star*, July 4, 1865.
8. *Philadelphia Inquirer*, July 7, 1865.
9. *New York Herald*, July 7, 1865.
10. Ibid.
11. Swanson, *Manhunt*, 364; *Washington Evening Star*, July 7, 1865; *New York Herald*, July 7, 1865.
12. Gray, "Fate of the Lincoln Conspirators," 635.
13. *Philadelphia Inquirer*, July 8, 1865.
14. *New York Times*, July 7, 1865.

CHAPTER 15. THE EXECUTION

1. *Washington National Republican*, July 7, 1865.
2. Ibid.
3. Ibid.
4. *New York Times*, July 8, 1865.
5. *Washington National Republican*, July 7, 1865.
6. *New York Herald*, July 8, 1865.
7. *Washington Evening Star*, June 18, 1864.
8. *Washington National Republican*, July 7, 1865.
9. Gray, "Fate of the Lincoln Conspirators," 635.
10. *Washington Evening Star*, July 7, 1865.
11. Ibid.
12. *Tarborough Southerner* (Tarboro, NC), October 8, 1875.
13. *Philadelphia Inquirer*, July 8, 1865.
14. *Tarborough Southerner* (Tarboro, NC), October 8, 1875.
15. *Tarborough Southerner* (Tarboro, NC), July 8, 1865.
16. *Washington Evening Star*, July 7, 1865.
17. *Washington National Republican*, July 7, 1865.
18. *New York Herald*, July 8, 1865.
19. Elizabeth Steger Trindal, *Mary Surratt: An American Tragedy*, 206.
20. Gray, "Fate of the Lincoln Conspirators."
21. *Philadelphia Inquirer*, July 8, 1865.
22. *Sterling (IL) Standard*, March 8, 1888.
23. Townsend, *Life, Crime, and Capture of Booth*, 76.
24. *Philadelphia Inquirer*, July 8, 1865.

CHAPTER 16. BROKEN

1. Robert H. Kellogg, *Life and Death in Rebel Prisons*, 67.
2. Katz, *Witness to an Era*, 192.
3. *Washington Evening Star*, November 10, 1865.
4. *New York Times*, November 11, 1865.
5. *New York Times*, February 4, 1866.
6. Katz, *Witness to an Era*, 239.
7. Ibid.
8. R. Wilson, *Mathew Brady*, 202.
9. *In the Matter of Mathew Brady, Bankrupt*, U.S. District Court, Southern District of New York.
10. R. Wilson, *Mathew Brady*, 211.
11. *Washington Evening Star*, February 17, 1873.
12. M. B. Brady, October 30, 1874, Records of the Adjutant General, National Archives and Records Administration, Washington, DC.
13. Katz, *Witness to an Era*, 262.
14. *Washington Post*, December 5, 1882.
15. *Washington Post*, December 11, 1882; *Philadelphia Photographer*, January 1883.

16. J. Wilson, *Eulogy on the Life and Character of Gardner.*
17. Townsend interview.
18. *Washington Critic*, May 23, 1887.
19. *Lafayette (LA) Advertiser*, August 3, 1889.
20. *Inter Ocean*, February 12, 1893.
21. *Philadelphia Times*, February 12, 1893.
22. *Washington Evening Star*, November 25, 1892.
23. Townsend interview.
24. *Washington Evening Star*, June 16, 1893.
25. *San Francisco Call*, September 18, 1894.
26. R. Wilson, *Mathew Brady*, 228.
27. *Washington Evening Star*, January 18, 1896.

EPILOGUE. MOTION PICTURES

1. *New York Evening World*, December 24, 1890.
2. Todd L. Shulman, *Murder and Mayhem in the Napa Valley*, 105.
3. *San Francisco Chronicle*, February 7, 1875.
4. *Bloomington (IN) Pantagraph* (reprint of *San Francisco Post* article), July 2, 1878.
5. *Reno Evening Gazette*, September 24, 1878.
6. *Reno Evening Gazette*, March 23, 1935.

BIBLIOGRAPHY

Alford, Terry. *Fortune's Fools: The Life of John Wilkes Booth*. New York: Oxford University Press, 2015.

Bachelder, John B. *Bachelder's Illustrated Tourist's Guide of the United States*. Boston: J. B. Bachelder, 1873.

Ball, Edward. *The Inventor and the Tycoon: A Gilded Age Murder and the Birth of Moving Pictures*. New York: Doubleday, 2013.

Bogard, Thomas. *Backstage at the Lincoln Assassination: The Untold Story of the Actors and Stagehands at Ford's Theatre*. Washington, DC: Regnery, 2013.

Booth, John Wilkes. *Right or Wrong, God Judge Me: The Writings of John Wilkes Booth*. Edited by John Rhodehamel and Louise Taper. Urbana: University of Illinois Press, 1997.

Bradley, James. *The Imperial Cruise: A Secret History of Empire and War*. New York: Little, Brown, 2009.

Cannan, John. *The Antietam Campaign: August–September 1862*. Cambridge, MA: Da Capo Press, 1997.

Carpenter, Francis Bicknell. *The Inner Life of Abraham Lincoln: Six Months at the White House*. Whitefish, MT: Kessinger, 2008.

Carrier, Thomas J. *Washington, DC: A Historical Walking Tour*. Charleston, SC: Arcadia, 1999.

Catton, Bruce. *Glory Road*. New York: Doubleday, 1990.

———. *Mr. Lincoln's Army*. New York: Open Road Media, 2015.

Croffut, W. A. *An American Procession, 1855–1914: A Personal Chronicle of Famous Men*. Freeport, NY: Books for Libraries Press, 1968.

Donald, David Herbert. *Lincoln*. New York: Simon & Schuster, 1996.

Doyle, Vernell, and Tim Doyle. *Sharpsburg*. Charleston, SC: Arcadia, 2009.

Dreese, Michael. *The Hospital on Seminary Ridge at the Battle of Gettysburg*. Jefferson, NC: McFarland, 2002.

Edgerton, Gary R. *Ken Burns's America: Packaging the Past for Television*. New York: Palgrave, 2001.

Edwards, Anne, and Marylin Hafner. *P. T. Barnum*. New York: Putnam, 1977.

Egan, Timothy. *Short Nights of the Shadow Catcher: The Epic Life and Immortal Photographs of Edward Curtis*. Boston: Houghton Mifflin Harcourt, 2013.

Everett, Charles Carroll. *A Sermon in Commemoration of the Death of Abraham Lincoln*. Bangor, ME: B. A. Burr, 1865.

Fox, Richard Wightman. *Lincoln's Body: A Cultural History*. New York: W. W. Norton, 2016.

Fraser, Hamish, and Callum G. Brown. *Britain Since 1707*. London: Routledge, 2010.

Frassanito, William A. *Antietam: The Photographic Legacy of America's Bloodiest Day*. New York: Charles Scribner's Sons, 1978.

———. *Gettysburg: A Journey in Time*. Gettysburg, PA: Thomas, 1996.

Furgurson, Ernest B. *Freedom Rising: Washington in the Civil War*. New York: Vintage Books, 2005.

———. "The Man Who Shot the Man Who Shot Lincoln." *American Scholar* (March 1, 2009).

Gardner, Alexander. *Gardner's Photographic Sketch Book of the War*. Washington, DC: Philp & Solomons, 1866.

Gerry, Margarita Spalding, ed. *Through Five Administrations: Reminiscences of Colonel William H. Crook*. New York: Harper & Brothers, 1910.

Good, Timothy S. *We Saw Lincoln Shot: One Hundred Eyewitness Accounts*. Jackson: University Press of Mississippi, 1995.

Goodrich, Thomas. *The Darkest Dawn: Lincoln, Booth, and the Great American Tragedy*. Bloomington: Indiana University Press, 2005.

Goodwin, Doris Kearns. *The Bully Pulpit: Theodore Roosevelt, William Howard Taft, and the Golden Age of Journalism*. New York: Simon & Schuster, 2014.

———. *Team of Rivals: The Political Genius of Abraham Lincoln*. New York: Simon & Schuster, 2005.

Grant, Ulysses S. *The Papers of Ulysses S. Grant: November 16, 1864– February 20, 1865*. Edited by John Y. Simon. Carbondale: Southern Illinois University Press, 1985.

———. *Personal Memoirs*. New York: C. L. Webster, 1885–1886.

Gray, John A. "The Fate of the Lincoln Conspirators." *McClures*, October 1911.

Griffin, John Chandler. *Abraham Lincoln's Execution*. Gretna, LA: Pelican, 2006.

Harris, Brayton. *War News—Blue & Gray in Black & White: Newspapers in the Civil War*. Washington, DC: Brassey's, 1999.

Hartwig, D. Scott. *To Antietam Creek: The Maryland Campaign of September 1862*. Baltimore: Johns Hopkins University Press, 2012.

Hayes, Melvin L. *Mr. Lincoln Runs for President*. New York: Citadel Press, 1960.

Henderson, Debbie. *The Top Hat: An Illustrated History of Its Style and Manufacture*. Yellow Springs, OH: Wild Goose Press, 2000.

Herdegen, Lance J. *The Men Stood Like Iron: How the Iron Brigade Won Its Name*. Bloomington: Indiana University Press, 2005.

Herndon, William. *Life of Lincoln*. New York: Da Capo Press, 1983.

Hertz, Emanuel. *Lincoln Talks*. New York: Viking Press, 1939.

Hodes, Martha. *Mourning Lincoln*. New Haven, CT: Yale University Press, 2015.

Holmes, Oliver Wendell. *The Writings of Oliver Wendell Holmes*. Boston: Houghton Mifflin, 1891–1895.

Holzer, Harold. *Lincoln and the Power of the Press: The War for Public Opinion*. New York: Simon & Schuster, 2015.

Horan, James D. *Mathew Brady: Historian with a Camera*. New York: Bonanza Books, 1965.

Katz, D. Mark. *Witness to an Era: The Life and Photographs of Alexander Gardner—the Civil War, Lincoln, and the West*. New York: Viking, 1991.

Kauffman, Michael W. *American Brutus: John Wilkes Booth and the Lincoln Conspiracies*. New York: Random House, 2004.

Kellogg, Robert H. *Life and Death in Rebel Prisons*. Hartford, CT: L. Stebbins, 1865.

Kunhardt, Dorothy. *Twenty Days*. New York: Harper & Row, 1965.

Kunhardt, Philip B., Peter W. Kunhardt, and Peter W. Kunhardt Jr. *Lincoln, Life-Size*. New York: Alfred A. Knopf, 2009.

Lamon, Ward Hill. *Recollections of Abraham Lincoln, 1847–1865*. Edited by Dorothy Lamon Teillard. Washington, DC: Dorothy Lamon Teillard, 1911.

Leech, Margaret. *Reveille in Washington, 1860–1865*. New York: Simon, 2001.

Lowen, George Edward. *History of the 71st Regiment, N.G., N.Y., American Guard*. New York: Veterans Association, 71st Regiment, N.G., N.Y., 1919.

Lowry, Richard S. *The Photographer and the President*. New York: Rizzoli, 2015.

Meacham, Jon. *American Lion: Andrew Jackson in the White House*. New York: Random House, 2009.

McPherson, James M. *Battle Cry of Freedom*. New York: Oxford University Press, 2003.

Meredith, Roy. *Mr. Lincoln's Camera Man: Mathew B. Brady*. New York: Dover, 1974.

Millard, Candice. *Destiny of the Republic: A Tale of Madness, Medicine, and the Murder of a President*. New York: Random House, 2011.

Mundhenk, R. J., and L. M. Fletcher. *Victorian Prose: An Anthology*. New York: Columbia University Press, 1999.

Newhall, Beaumont. *The History of Photography: From 1839 to the Present Day*. Boston: Little, Brown, 1988.

Nardo, Don. *Mathew Brady: The Camera Is the Eye of History*. Berkeley Heights, NJ: Enslow, 2009.

Oldroyd, Osborn Hamiline. *The Assassination of Abraham Lincoln: Flight, Pursuit, Capture, and Punishment of the Conspirators*. Washington, DC: O. H. Oldroyd, 1901.

Orrmont, Arthur. *Mr. Lincoln's Master Spy: Lafayette Baker*. New York: Messner, 1966.

Ownsbey, Betty J. *Alias "Paine": Lewis Thornton Powell, the Mystery Man of the Lincoln Conspiracy*. Jefferson, NC: McFarland, 1993.

Panzer, Mary, and Mathew Brady. *Mathew Brady*. Berlin: Phaidon, 2001.

Parker, Franklin. *George Peabody: A Biography.* Nashville: Vanderbilt University Press, 1971.

Philbrick, Nathaniel. *Mayflower: A Story of Courage, Community, and War.* New York: Viking, 2006.

Pitman, Benn, comp. *The Assassination of President Lincoln and the Trial of the Conspirators.* New York: Moore, Wilstach & Baldwin, 1865.

Poore, Ben Perley, ed. *The Conspiracy Trial for the Murder of the President, and the Attempt to Overthrow the Government by the Assassination of Its Principal Officers.* Boston: J. E. Tilton, 1865.

Putnam, George Haven. *Abraham Lincoln: The People's Leader in the Struggle for National Existence.* New York: G. P. Putnam's Sons, 1909.

Russell, William Howard. *My Diary North and South.* New York: Harper & Brothers, 1863.

Shea, John Gilmary. *The Lincoln Memorial: A Record of the Life, Assassination, and Obsequies of the Martyred President.*

Shulman, Todd L. *Murder and Mayhem in the Napa Valley.* Charleston, SC: History Press, 2012.

Siegel, Alan A. *Beneath the Starry Flag: New Jersey's Civil War Experience.* New Brunswick, NJ: Rutgers University Press, 2001.

Smith, Gene. *American Gothic: The Story of America's Legendary Theatrical Family—Junius, Edwin, and John Wilkes Booth.* New York: Simon & Schuster, 1992.

Stackpole, Edward J., and Wilbur S. Nye. *The Battle of Gettysburg: A Guided Tour.* Harrisburg, PA: Stackpole, 1960.

Starr, Louis Morris. *Bohemian Brigade: Civil War Newsmen in Action.* Madison: University of Wisconsin Press, 1987.

Stashower, Daniel. *The Hour of Peril: The Secret Plot to Murder Lincoln Before the Civil War.* New York: Minotaur, 2013.

Steers, Edward. *Blood on the Moon: The Assassination of Abraham Lincoln.* Lexington: University Press of Kentucky, 2009.

Steers, Edward, Jr., and Harold Holzer, eds. *The Lincoln Assassination Conspirators.* Baton Rouge: Louisiana State University Press, 2009.

Swanson, James L. *Manhunt: The 12-Day Chase for Lincoln's Killer.* New York: Harper Perennial, 2006.

———. "Was Jefferson Davis Captured in a Dress?" *American Heritage* (Fall 2010).

Swanson, James L., and Daniel R. Weinberg. *Lincoln's Assassins: Their Trial and Execution; An Illustrated History.* New York: Harper Perennial, 2008.

Tallis, J., et al. *Tallis's History and Description of the Crystal Palace and the Exhibition of the World's Industry in 1851.* London: J. Tallis, 1852.

Thompson, Zadock. *Journal of a Trip to London, Paris, and the Great Exhibition, in 1851.* London: Nichols & Warren, 1852.

Townsend, George Alfred. *The Life, Crime, and Capture of John Wilkes Booth.* New York: Dick & Fitzgerald, 1865.

Trindal, Elizabeth Steger. *Mary Surratt: An American Tragedy.* Gretna, LA: Pelican, 1996.

U.S. Navy. *Navy-Yard, Washington: History from Organization.* Washington, DC: Government Printing Office, 1890.

Walters, Kerry S. *Outbreak in Washington, D.C.: The 1857 Mystery of the National Hotel Disease.* Charleston, SC: History Press, 2014.

Ward, Geoffrey C., Ken Burns, Ric Burns, and Don E. Fehrenbacher. *The Civil War: An Illustrated History.* New York: Alfred A. Knopf, 2015.

Watson, Roger, and Helen Rappaport. *Capturing the Light: The Birth of Photography, a True Story of Genius and Rivalry.* New York: St. Martin's Griffin, 2015.

Welles, Gideon. *The Civil War Diary of Gideon Welles, Lincoln's Secretary of the Navy.* Urbana: University of Illinois Press, 2014.

———. *A Connecticut Yankee in Lincoln's Cabinet.* Middletown, CT: Wesleyan University Press, 2014.

Williams, Alpheus Starkey. *From the Cannon's Mouth.* Lincoln: University of Nebraska Press, 1995.

Williamson, David Brainerd. *Illustrated Life, Services, Martyrdom, and Funeral of Abraham Lincoln.* Philadelphia: T. B. Peterson & Brothers, 1865.

Wilson, Joseph M. *A Eulogy on the Life and Character of Alexander Gardner.* Delivered January 19, 1883. Washington, DC: R. Beresford, 1883.

Wilson, Robert. *Mathew Brady: Portraits of a Nation.* New York: Bloomsbury, 2013.

Wilson, Rufus Rockwell, ed. *Intimate Memories of Lincoln.* Elmira, NY: Primavera Press, 1945.

Wood, Thomas N. *Saratoga.* Charleston, SC: Arcadia, 2010.

Zeitz, Joshua. *Lincoln's Boys: John Hay, John Nicolay, and the War for Lincoln's Image.* New York: Viking, 2014.

INDEX